11/1/19

4.00

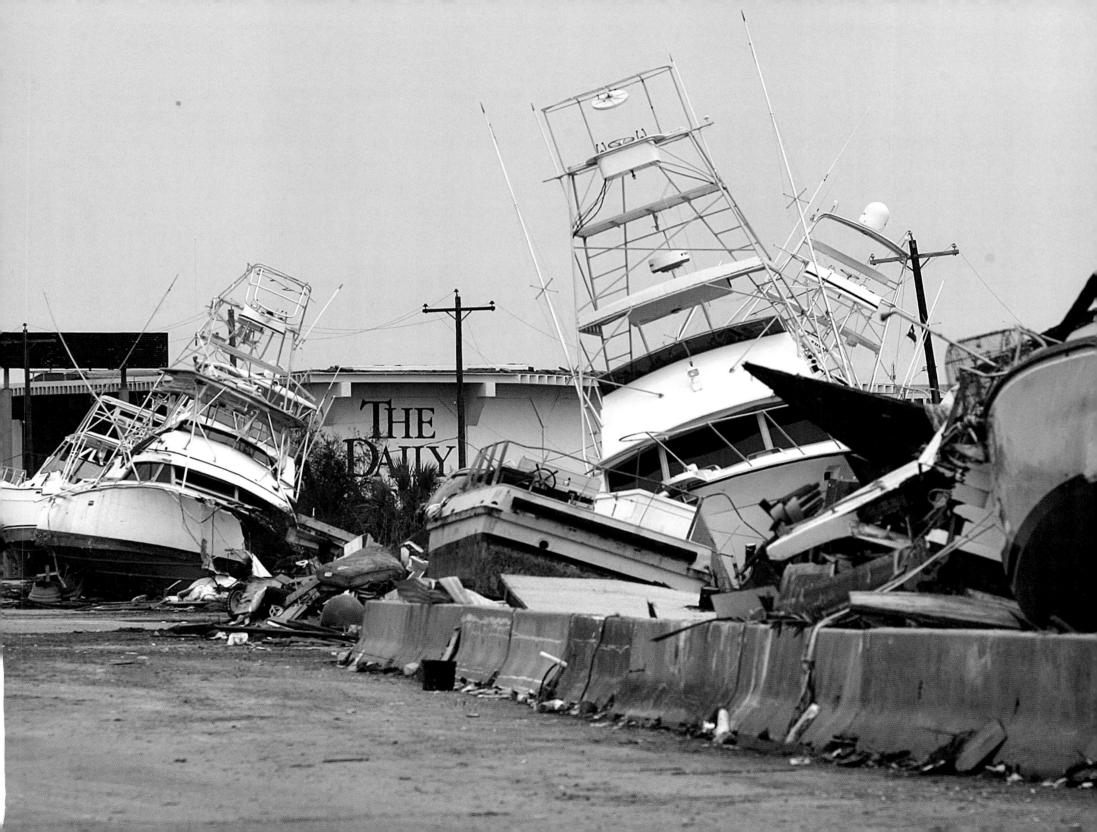

CONTENTS

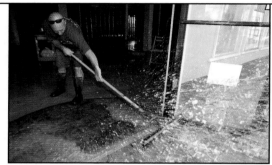
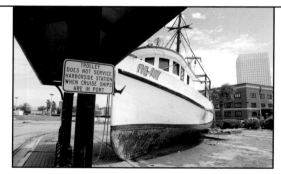
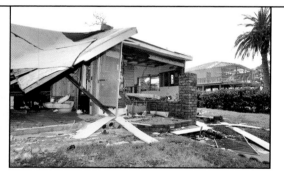
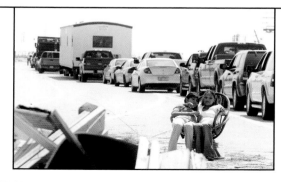

On the cover: Waves from Hurricane Ike's storm surge crashed over the Galveston seawall around the statue honoring the victims of the 1900 Storm.
JENNIFER REYNOLDS

Previous page: Boats tossed from Galveston Bay came to rest on Interstate 45 in front of The Galveston County Daily News offices at the end of the causeway.
KEVIN M. COX

Page 4: Christel and Donald La Bomme watched pieces of the 61st Street Fishing Pier crash against the seawall as Hurricane Ike headed toward Galveston.
JENNIFER REYNOLDS

Riders on the storm

JENNIFER REYNOLDS, PHOTO EDITOR

KEVIN M. COX, PHOTOGRAPHER

One of the unforgettable images from the days just after Hurricane Ike hit Galveston is of Jennifer Reynolds sitting in middle of The Daily News parking lot. She seemed to be praying over her laptop computer. Actually, she was trying to get a signal to transmit photographs of the storm damage.

Reynolds, the photo editor, and photographer Kevin M. Cox had been taking pictures all day. They were hot, tired and muddy. Access to the island and to much of the rest of the county was restricted. People badly wanted to know what had happened. The two photographers were trying to get their pictures out to the world over the shakiest of telecommunications signals.

Reynolds' signal faded. She eventually ended up on the roof of The Daily News building, trying to send photographs that told the story of what had happened to Galveston County.

It was tiring, frustrating work. Reynolds stayed at it. She transmitted as the sun set. An hour later, the glow of her computer screen could be seen on the roof as she sent images for publication.

That image is in the memories of Daily News staff members, rather than on film or digital disk. Unfortunately, it was a picture the rest of us at The Daily News missed.

Fortunately, Reynolds and Cox didn't miss much. Their photographs tell the story of the storm and of the damage. They also tell the story of the beginnings of Galveston County's recovery.

The photographers' colleagues at the newspaper found their images spellbinding. We hope you do too.

— *Heber Taylor, Daily News editor*

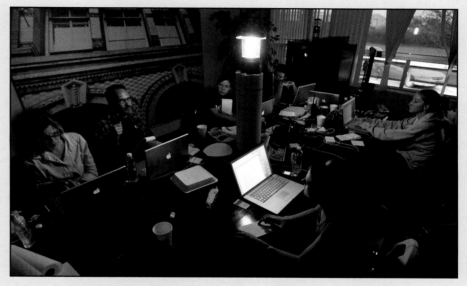

Daily News staff members, clockwise from left, Laura Elder, Michael A. Smith, Sara Foley, Mark Collette, Rhiannon Meyers and Leigh Jones worked from the conference room in the paper's Galveston building after Hurricane Ike struck. The room was lit by a single lantern and the glow from their laptop screens.
JENNIFER REYNOLDS

Publisher: Dolph Tillotson
Project Editor: Michael A. Smith
Layout/Design: Brian Grant
Pre-Press Production: Robin Lashway

"Ike: Stories of the Storm" is available for purchase at www.galvnews.com, as well as Houston-area bookstores and other retailers. Call 409-683-5200 or check out storiesofthestorm.com for information and photo reprints.

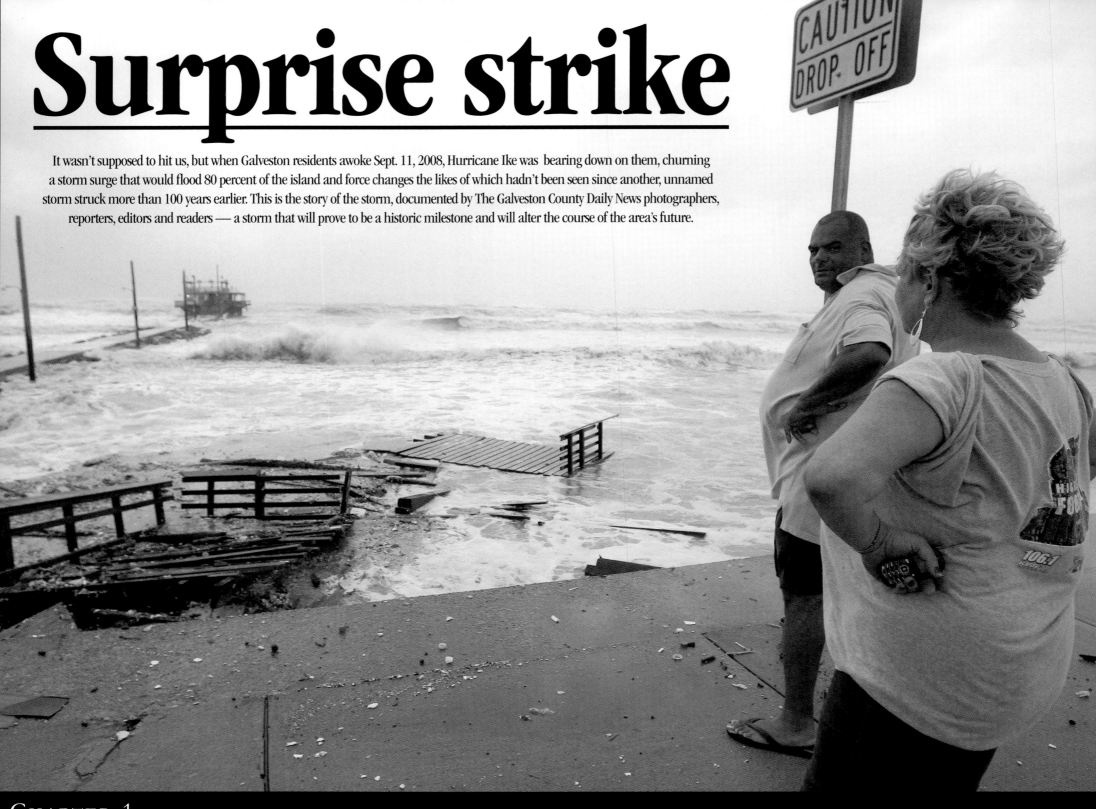

Surprise strike

It wasn't supposed to hit us, but when Galveston residents awoke Sept. 11, 2008, Hurricane Ike was bearing down on them, churning a storm surge that would flood 80 percent of the island and force changes the likes of which hadn't been seen since another, unnamed storm struck more than 100 years earlier. This is the story of the storm, documented by The Galveston County Daily News photographers, reporters, editors and readers — a storm that will prove to be a historic milestone and will alter the course of the area's future.

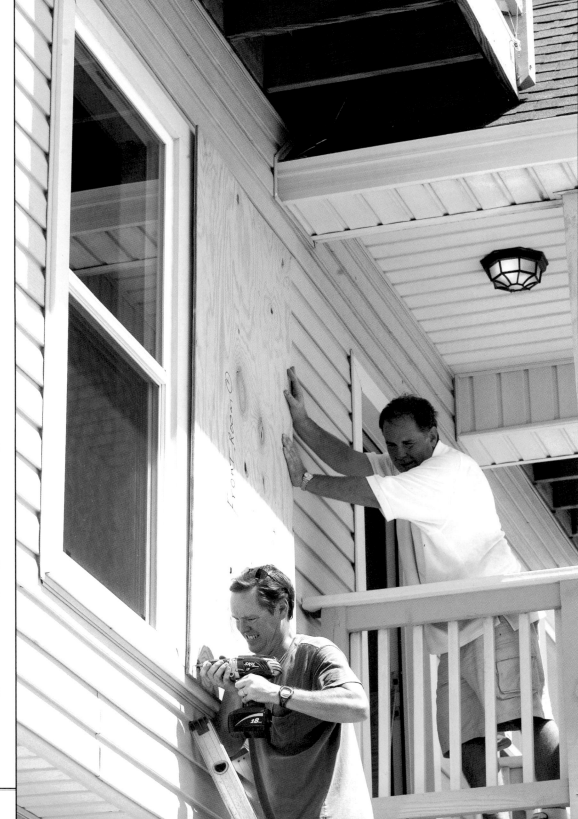

T ropical Depression Nine, which over 12 days would grow into one of the most destructive hurricanes to strike Galveston County in more than 100 years, formed Sept. 1, 2008, in the Atlantic Ocean at latitude 17.6 N, longitude 39.5 W.

National Hurricane Center forecasters pondered computer models to divine from intricate weather patterns where the brewing storm would go and what it would become. The tracks forecast by these digital oracles fanned out like the fingers of a spread hand, some south, some west, some almost due north.

Hurricane Ike was christened 4 p.m. Central Standard Time on Sept. 3. The fifth hurricane of the 2008 season, Ike was clipping along a northwest bearing at 18 mph. The official track said it would turn a little south, then swing back north toward the Bahamas and South Florida.

In the next five days, Ike grew into a major hurricane, persisted south and west of earlier forecasts, and began crawling along the spine of Cuba.

Hurricane buffs began to notice how its projected path into the Gulf of Mexico had come to resemble that of another Cape Verde hurricane, an infamous, nameless one of the century before.

By the morning of Sept. 9, as Ike flailed against the mountains of western Cuba, the heavy black line on hurricane center forecast maps had swung in a huge southward arc and met the Texas Coast between Brownsville and Corpus Christi, about 300 miles south of Galveston.

Some people relaxed. Others said you could never trust a westering hurricane; they like to turn north. And soon, that black line on forecast maps was ticking northward along the coast like the hand of an ominous clock, each tick bringing Ike's projected landfall a little closer to Galveston County.

Storms that set the stage

It's impossible to tell the story of Hurricane Ike without the context of three other storms.

First, The Great Storm that blew ashore at Galveston on Sept. 8, 1900, killing 6,000 island residents and another 4,000 to 6,000 elsewhere.

The 1900 Storm knocked Galveston from its place among the nation's most wealthy and important cities, linked the island forever to the country's most deadly natural disaster and shaped local attitudes about hurricanes for generations after.

Many islanders, some tracing their roots back to the people who survived The Great Storm and dragged the city back to life, refuse to run from hurricanes. It's a matter of pride.

Then came Hurricane Katrina, which slammed the Louisiana and Mississippi coasts on Aug. 28, 2005, killing more than 1,000 people and causing about $75 billion in dam-

age. Katrina made hurricanes a national obsession for a time, reminded modern Americans how deadly hurricanes can be and provided the rationale for a new Texas law allowing local leaders for the first time in history to order mandatory evacuations.

Finally came Hurricane Rita, another massive storm of the 2005 season, which bore toward Galveston for days with winds as high as 175 mph. Rita forced the first test of the state's new evacuation law. More than 2 million people tried to leave the region. Chaos ensued. People spent hours creeping along gridlocked roads leading inland. Getting to north Houston took as long as 12 hours.

The roadsides were lined with cars and trucks that had failed in the heat or run out of gas. People wandered lost along dark, foreign backroads, terrified of being trapped there when the storm hit. They sheltered in parking lots and the houses of strangers. About 100 died in the evacuation. Many who left swore they would never do it again.

Just before landfall, Rita pivoted sharply north, giving Galveston nothing more than a rough kiss.

The one that didn't turn

Galveston County went to bed Wednesday, Sept. 10, 2008, thinking Ike would go ashore well to the south. The city of Galveston had ordered an evacuation of the island's West End, which lies outside the seawall's protection, and had encouraged the rest of the city to leave voluntarily. Forecasts called for minor flooding and winds as high as 95 mph.

People awoke Thursday, Sept. 11, to bad news: Ike's track had shifted north again. The city ordered an evacuation of the entire island.

Many began making their first preparations to leave or to batten down for the storm.

Buses rolled into town to evacuate people who couldn't leave on their own.

Two storms, similar paths

The path Hurricane Ike took as it entered the Gulf of Mexico was similar to that of the Great Storm of 1900, which practically wiped out Galveston and killed some 6,000 people in early September.

Hurricane Ike

1900 Storm

Saffir-Simpson Hurricane Scale

TD TS Cat1 Cat2 Cat3 Cat4 Cat5

Grocery store parking lots were ful as people stocked up with food, water and ice. It was obvious many planned to ride out the storm on the island.

Traffic on Interstate 45 backed up most to 61st Street early in the day, b by midafternoon, traffic moved inlan at good speed.

Bay water alrea had begun gurglir up through storm drains, flooding streets in neighbo hoods east of Eng Bayou. Ike was sti more than 300 mi out at sea.

About 130 people fleeing high water in mainland areas gathered at the Charles T. Doy Convention Center Texas City.

At 4 p.m., foreca ers changed Ike's path again, predic ing a direct hit on Galveston early Saturday morning People hoped it would move farther north.

A different kind of storm

The forecasters also had begun warning that Ike would be a differe kind of hurricane. It was generating only Category 2 wind speeds, but Ike was huge, almost 600 miles wide. Hurricane-force winds extended more than 100 miles fron a large, wobbling, asymmetrical ey Forecasters warned Ike could bring as much as 20 feet of storm surge t Galveston and the Bolivar Peninsu 25 feet in narrow bay inlets, numb usually associated with Category 4 storms.

On Thursday night, the National Weather Service issued an unprecedented warning: "Persons not heeding evacuation orders in single-family one- or two-story

...nes will face certain death."

When the sun rose Friday, Sept. 12, huge ...es were slamming against the concrete ... of the seawall, sending foamy geysers ...rown water many feet into the air. Even ...e old-school islanders who'd sworn ...'d never evacuate took one look, packed ...at they could and headed inland.

...3y 7 a.m., The Strand area was flooded ...n Harborside Drive to Market Street. ...bout 15,000 people still were in the city; ...ther 200 or so were trapped on Bolivar ...insula, where U.S. Coast Guard helicop-...already were flying rescue missions.

...arrives

...ke lashed Galveston County for about ...hours on Sept. 12 and 13, at times with ...ds of more than 100 mph. By noon on ...12th, it was clear that flooding would ...unprecedented in modern times. Many ...ple who stayed began to wonder whether ...y had made a fatal mistake. In the end, ...e had. More than 40 houses burned on ...island because firefighters were unable to ...verse the flooded city.

...he same natural forces that conspired to ...n Ike and steer it to Galveston ordained ...t its main force would arrive well after ...set Sept. 12. Whatever the storm would ...ng for people who had stayed would have ...e dealt with in the dark.

...About 100 people called 911 during the ...m begging for rescue. Many told emer-...cy dispatchers the water was so high in ...ir houses they were retreating into attics. ...ke's eye came ashore about 1 a.m. ...urday, Sept. 13. An eerie calm fell over the ...nd. The sky turned orange and seemed ...low.

...At the peak of flooding, water from ...veston Bay and the Gulf of Mexico met ...the island's east and west ends. Only a ...row strip of the city running south from ...nue O and east from 53rd to the seawall ...ved above water. The sea had claimed ...rest.

...Covered in seething water perhaps 14 feet ...p, the Bolivar Peninsula had ceased to ex-...s a geographical feature. The unimpeded ...ves knocked whole houses off their pilings ...d swept them into Galveston Bay. People

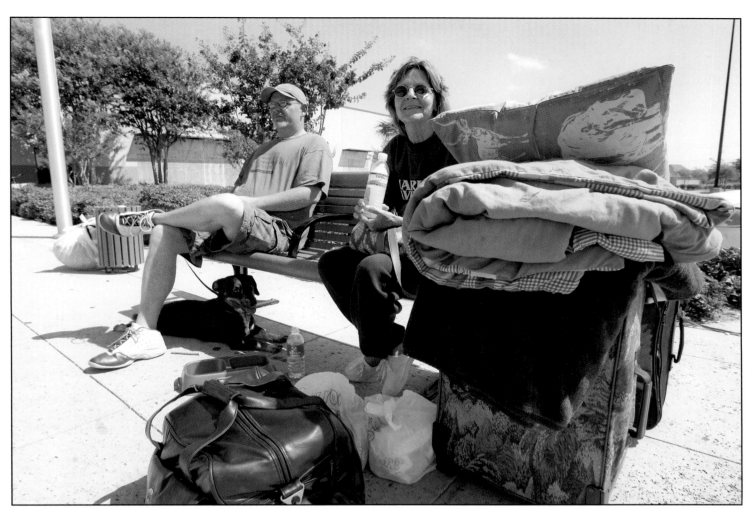

Left: Jeffery Stevens, his mother, Dorothy Burch, and their dog, Boomer, waited outside the Island Community Center in Galveston to board a bus to evacuate the island Thursday, Sept. 11, 2008, ahead of Hurricane Ike.

JENNIFER REYNOLDS

Below, left: A truck was underwater at Washington Park on Friday morning, Sept. 12, 2008, as water in Offatts Bayou rose.

JENNIFER REYNOLDS

Below: Sharon Walker loaded her belongings onto her scooter and rode down Avenue P in Galveston Thursday, Sept. 11, 2008. Walker said she was trying to finish moving to a new apartment before Hurricane Ike made landfall.

JENNIFER REYNOLDS

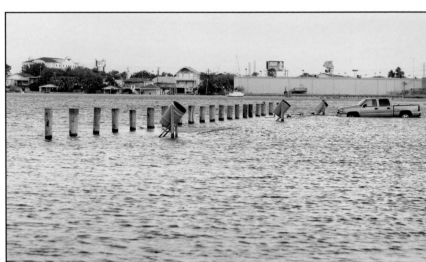

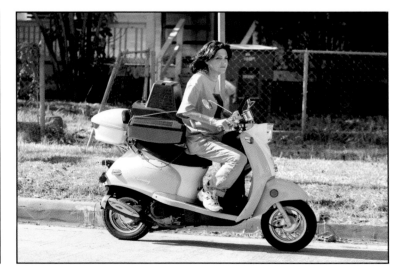

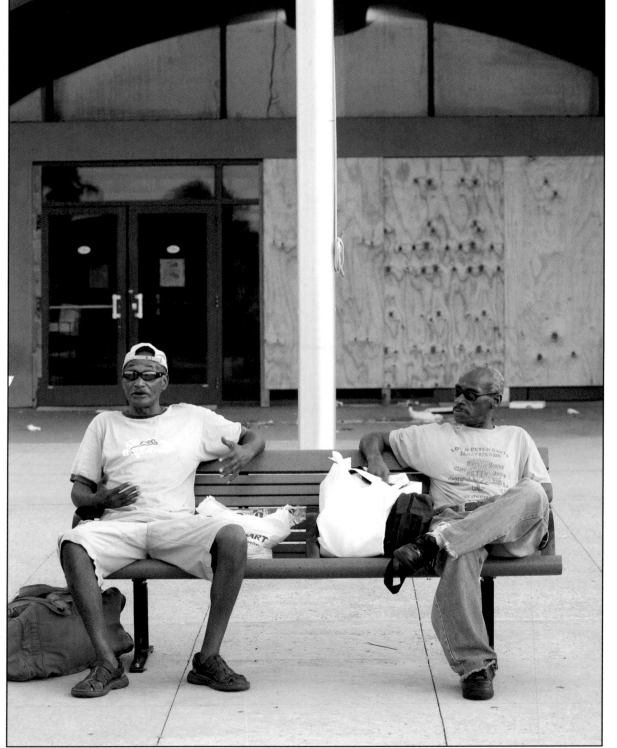

Louis Gross, left, and Don Davis sat outside the Island Community Center in Galveston on Friday morning, Sept. 12, 2008, hoping another evacuation bus will show up. Galveston emergency officials said that no buses would be available after Thursday's evacuation.

JENNIFER REYNOLDS

rode out the remaining storm adrift in the darkness on pieces of their shattered dwellings.

By the late morning Sept. 13, the wind had calmed and water receded enough for people to leave shelter. It was clear that Ike had mauled most of the county.

The storm had killed at least 15 people, directly or indirectly, in the county. The full count was unknown more than a month later.

It appeared the death toll would be highest among residents of the low-lying, unprotected Bolivar Peninsula. Huge debris fields there and across the bay in Chambers County — said to be 30 feet high, 30 feet wide and a mile long — had not been completely searched for bodies.

The cost

Ike was the most expensive hurricane in Texas history, causing an estimated $11.4 billion in damage across 29 counties.

A month later, the full extent of the damage in Galveston County was unknown. County officials estimated repairs to the seawall and other county structures would cost $10 million.

The county's hurricane levee, which protects parts of La Marque and Texas City sustained $1.9 million in damage.

The city of Galveston estimated that 75 percent of island buildings sustained flood damage.

The storm damaged 4,873 structures in floodplains in the unincorporated areas of the county.

The Texas Windstorm Insurance Association, which underwrites property in 14 coastal counties, estimated its liability at just less than $3 billion. The National Flood Insurance Program had no estimate of damage.

Aftermath

In late October, more than 400 people still were living in a Red Cross tent shelter on the grounds of Alamo Elementary School in Galveston. The city had not revealed a plan to house them. Anger and frustration were mounting among the displaced.

Another 150 or so people who had evacu-

ated by bus after the storm still were living shelters and in hotels around San Antonio. An untallied number still was living in plac other than home.

People also were frustrated about the time it was taking to get city permits to beg rebuilding. Many lived in limbo, waiting to learn whether they could repair their damaged houses and commercial buildings or whether they would be required to build to new, more expensive codes.

On Oct. 23, 2008, a cold front blew through Galveston County, dropping overnight temperatures into the 50s. For some, the first October cold snap marks the practical end of hurricane season. National Weather Service forecasters noted that no hurricane had ever struck the Texas Coast after Halloween.

People had begun to talk about high school football and a November election, di ing which voters would pick a new preside of the United States.

Schoolchildren were back in class; man businesses had reopened.

Restaurants were packed with locals an people from all over the country working o a massive cleanup effort.

The official end of hurricane season 200 was only 38 days away. The tropical zones where hurricanes are born were calm.

But everywhere remained the signs of Hurricane Ike's passing.

Heaps of debris still were piled at the cur along Galveston streets and along roads on the mainland.

The Galveston-Port Bolivar Ferry was closed to the public and most services were still out on the peninsula.

Boats were grounded all along the bay a beside island roads.

Two huge debris piles had been assemble in Galveston. One estimate said 1.5 billion cubic yards of debris would have to be haul from Galveston alone. The job could take three years and cost as much as $50 millio

And everybody knew it would be a very long time before the 2008 hurricane seasor really would be over.

— *By Michael A. Smith, with contrib tions from Daily News reporters Laura Elder, Sara Foley, Leigh Jones, Rhiannor Meyers and Chris Paschenko.*

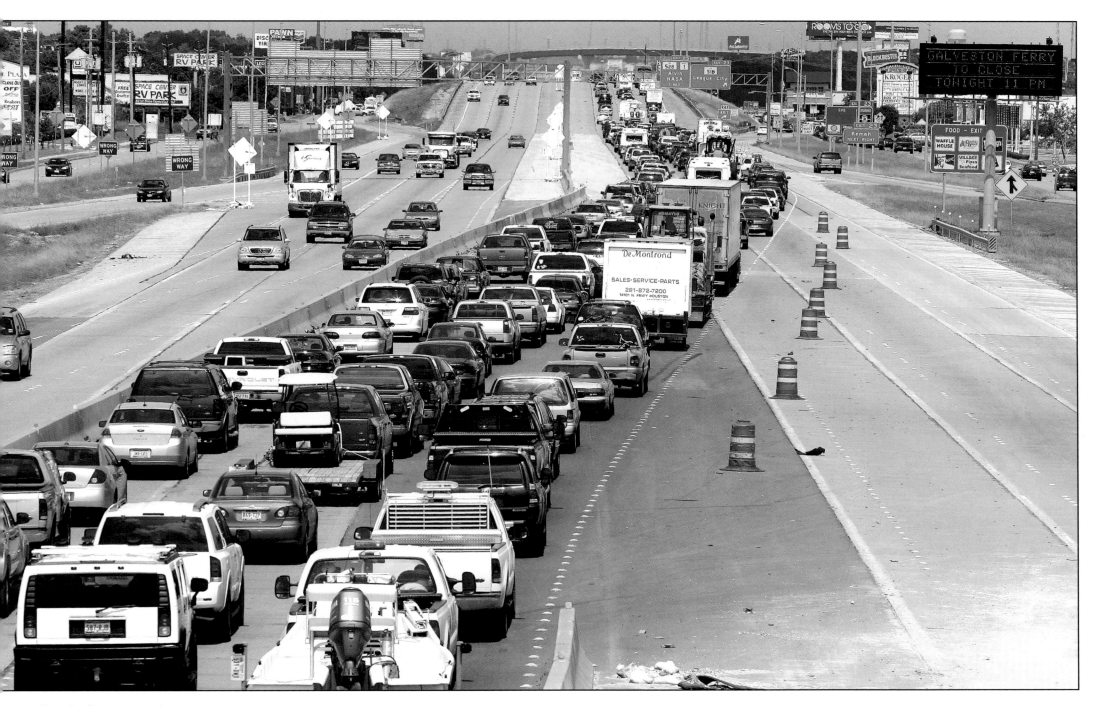

Above: Northbound traffic on Interstate 45 in League City backed up south of the FM 518 bridge on Thursday afternoon, Sept. 11, 2008. Galveston County residents were fleeing the path of Hurricane Ike.

KEVIN M. COX

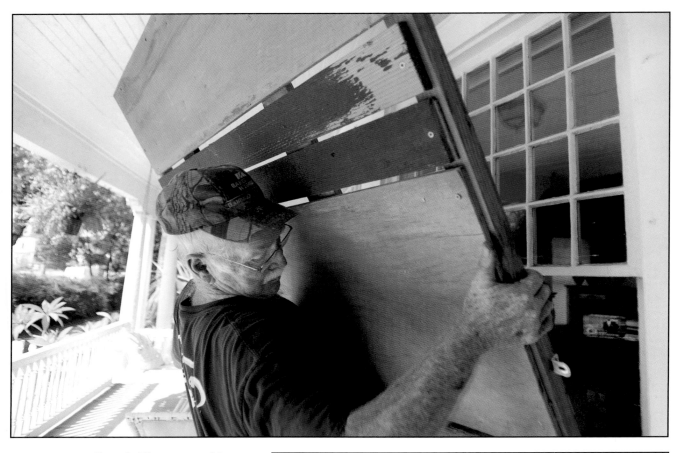

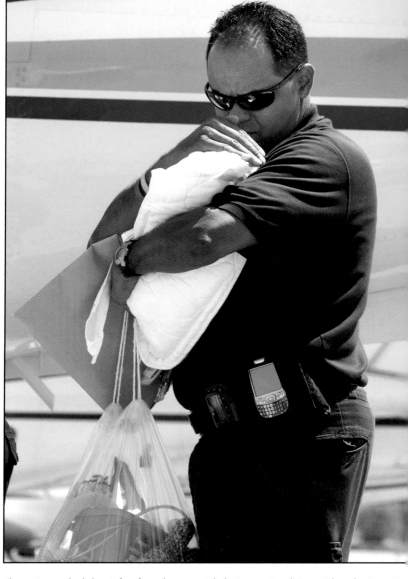

Above: Red Henry put one of three boards up on a bay window of his 1903 house in Galveston Wednesday, Sept. 10, 2008, as Hurricane Ike headed for the Texas Coast. Although landfall at the time was predicted farther down the coast, Galveston was forecast to receive tropical storm force winds with higher tides and storm surge.

JENNIFER REYNOLDS

Left: Bradley Etie of San Leon waited for his turn to board an evacuation bus at the Doyle Convention Center in Texas City on Thursday afternoon, Sept. 11, 2008. Galveston County residents who wanted to evacuate Hurricane Ike's path but could not do so on their own were brought to the center to board buses bound for Austin.

KEVIN M. COX

Above: A man shaded an infant from the sun at Scholes International Airport Thursday, Sept. 11, 2008. Emergency personnel evacuated infants from The University of Texas Medical Branch at Galveston neonatal unit by plane as Hurricane Ike headed for the Texas coast.

JENNIFER REYNOLDS

Next page: An island resident watched waves crash over the top of the seawall near 75th Street Friday morning, Sept. 12, 2008, as Hurricane Ike approached Galveston.

JENNIFER REYNOLDS

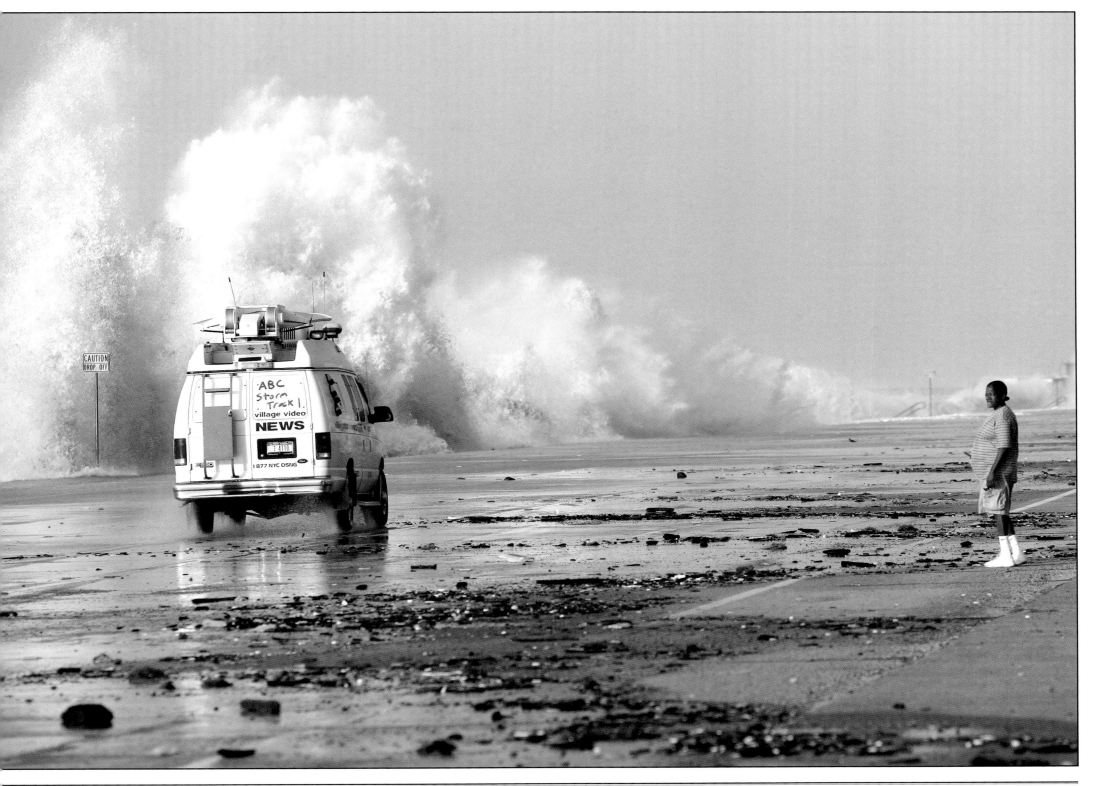

Left: Dennis Byrd, owner of The Spot on the seawall, opened the bar Thursday, Sept. 11, 2008, for residents still on the island.

JENNIFER REYNOLDS

Below: J.D. Flores, left, Mike Teel and Randall Hopper kicked back and watched the waves at The Spot on the seawall Thursday, Sept. 11, 2008.

JENNIFER REYNOLDS

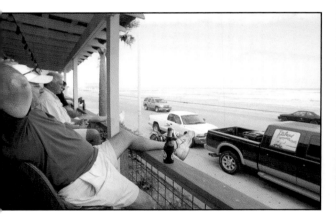

Aug. 19 — An easterly tropical wave formed in the upper atmosphere over Sudan and began moving west across Africa.

Aug. 28 — The tropical wave hit the coastal African country of Senegal.

Early Sept. 1 — The wave developed a sufficient amount of convection and was designated Tropical Depression Nine.

Late Sept. 1 — The tropical depression had strengthened to become Tropical Storm Ike.

Sept. 3 — After some weakening the day before, the storm intensified and was upgraded to Hurricane Ike by mid-afternoon. The hurricane rapidly intensified, and became a Category 4 hurricane within three hours.

Sept. 4 — Hurricane Ike reached its maximum winds of 145 mph.

Sept. 5 — Hurricane Ike's eye became more developed even as wind shear caused it to weaken.

Sept. 6. — Ike was downgraded to a Category 2 hurricane. But it re-intensified to a Category within six hours.

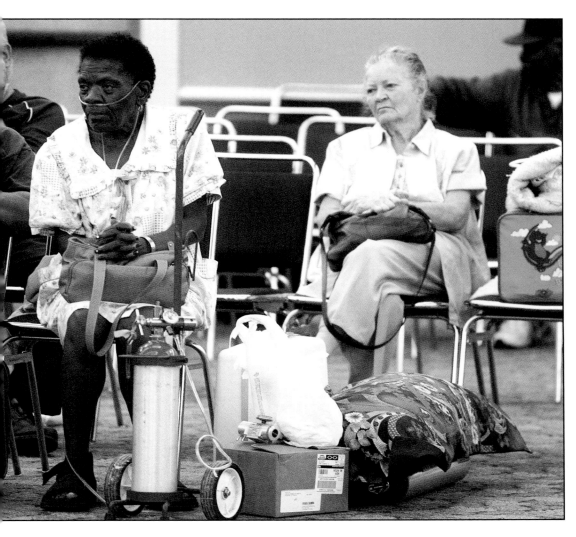

Left: Joyce Nichols of La Marque and LaVerne Montgomery of Dickinson waited to board an evacuation bus at the Doyle Convention Center in Texas City on Thursday afternoon, Sept. 11, 2008. Nichols arrived at the center with two extra oxygen bottles, but both were stolen while she registered for a ride. Galveston County residents who wanted to evacuate Hurricane Ike's path but could not do so on their own were brought to the center to board buses bound for Austin.

KEVIN M. COX

Below: Denise Dreitner secured storm shutters to her Bacliff home on Thursday afternoon, Sept. 11, 2008, in preparation for Hurricane Ike. Dreitner, who spent 23 hours in the car evacuating before Hurricane Rita in 2005, planned to ride out Ike at home. "I did that last time with Rita, 23 hours, I ain't doing that again," she said.

KEVIN M. COX

t. 7 — Ike passed ctly over the Turks l Caicos Islands with ds of 135 mph early he morning. It hit theastern Cuba in the ning.

Sept. 8 — The hurricane emerged over the sea to the south of Cuba before hitting the western tip of the country.

Sept. 9 — Hurricane Ike entered the Gulf of Mexico.

Early Sept. 10 — A mandatory evacuation was ordered for the West End of Galveston Island despite a projected landfall more than 100 miles to the south.

Late Sept. 10 — Meteorologists noted the storm was absorbing and distributing energy over a large area, rather than concentrating it near the center. Although it was a strong Category 2 hurricane, the storm surge was predicted to match that of a Category 4.

Early Sept. 11 — Ike made a sudden shift to the north. Officials ordered a mandatory evacuation for the rest of the island.

Sept. 11, 9:30 a.m. — About 1,500 Galveston residents began to line up at the Island Community Center to wait for evacuation buses to take them to Austin.

Sept. 11, 11 p.m. — Officials closed the Galveston-Port Bolivar Ferry to traffic to stop people from coming onto the island or leaving for the peninsula.

Right: Waves broke between a Murdoch's Pier souvenir shop at 23rd Street and Seawall Boulevard in Galveston on Friday, Sept. 12, 2008. Stairs to the store, which sat on piers over the water, had been ripped away, as had part of a walkway over the Gulf. Ike destroyed the iconic shop.
JENNIFER REYNOLDS

Below: Jessica Stevenson and her son, Elijah Roberts, waited at the Island Community Center in Galveston on Thursday, Sept. 11, 2008, to evacuate by bus to Austin. She, her three children and another family member were leaving the island as Hurricane Ike headed for the coast.
JENNIFER REYNOLDS

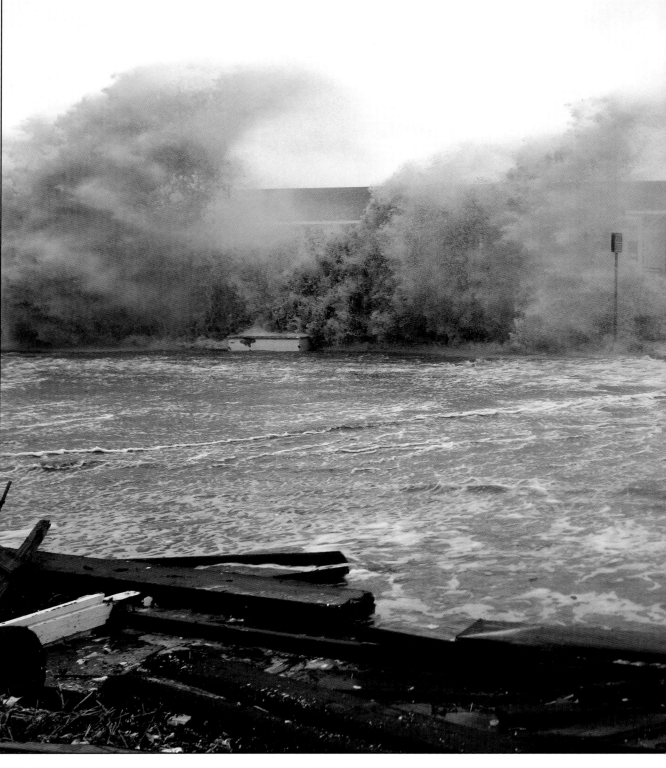

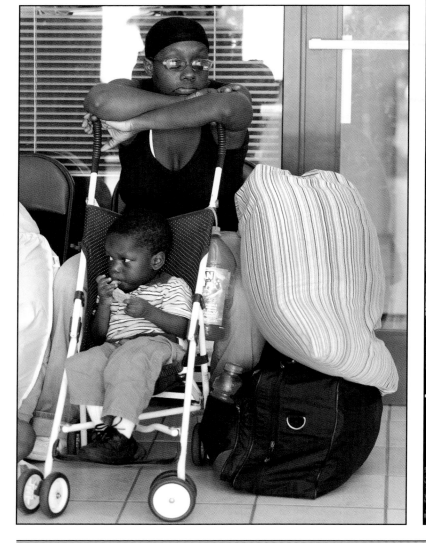

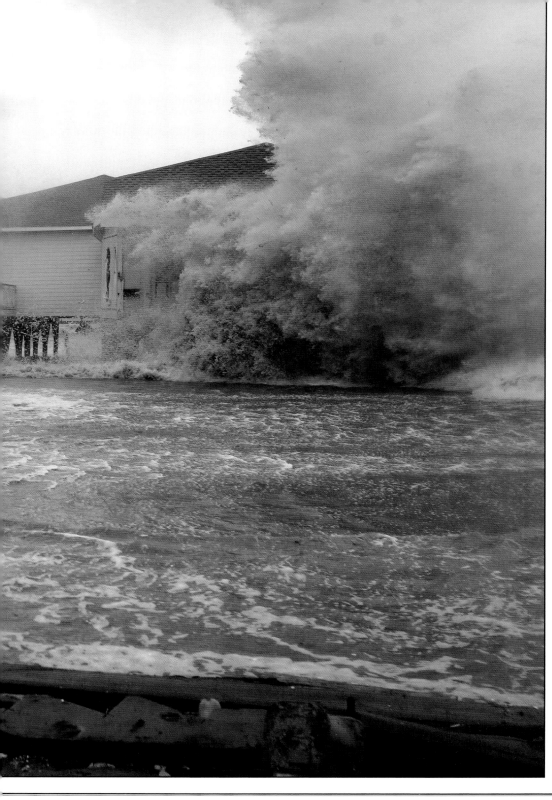

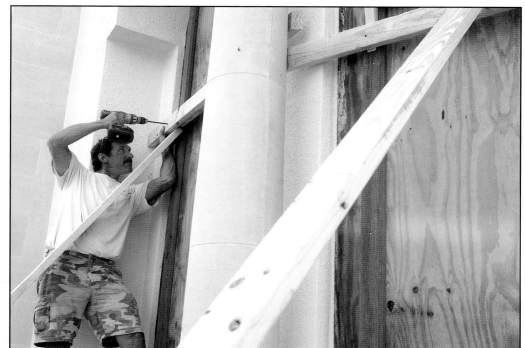

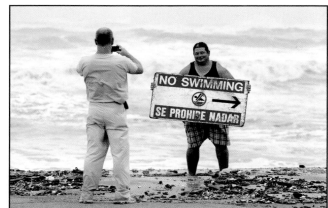

Above: Vito Mantegna boarded up his home in Clear Lake Shores before the arrival of Hurricane Ike on Friday morning Sept. 12, 2008.
KEVIN M. COX

Left: Kelly Carmichael took Clay Stucker's photo with one of the Galveston beach warning signs that washed up on the seawall Friday, Sept. 12, 2008, as the early storm surge from Hurricane Ike battered the island.
JENNIFER REYNOLDS

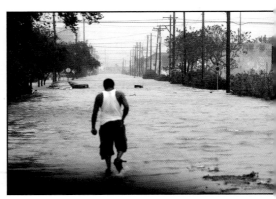

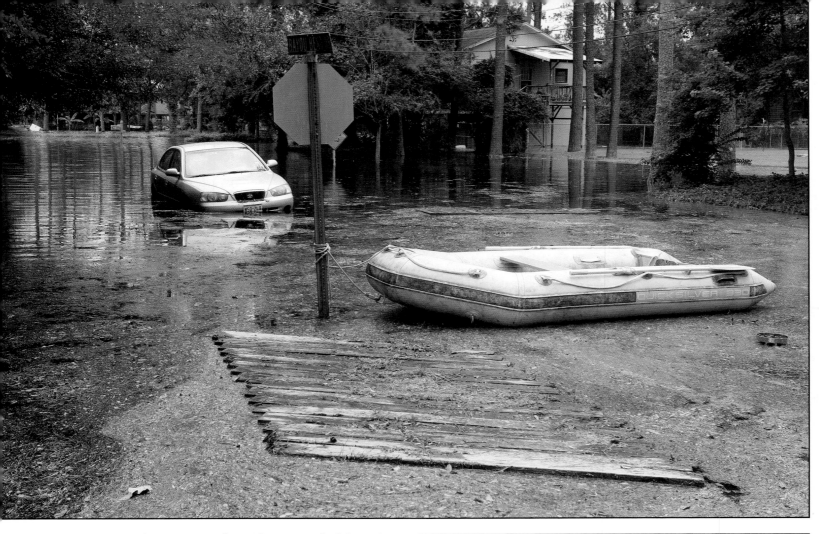

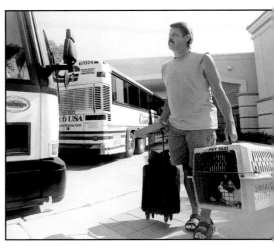

Above: Rising water from Dickinson Bayou flooded streets in the Country Club Estates neighborhood of Dickinson on Friday afternoon, Sept. 12, 2008. The storm surge leading Hurricane Ike pushed high water inland from Galveston Bay.

KEVIN M. COX

Right: Josephine Jessing held her grandson, Joseph Allen, in the Ball High School cafeteria. City officials opened the high school as a shelter of last resort Friday afternoon, Sept. 12, 2008, for residents who did not evacuate for Hurricane Ike.

JENNIFER REYNOLDS

Far right: Employees at Sand Dollar Autoplex in Galveston had fun with the Category 2 hurricane's name when they boarded up windows Thursday, Sept. 11, 2008, in preparation for the storm.

JENNIFER REYNOLDS

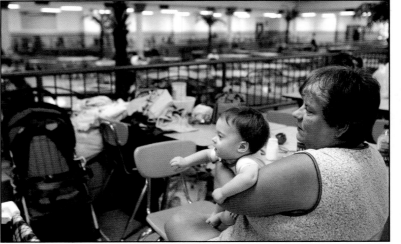

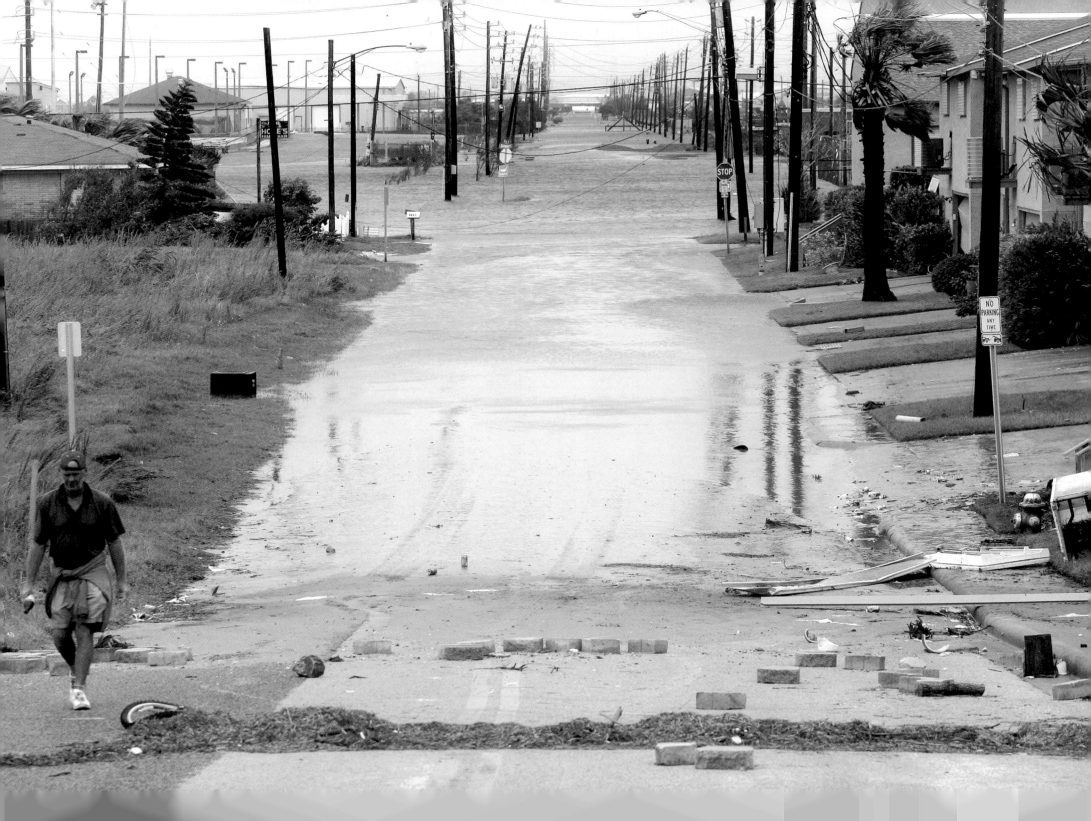

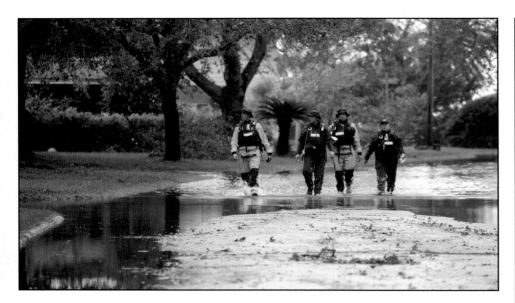

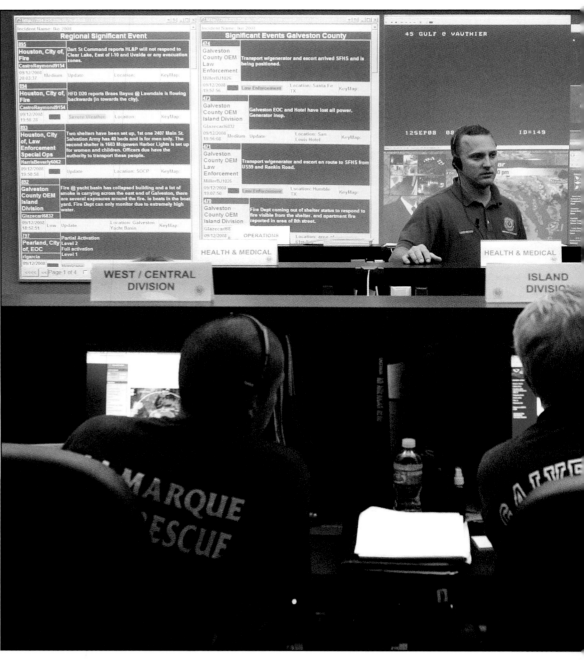

Above: A search and rescue team walked through receding floodwaters near English Bayou on Saturday, Sept. 13, 2008, after searching homes flooded during Hurricane Ike.

JENNIFER REYNOLDS

Previous page: A man walked toward the seawall on 83rd Street, which was still flooded after Hurricane Ike slammed into the Texas coast in the early morning hours Saturday, Sept. 13, 2008.

JENNIFER REYNOLDS

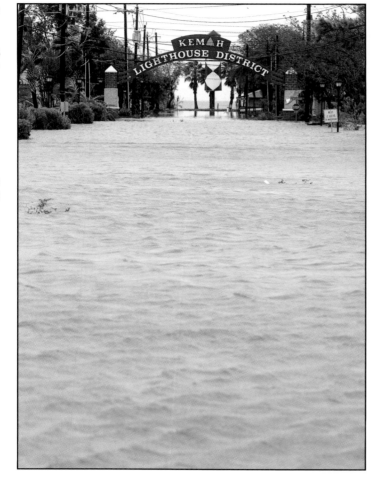

Above: Operations Coordinator Lee Lockwood managed the Galveston County Emergency Operations Center in League City as Hurricane Ike approached on Friday evening Sept. 12, 2008.

KEVIN M. COX

Left: The Kemah Boardwalk and Lighthouse District was underwater on Saturday morning, Sept. 13, 2008. Hurricane Ike made landfall on Galveston Bay early Saturday morning as a Category 2 storm.

KEVIN M. COX

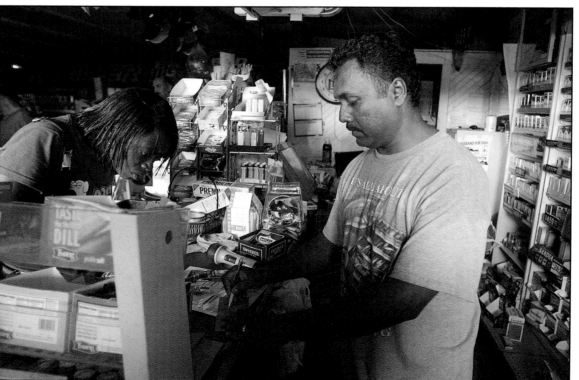

Above: Galveston police officers helped a man and his daughter to a squad car for a ride to Ball High School, which opened as a shelter of last resort as Hurricane Ike approached Galveston on Friday, Sept. 12, 2008.
JENNIFER REYNOLDS

Left: Francis Correia helped customers at the Palmer Food Mart in Texas City on Saturday afternoon, Sept. 13, 2008. Palmer was one of two local stores open despite widespread power outages.
KEVIN M. COX

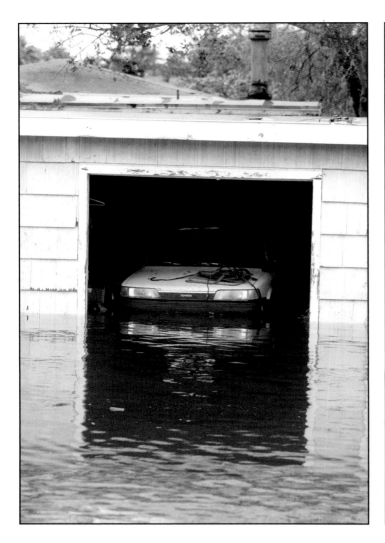

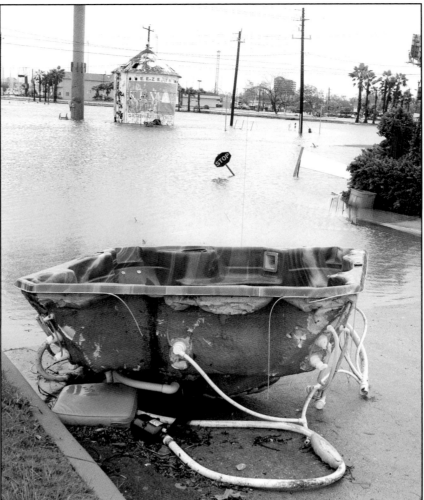

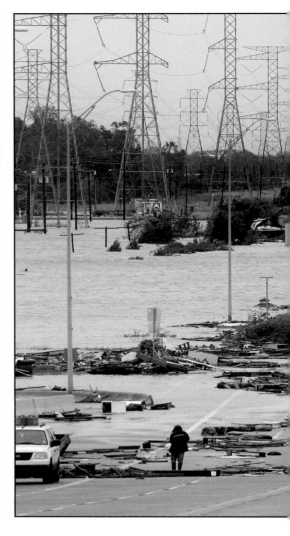

Thursday, Sept. 11, early afternoon — Traffic on the causeway backed up almost to 61st Street.

Thursday, Sept. 11, 2 p.m. — A tidal surge on the West End pushed water over roads and flooded sewers. The tide was 3 feet at 61st Street Pleasure Pier and 3.2 feet at the North Jetty. By this time, tides were predicted at a maximum of 16 feet.

Thursday, Sept. 11, 4 p.m. — Forecasters changed Ike's projected path and predicted a direct landfall on Galveston for early Saturday morning as a Category 2 storm.

Thursday, Sept. 11, 6 p.m. — Buses with evacuees bound for Austin left the island.

Friday, Sept. 12 — Ball High School opened as a shelter of last resort for those who did not evacuate the island. The U.S. Coast Guard evacuated 94 people from Bolivar Peninsula as waves from Hurricane Ike inundated the coastal communities.

Friday, Sept. 12, night — Firefighters were unable to reach several fires raging across Galveston because of flooded streets.

Friday, Sept. 12, night — Galveston's water services stopped functioning.

Saturday, Sept. 13 — Ike's eye made landfall on Galveston about 1 a.m. with 110 mph win More than 2 million CenterPoint Energy cu tomers lost electricity.

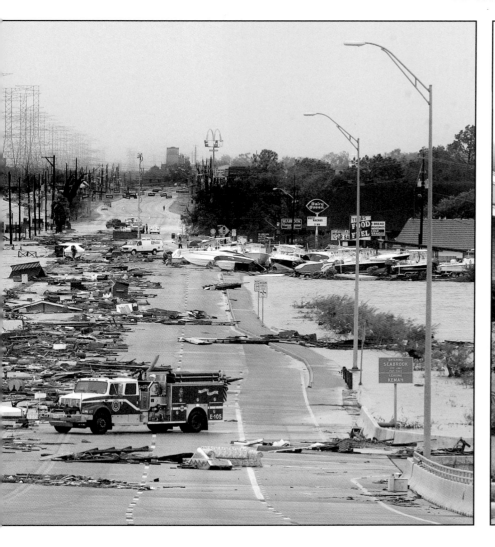

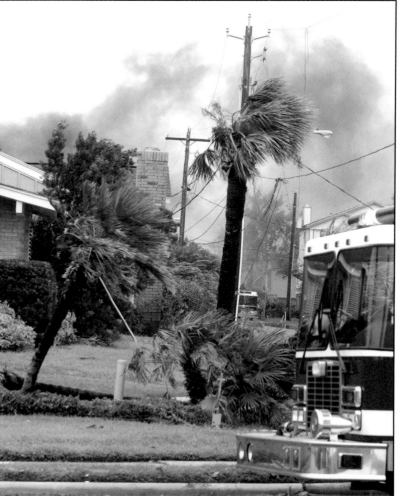

From far left: Floodwaters from Hurricane Ike covered the bumper of a car in a garage on 69th Street in Galveston on Saturday, Sept. 13, 2008.
JENNIFER REYNOLDS

A hot tub sat at the entrance of a shopping center on FM 2094 in Kemah on Saturday morning, Sept. 13, 2008. Hurricane Ike made landfall on Galveston Bay early Saturday morning as a Category 2 storm.
KEVIN M. COX

Debris covered state Highway 146 at the Galveston County and Harris County line in Seabrook on Saturday morning, Sept. 13, 2008.
KEVIN M. COX

Firefighters responded to a structure fire in the Havre Lafitte subdivision hours after Hurricane Ike moved inland. Several town houses burned to the ground as flames were fanned by high winds.
JENNIFER REYNOLDS

...rday, Sept. 13, late ...rning — Ike passed ...ugh Houston and ...tinued through ...theast Texas. ...sident Bush declared ...theast Texas and ...thwest Louisiana ...ster areas.

Sunday, Sept. 14 — The Texas Army National Guard set up distribution centers in Galveston County to hand out water and ice to a public made powerless by Ike.

Sunday, Sept. 14 — Hundreds more islanders evacuated the island in buses.

Sunday, Sept. 14 — Ike continued northeast as a tropical depression and caused power outages and deaths as far north as Pennsylvania and flooding in Ohio.

Sunday, Sept. 14 — Galveston City Manager Steve LeBlanc said some residents might never return to the island. "My guess is it will take about a year before we can resume normal operations," he said.

Sunday, Sept. 14 — The Federal Emergency Management Agency set up mobile units on the island.

Sunday, Sept. 14 — Galveston officials confirmed five deaths as a street-by-street search of the city began.

Sunday, Sept. 14 — Officials announced that the southbound lanes of the Galveston Causeway wouldn't reopen until engineers could inspect it to see whether it sustained damage when several large yachts and other vessels crashed into it.

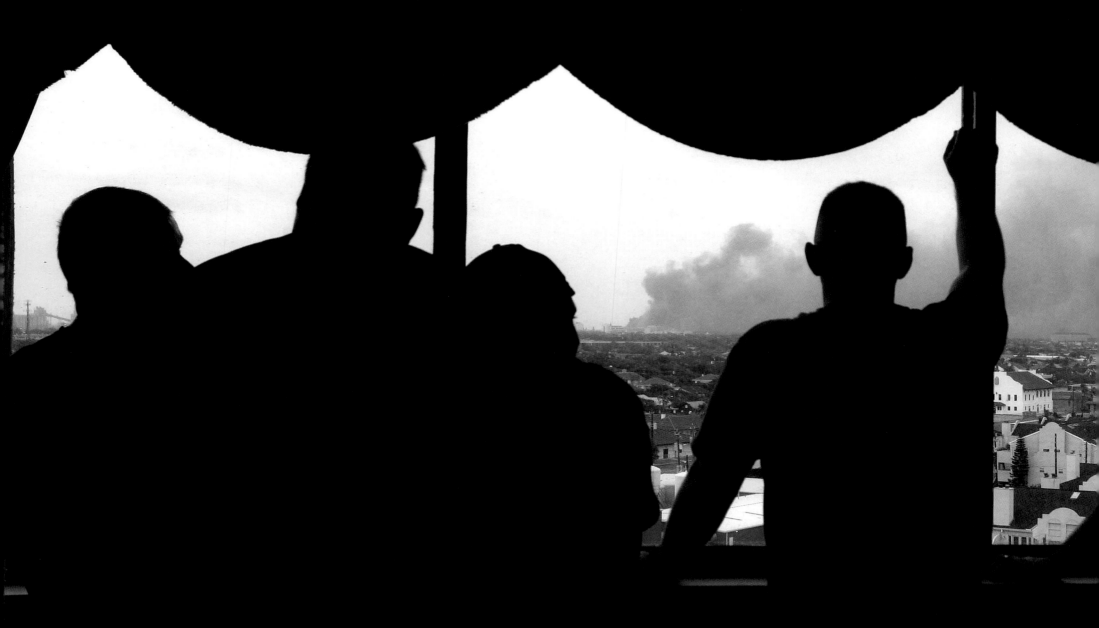

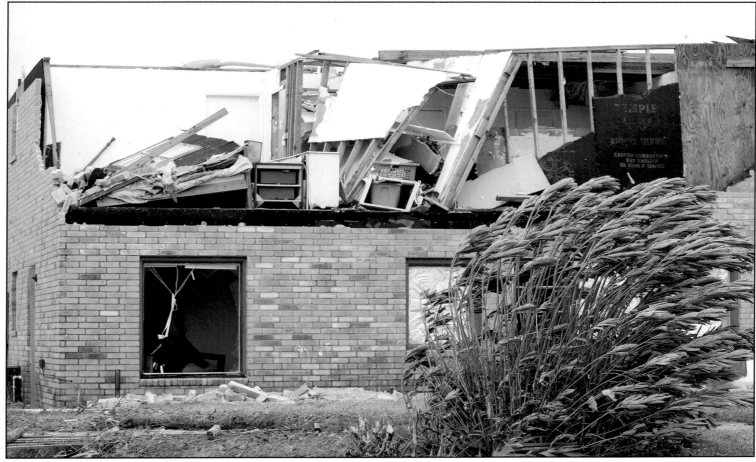

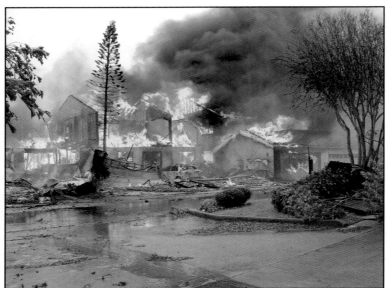

Above: Exterior walls of an apartment building on Stewart Road in Galveston were ripped away as strong winds blew Saturday Sept. 13, 2008, several hours after Hurricane Ike slammed into the coast.

JENNIFER REYNOLDS

Far left: Emergency personnel watched a fire burn out of control at a dry storage facility at the Galveston Yacht Basin from the ninth floor of the San Luis Hotel on Friday evening, Sept. 12, 2008.

JENNIFER REYNOLDS

Left: A row of houses burned to the ground on the island's West End after Hurricane Ike struck. Firefighters were unable to get to many fires because of the harsh conditions.

ERIC SATTERLY

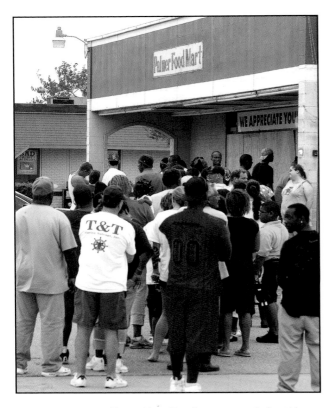

Above: A long line of customers waited outside Palmer Food Mart in Texas City on Saturday afternoon, Sept. 13, 2008. Palmer was one of two stores reported open in an area with widespread power outages.

KEVIN M. COX

Above, right: A crowd gathered to see what was left of the Texas City Dike on Saturday afternoon, Sept. 13, 2008. The storm surge destroyed the dike road and downed power lines.

KEVIN M. COX

Far right: Homes and businesses on the Clear Creek Channel in Seabrook were surrounded by water from Galveston Bay on Saturday morning, Sept. 13, 2008.

KEVIN M. COX

Right: A large tree and high water blocked Ninth Street in Kemah on Saturday morning, Sept. 13, 2008. Hurricane Ike made landfall on Galveston Bay early Saturday morning as a Category 2 storm.

KEVIN M. COX

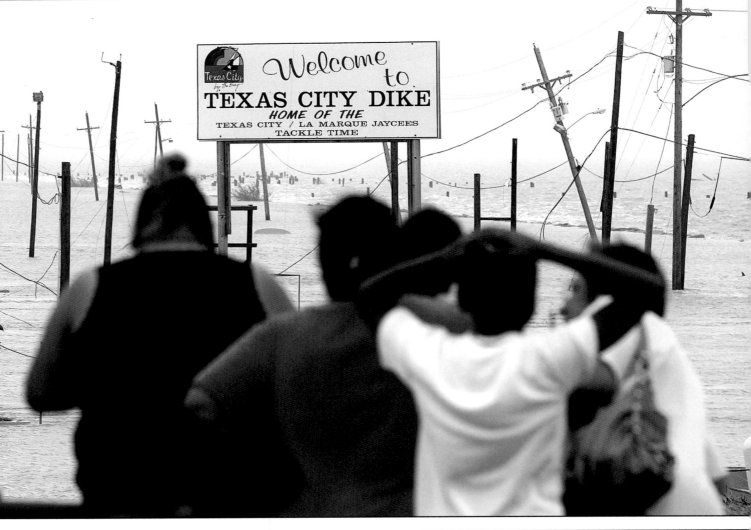

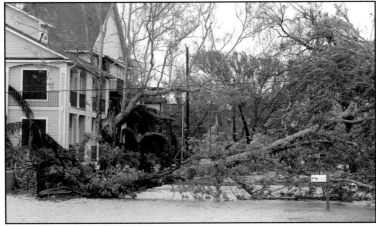

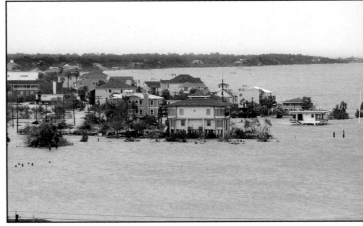

Family rides out storm at O'Connell

It was Sept. 12, the day of the hurricane. My family decided to have a meeting at my Uncle Tino's house. When everybody was there, we sat down and started to talk. We talked about where to stay during the storm. Wherever we stayed, it would be as a family.

We chose O'Connell High School. We all headed back home to pack up. Then we headed out to O'Connell. When we got there, I saw the rest of my family, my cousin's dog, my brother's friend P.J. and O'Connell's principal, Patrick Danesi.

We got out and brought our things into the school. I looked around and wondered what the night would be like. Honestly, I didn't know if the water would get into the first floor, but if it did, we would be safe on the second floor. I wasn't worried about the water or my house. The only thing I was worried about was our dog, Duchess.

When I went back outside, my Uncle Tino and Aunt Denise had arrived. While we waited for night to come, we rode around Galveston. It was amazing seeing the Gulf level with the seawall. We also barbecued, played volleyball in the gym and played around.

After a while, it started to get dark, and the winds started to pick up. We went inside. We hung lights powered by a generator and set up where we were going to sleep. I did homework. Every few minutes we would check the water level. When the water reached the bottom of the handrail, we went to the second floor.

There, I played Nintendo, slept for a couple of minutes and did anything to take my mind off everything. When I took a nap and woke up, I went downstairs. I was surprised with what I saw.

Water was in the Barbara Kleinecke building's lobby. That meant water was in the gym, cafeteria and the Patricia Teltschik building. That included a few classrooms, and the library had taken in water.

My mom and I went to the front door where Mr. Danesi had placed a statue of the Blessed Virgin Mary. We prayed the Memorare — a prayer to the Virgin Mary asking for her intercession to protect us from the storm.

I went back up and thought about the whole situation. After a while, I fell asleep for a few hours. When I woke up, it was morning. The damage had been done. I went downstairs; that's when I found out we had lost our Suburban. In a couple of minutes, we were packing up our things. We were going to see how our houses and businesses fared.

Our house only had some broken windows, and our garage got about 10 inches. Our dog was perfectly fine. Not everybody was as lucky as we were. My Uncle Tony had about 6 feet of water in his restaurant, and my aunt had about 6 feet in her garage.

My heart and prayers go out to those who were affected by Ike. Galveston is my hometown, and I know Galveston will come back.

— Francesca Gonzalez, fifth grade student, Galveston Catholic School

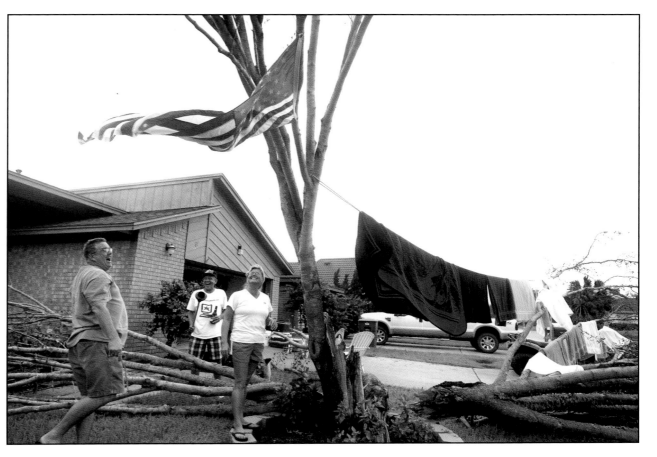

Above: R.J. Vanda, from left, Alfio Tropea and Jessica Bacon flew a flag from the tree that survived Hurricane Ike. They made makeshift clothes lines to dry towels and rugs as they began cleaning their damaged home in Campeche Cove in Galveston.

JENNIFER REYNOLDS

Right: Winds from Hurricane Ike uprooted a live oak tree on Broadway in Galveston.

JENNIFER REYNOLDS

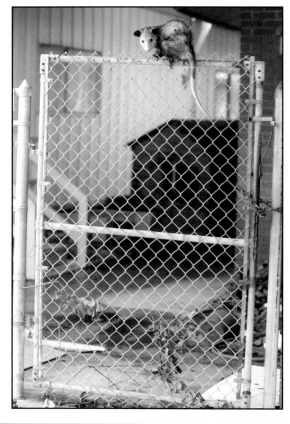

Right: A dazed possum perched on a gate at Burnet Elementary School in Galveston Saturday, Sept. 13, 2008, hours after Hurricane Ike slammed into the Texas coast.

JENNIFER REYNOLDS

Below: Ike victims were moved from a National Guard helicopter to buses waiting at Stingaree Stadium in Texas City to be taken out of the area on Saturday afternoon, Sept. 13, 2008.

KEVIN M. COX

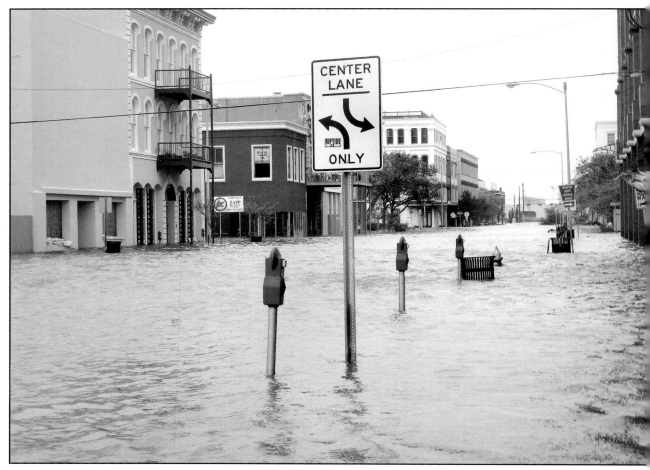

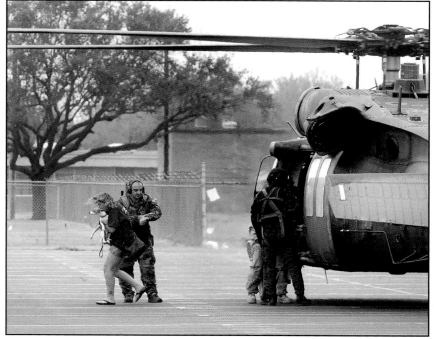

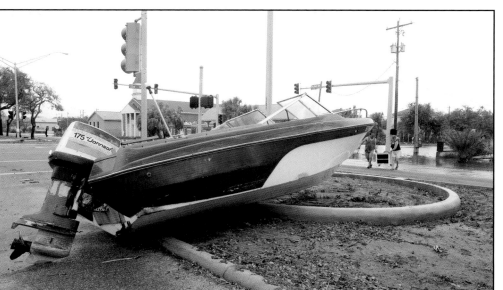

Above: Downtown Galveston remained flooded Saturday, Sept. 13, 2008, after Hurricane Ike slammed into the coast and moved inland.

MICHAEL A. SMITH

Left: A motor boat sat in the esplanade at 33rd Street and Broadway in Galveston after Hurricane Ike made landfall in the early morning hours Saturday, Sept. 13, 2008.

JENNIFER REYNOLDS

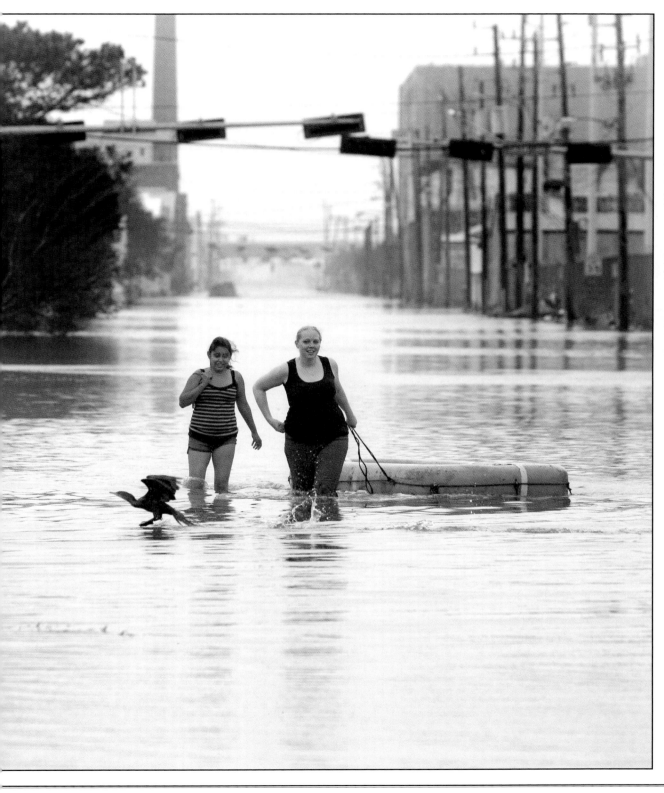

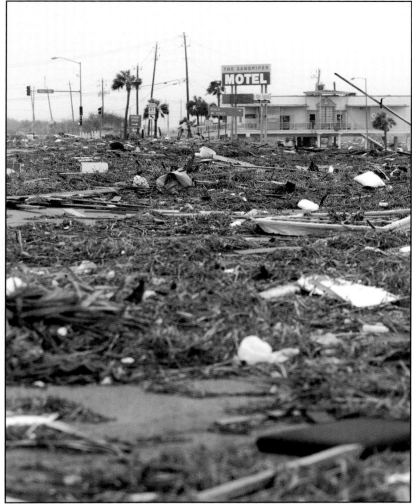

Above: Debris from Hurricane Ike's storm surge covered Seawall Boulevard between Holiday Drive and Ferry Road. The remains of houses and businesses were strewn about the entire roadway.

JENNIFER REYNOLDS

Left: A cormorant took flight as Monica Delossantos, left, and Katie Taylor pulled a life raft down Harborside Drive near the University of Texas Medical Branch in Galveston. The two were going to visit Taylor's mother, who worked in the emergency room at the hospital.

JENNIFER REYNOLDS

Three people and a dog walked across the Interstate 45 Causeway off Galveston Island in the aftermath of Hurricane Ike on Sunday afternoon, Sept. 14, 2008.
KEVIN M. COX

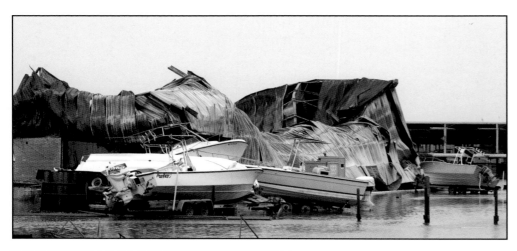

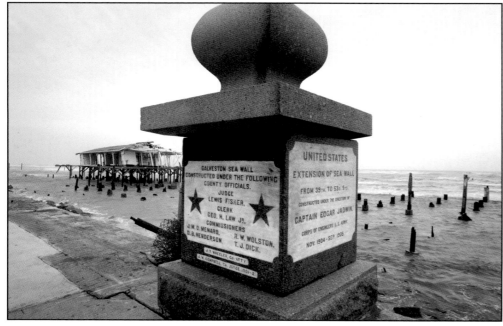

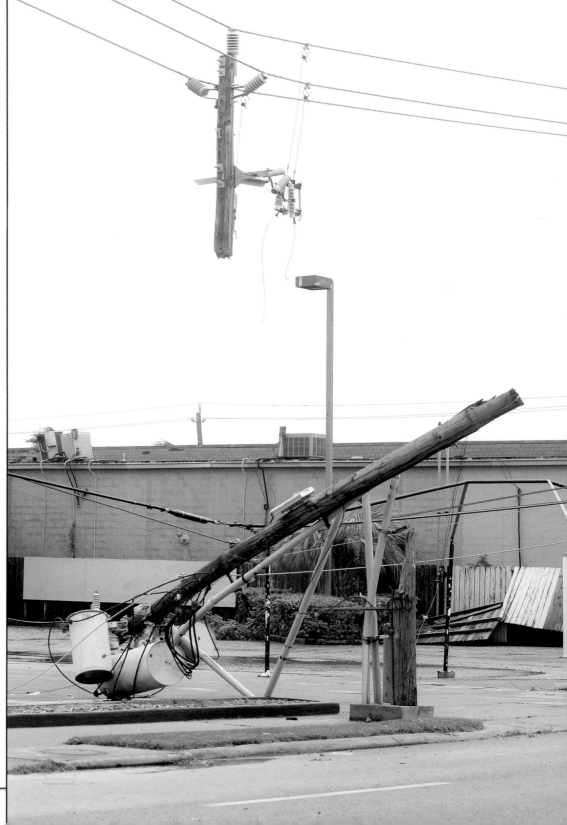

Above: Ike destroyed the piers along the seawall near 23rd Street and moved a large granite monument several inches.
JENNIFER REYNOLDS

Top: A storage facility at the Galveston Yacht Basin was destroyed after catching fire Friday, Sept. 12, 2008.
JENNIFER REYNOLDS

Right: Part of a power pole dangled on 61st Street after being splintered during Hurricane Ike.
JENNIFER REYNOLDS

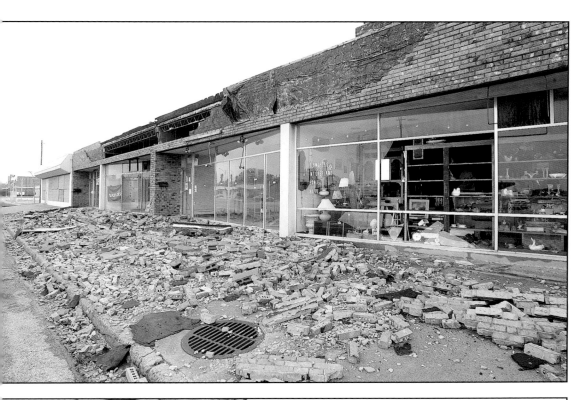

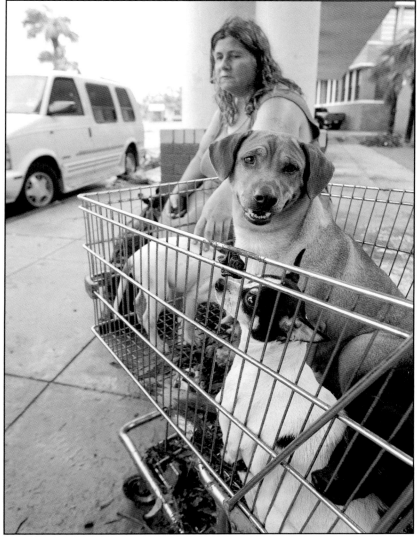

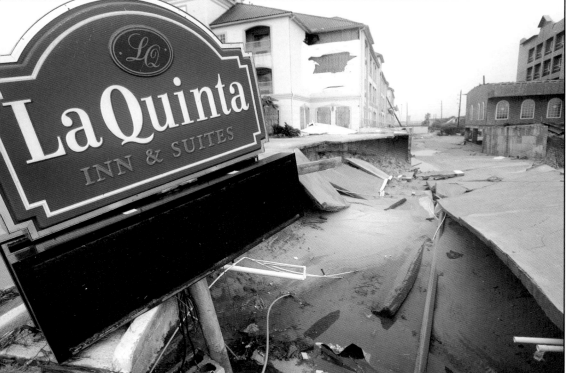

Left: The entryways to the La Quinta Inn & Suites and a neighboring hotel under construction on the West End of the seawall in Galveston were washed away by Hurricane Ike.

JENNIFER REYNOLDS

Above left: Stores on Ninth Avenue North in Texas City sustained damage on Saturday afternoon, Sept. 13, 2008. Hurricane Ike made landfall on Galveston early Saturday morning as a Category 2 storm.

KEVIN M. COX

Above: Lee Ann Reed sat outside the Ball High School shelter with her family's dogs. Reed, who lost everything in her first-floor apartment on 30th Street in Galveston, said she had to take refuge in a neighbor's second floor apartment during the storm.

JENNIFER REYNOLDS

Next page: Daniel Mulder, from left, Sabrina Saltz, Arturo Garcia, Victor Ramirez and Terry Ramirez Jr. headed toward the Galveston Causeway on Interstate 45 Sunday, Sept. 14, 2008. The group rode out Hurricane Ike on the island then headed to Texas City on foot.

JENNIFER REYNOLDS

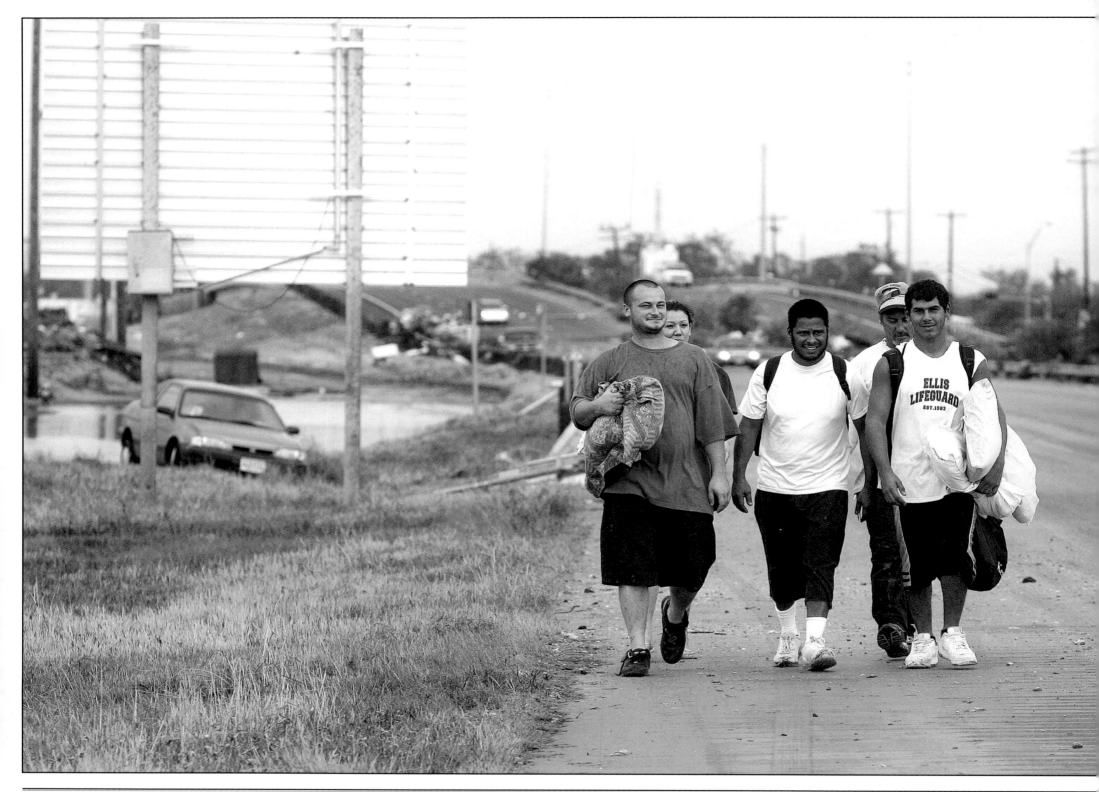

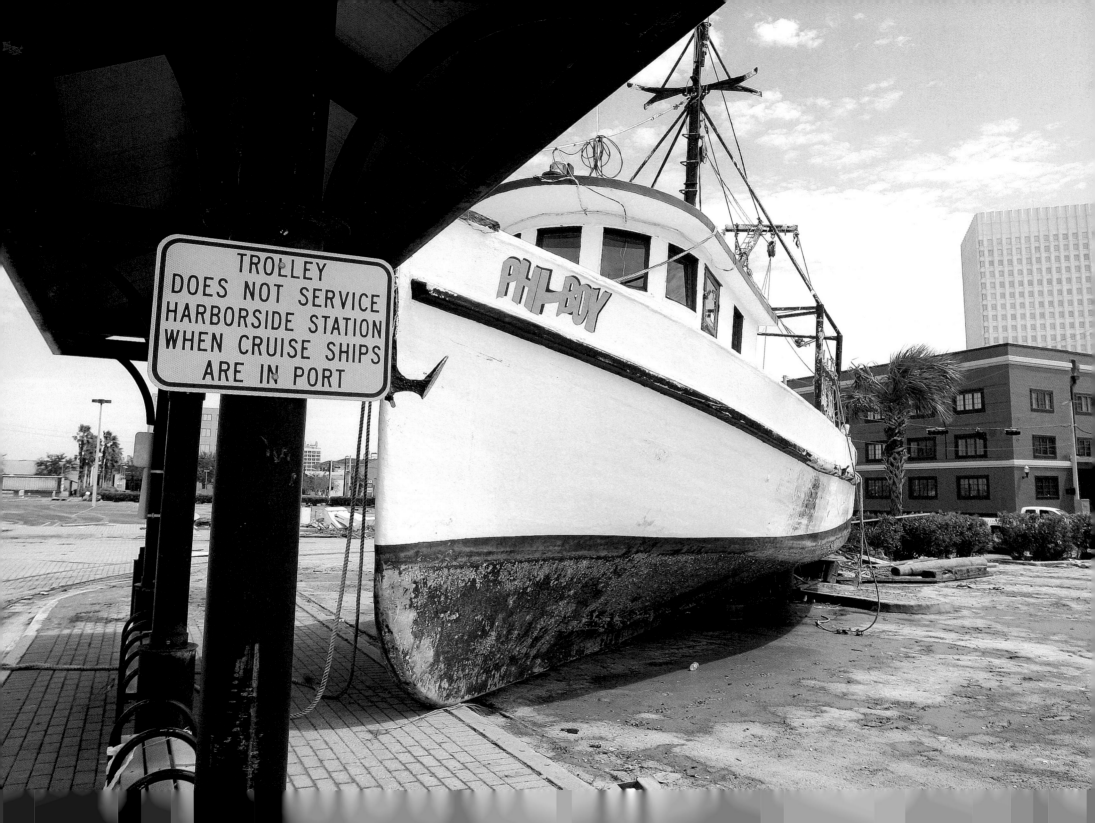

On the roof, awaiting death

I moved to Galveston after marrying my husband, Bobby, on April 10th of this year.

On the morning of Sept. 11, eight inches of water was in the street. We checked the Internet for storm updates, then began putting furnishings up higher.

As soon as we finished raising things, we checked the water level and started over, raising things even higher. Checked again, moved things again. We moved our vehicles to a shopping strip on Stewart Road, and waded back home in hip-high water. Around 4 p.m., the water was to my ribs. We gathered our computer, files, some clothes, shoes and keepsakes, and carried them to the second floor. We put photo albums in the tops of closets, and then took our dog, Lilly, and ferret, Buddy, upstairs.

We ventured the neighborhood in a boat. Vehicles were submerged. Folks were seemingly in good spirits, showing no worry of Ike. By nightfall, we had 3½ feet of water inside our home. We watched our neighbors' belongings moving swiftly out of and away from their homes. We stood helplessly watching years of lives disappear in a matter of minutes. We moved to the roof to get a better view. A helicopter hovered above us, urging us to allow crew members to airlift us. We waved them away.

We couldn't hear the fierce wind because of the high water level. We did hear a noise, but it was our garage contents hitting the ceiling. We could see the fires that were reported around town. Surprisingly, the storm passed quickly, and the eye calmed the water surrounding us.

The roar of the second half of the storm was actually inside the house. The door had been jerked from the hinges, and contents were being sucked out of the house with the water. Then, seconds later, it rushed back inside, filling the first floor completely and then was sucked out again.

We began thinking we might die, so we put on life jackets. Bobby wrapped duct tape around mine to keep it from sliding off, then attached us together with a rope. We sat waiting. Bobby laid his head back on the couch; I scribbled my Social Security number on my arm. I wanted to be identified. When Bobby woke, he was crushed to see my arm. I had come to terms with death, but "Mannnnn! This is going to hurt." All I could think about was being ripped from the house, slammed against walls, door frames, concrete steps, trees.

"Let it be quick, Lord!" I prayed.

— *Pamela Goza-Quiroga, Port Bolivar*

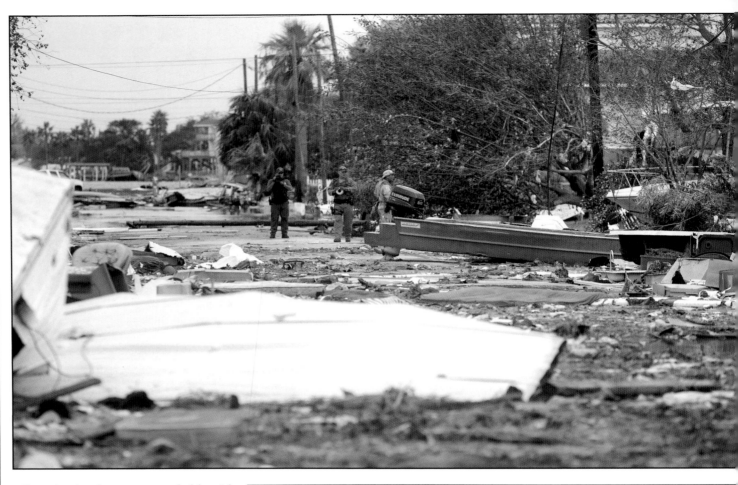

Above: Search and rescue crews searched the neighborhood at 64th Street and Avenue L in Galveston on Sunday, Sept. 14, 2008, for residents who tried to ride out Hurricane Ike in their homes or trailers. The storm surge from the hurricane demolished the neighborhood.

JENNIFER REYNOLDS

Right: A Bayou Vista home was dumped in a canal between Lakeside and Bayou Vista Drive when Hurricane Ike hit on Saturday morning, Sept. 13, 2008.

KEVIN M. COX

Previous page: A large boat rests at a trolley stop in the parking lot near Pier 21 in Galveston on Monday afternoon, Sept. 15, 2008.

KEVIN M. COX

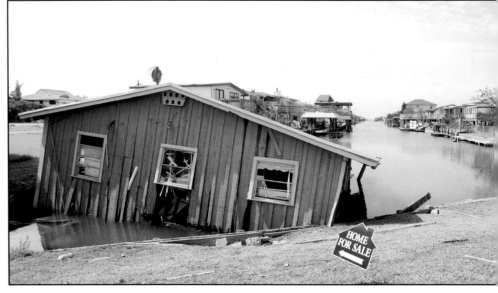

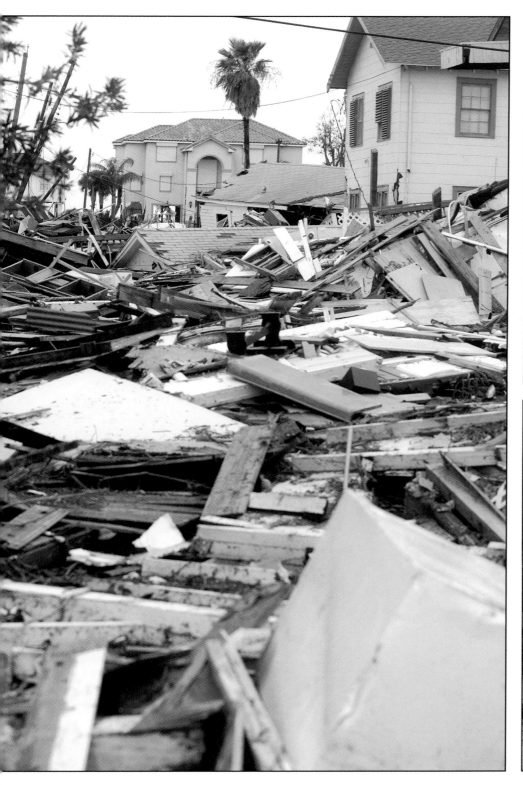

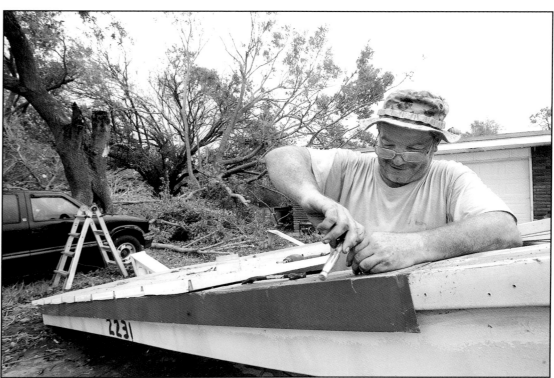

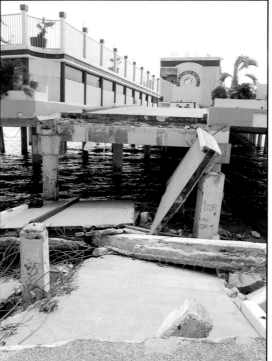

Above: Doug Young dismantled the carport that collapsed in front of his La Marque home on Sunday afternoon, Sept. 14, 2008.
KEVIN M. COX

Far left: The neighborhood at 62nd Street and Avenue L in Galveston was devastated by storm surge from Hurricane Ike.
JENNIFER REYNOLDS

Left: The bridge to the Flagship Hotel in Galveston lay in ruins, and a part of the wall was missing on Monday afternoon, Sept. 15, 2008.
KEVIN M. COX

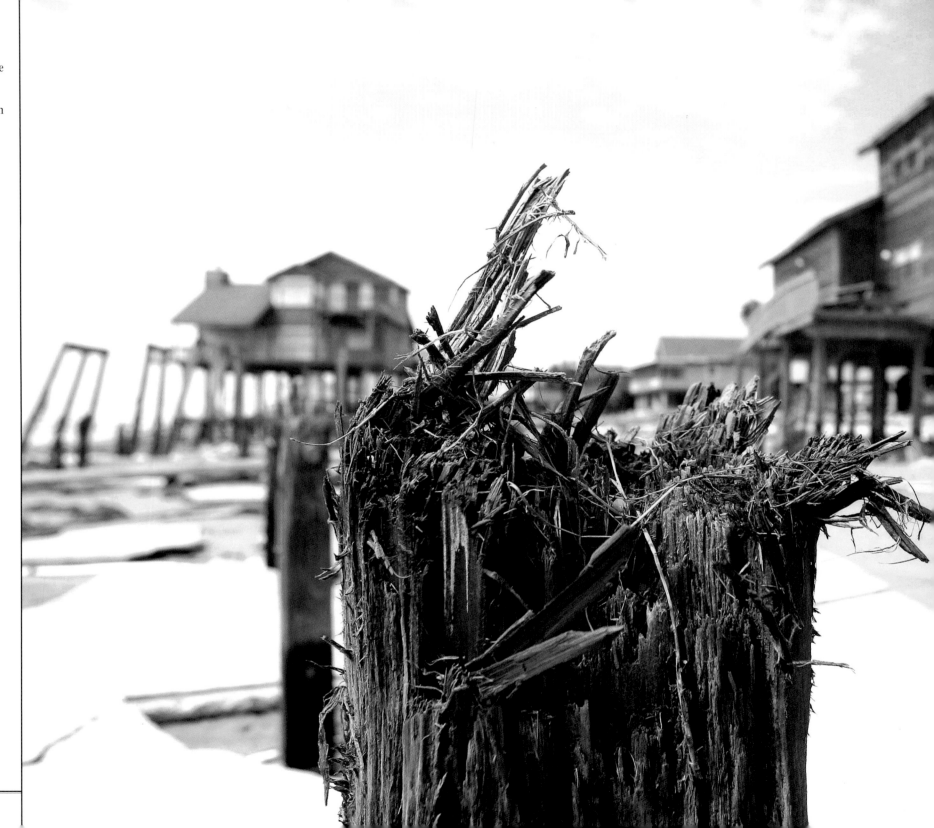

Right: A foundation piling for a house in the Spanish Grant Beachside subdivision was splintered and broken in half from Hurricane Ike's storm surge.

JENNIFER REYNOLDS

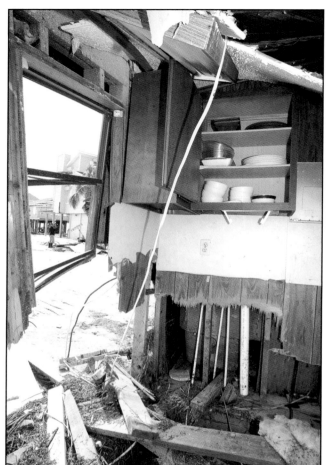

Far left: Members of Task Force 1 from Indiana checked houses on the East End of Galveston for residents who might be trapped.

JENNIFER REYNOLDS

Left: Dishes were still stacked neatly in a kitchen cupboard of a house torn from its foundation and moved roughly 200 feet by storm surge from Hurricane Ike in the Spanish Grant subdivision on the West End of Galveston.

JENNIFER REYNOLDS

Below, left: "It's Only Stuff" was spray painted on the back of a refrigerator amid a pile of debris in Bayou Vista on Wednesday afternoon, Sept. 17, 2008.

KEVIN M. COX

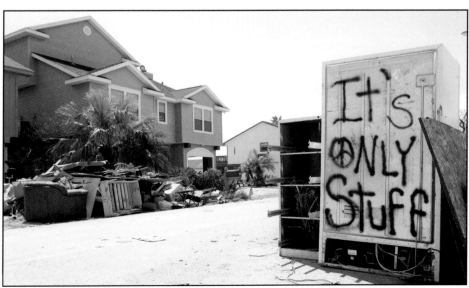

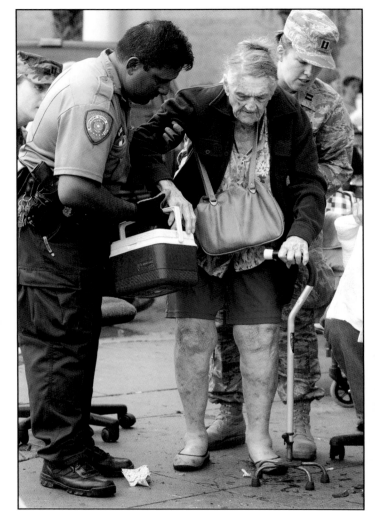

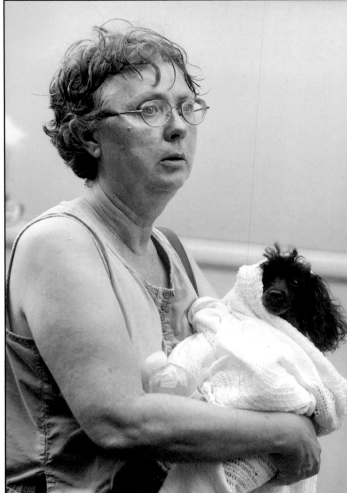

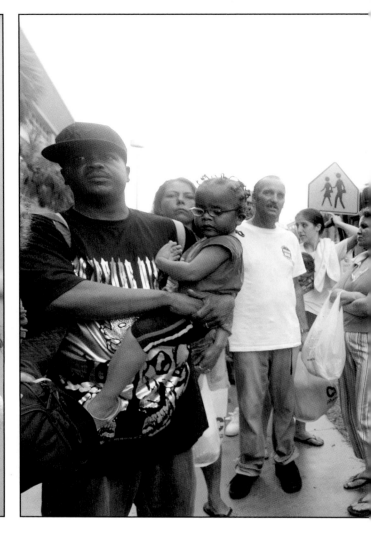

Sunday, Sept. 14 — Electricity service began to slowly be restored in the North County, leading to long lines as residents searched for gasoline and ice.

Sunday, Sept. 14 — County officials announced the ferry landing on the Bolivar side appeared to be damaged.

Sunday, Sept. 14 — Seven people were charged with looting on the island. Officials said they were beginning to get reports of price gouging.

Sunday, Sept. 14 — Large cargo planes were not allowed to land at Scholes International Airport because of questions about the runways' structural integrity, hampering efforts to deliver large amounts of relief supplies to the island.

Sunday, Sept. 14 — Port of Galveston officials announced that the port would be closed as federal teams assessed hazards in the ship channel.

Sunday, Sept. 14, 10 p.m. — Water service was restored to hotels on the seawall where city employees were living. Water service from the mainland to the island was also working.

Monday, Sept. 15 — Galveston Mayor Lyda Ann Thomas ordered all city employees not to speak with the news media. Only Thomas and City Manager Steve LeBlanc were authorized to speak to reporters.

Monday, Sept. 15 — Health conditions on the island continued to deteriorate.

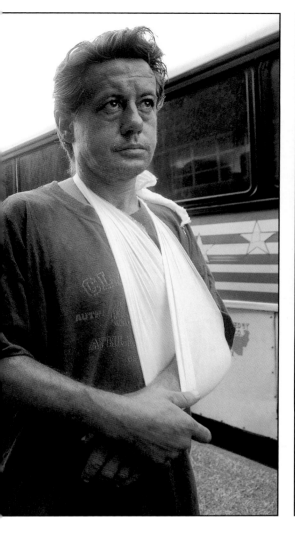

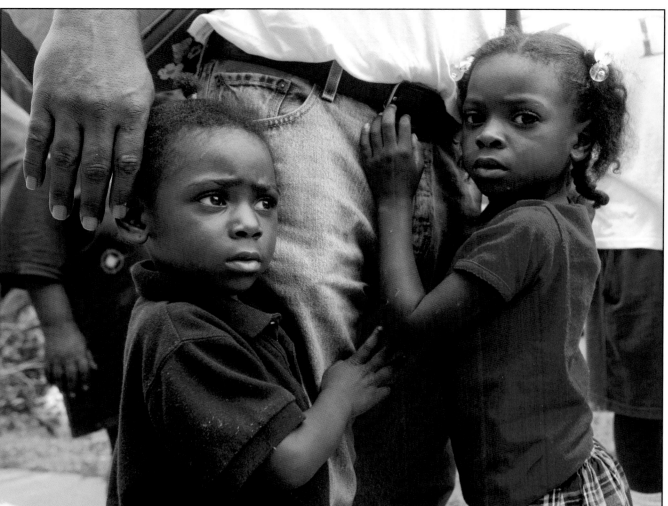

From far left:
Galveston Independent School District officer Willie Alcocer, left, helped Belle Kenney to one of the buses evacuating residents Sunday, Sept. 14, 2008, from Ball High School to a shelter in San Antonio.
JENNIFER REYNOLDS

Lynne Riggs held her dog, Gabby, as she waited to be evacuated. Riggs and two friends waded from their homes to the shelter at Ball High.
JENNIFER REYNOLDS

Joseph Hardy waited to get on the bus. He fell and injured his arm wading through chest-deep floodwaters.
JENNIFER REYNOLDS

Isis Flowers, 3, left, and her sister, Colbrina Flowers, 5, held on to their grandfather Tony Franklin's legs as they waited in line to board an evacuation bus.
JENNIFER REYNOLDS

...day, Sept. 15 — ...veston officials asked ...county for help with ...quito control.

Monday, Sept. 15 — Eleven people — including a group of television reporters — were rescued from the Flagship Hotel after Galveston Mayor Lyda Ann Thomas ordered the building shut down because of damage.

Monday, Sept. 15 — FEMA began making arrangements for hotels and apartments for island residents who could not or did not want to come back.

Monday, Sept. 15 — The Salvation Army began serving hot food at five mobile kitchens on the island.

Monday, Sept. 15 — County Judge Jim Yarbrough announced that an initial assessment of the causeway showed no damage. He also extended the county's 7 p.m. to 6 a.m. curfew until Friday.

Monday, Sept. 15 — Officials got a first look at damage on the West End.

Monday, Sept. 15 — Thomas and City Manager Steve LeBlanc urged the 15,000 to 20,000 people still left on the island to evacuate. LeBlanc said the city could not accommodate its population.

Monday, Sept. 15 — Yarbrough announced a mandatory evacuation for the Bolivar Peninsula.

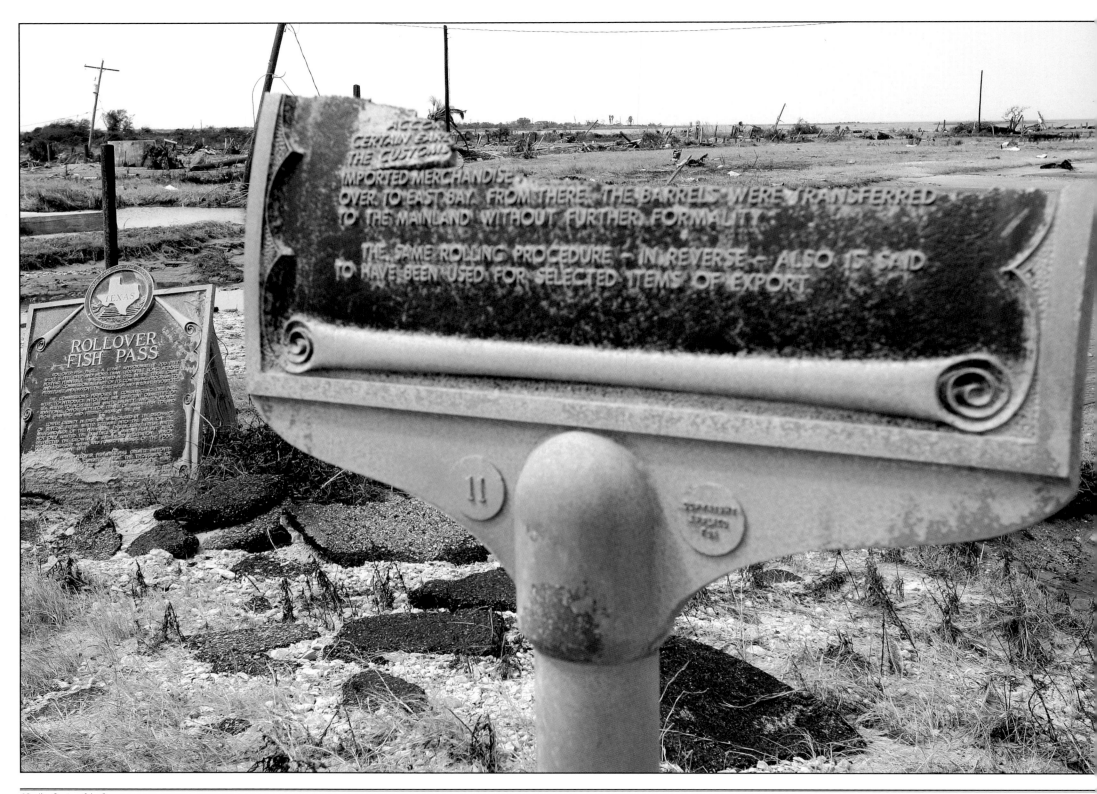

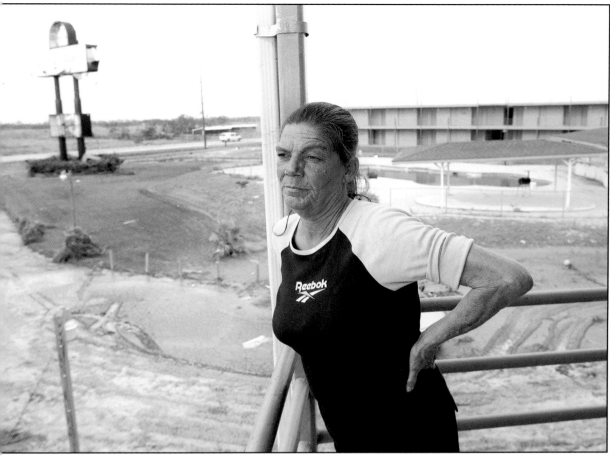

Left: Cheryl Harwell, assistant manager at the Crystal Palace Resort in Crystal Beach, took in the view from the balcony on Thursday afternoon, Sept. 18, 2008. Harwell, who had lived at the resort for nine years, never considered evacuating and refused all offers of rides out of the area.
KEVIN M. COX

Below: Artist Mary Shirey tried her first Meal Ready to Eat that the National Guard left her on the front steps of the Crenshaw Elementary and Middle School in Crystal Beach on Thursday, Sept. 18, 2008. Shirey and her husband, Al Newman, rode out the storm in the school's lobby.
KEVIN M. COX

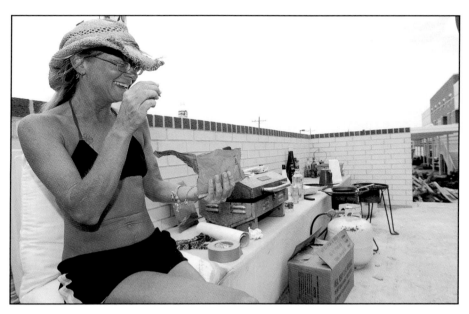

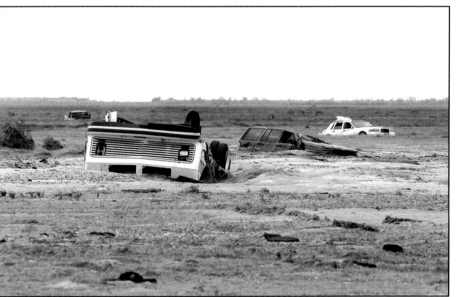

Previous page: The state marker at the Rollover Pass bridge in Gilchrist was split in two by Hurricane Ike on Thursday afternoon, Sept. 18, 2008.
KEVIN M. COX

Far left: The Rollover Pass bridge was wrecked in Gilchrist on Thursday afternoon, Sept. 18, 2008.
KEVIN M. COX

Left: Several vehicles lie in a field submerged in mud and sand 100 yards off state Highway 87 between High Island and Gilchrist.
KEVIN M. COX

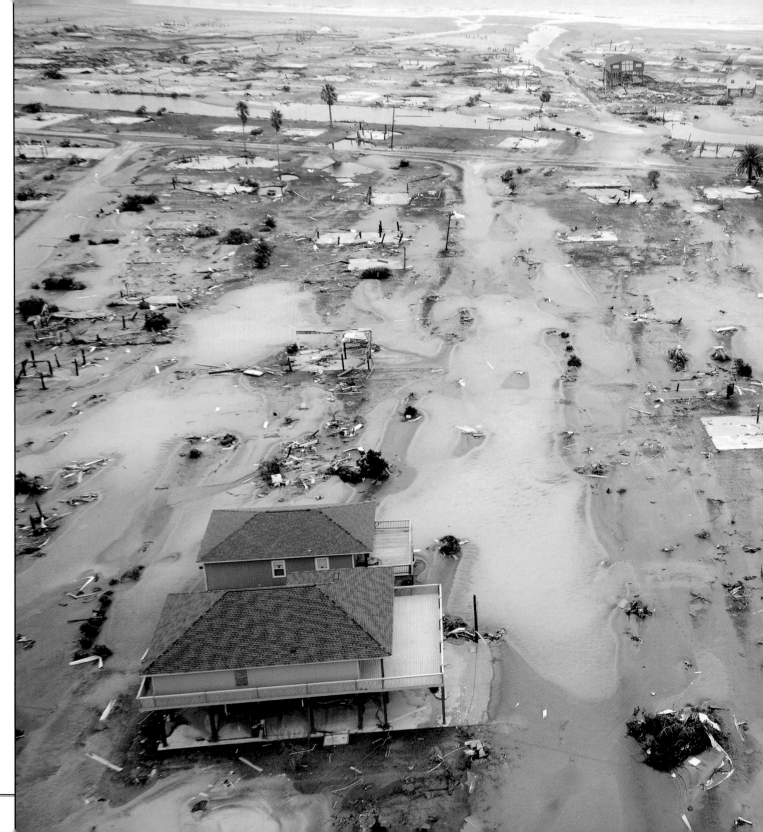

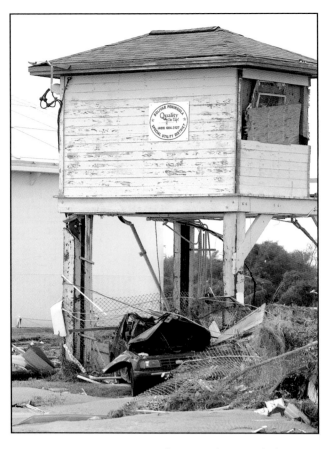

Above: A truck was smashed against a tower of the Bolivar Peninsula Special Utility District in Crystal Beach in the aftermath of Hurricane Ike on Thursday afternoon, Sept. 18, 2008.

KEVIN M. COX

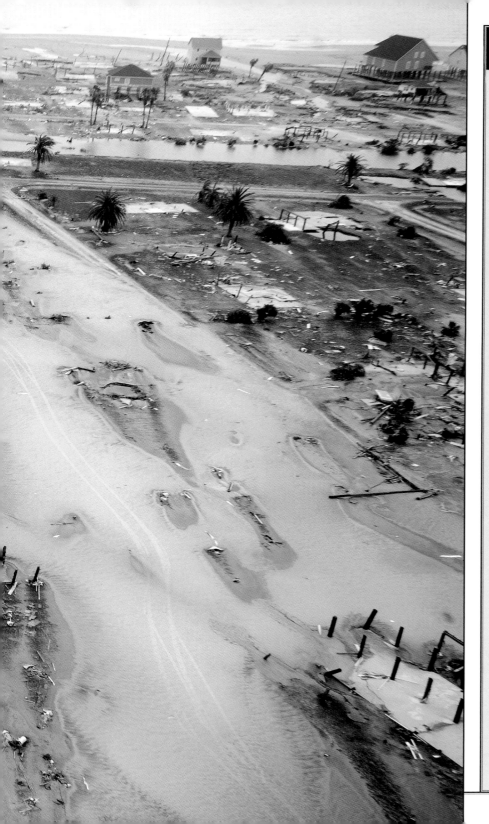

Bolivar light will still shine

Destruction and death have been evident in the days and weeks following Hurricane Ike. None of us could have fathomed the amount of damage this supposed Category 2 hurricane would cause.

I think even those of us who considered ourselves hurricane veterans would never have expected the amount of devastation caused by Hurricane Ike.

One of the early reports after the storm was that Hurricane Ike had destroyed the Point Bolivar Lighthouse.

The current lighthouse tower, built in 1872, has survived numerous hurricanes, including the infamous 1900 "Great Storm," Carla and Alicia.

The initial reports that the lighthouse had been destroyed by Hurricane Ike seemed just to top off all the bad news regarding this monster storm.

Decommissioned in 1933 and sold at an auction in 1947, the tower is no longer in pristine condition.

Its once black and white cast iron sheets have all rusted to give the lighthouse a grayish appearance.

I have traveled all across the United States photographing lighthouses.

The Point Bolivar Lighthouse was the first one I ever photographed.

Point Bolivar isn't the most picturesque lighthouse on the Gulf Coast, but it will always be one of my favorites.

News reports later revealed that the lighthouse had survived. Just as the Point Bolivar Lighthouse has survived Hurricane Ike, and has been surviving hurricanes for over a century, the Upper-Texas Gulf Coast will survive and will pick up the pieces as we put our lives back together again.

— *James Kingsmill, Baytown*

Below: A watch in debris along state Highway 87 in Gilchrist stopped at 7:07 on Sept. 11.
KEVIN M. COX

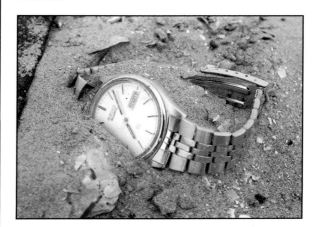

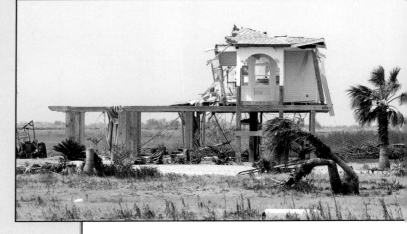

Left: Except for the occasional house, empty slabs and broken pilings were all that was left of homes on the Bolivar Peninsula after Hurricane Ike ripped through the area.
DAN DALSTRA/The (Brazosport) Facts

Above: A house on Ball Street in Gilchrist was among the many destroyed.
KEVIN M. COX

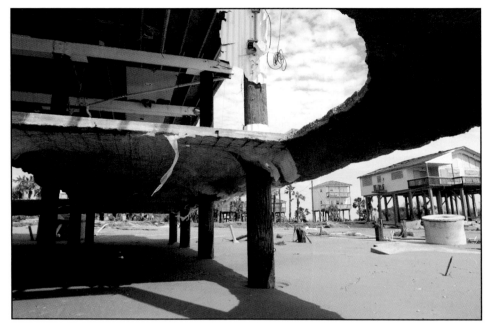

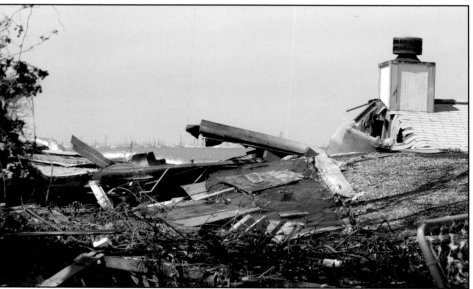

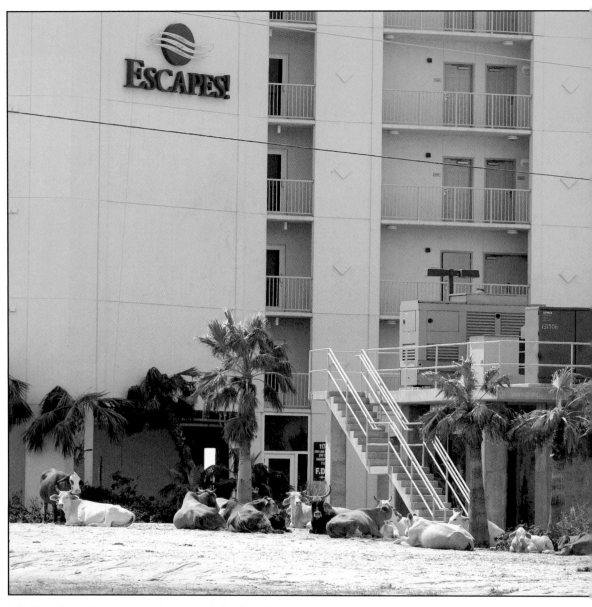

Left: The refineries in Texas City could be seen through the pile of debris from a collapsed house on Channelview in Galveston. Almost all of the houses in the neighborhood near Galveston Bay were destroyed by Hurricane Ike.

JENNIFER REYNOLDS

Above: A herd of cattle took up residence at Escapes Resort on Galveston's West End.

JENNIFER REYNOLDS

Above, left: The foundation of a house in Sunny Beach was washed out by the storm surge from Hurricane Ike.

JENNIFER REYNOLDS

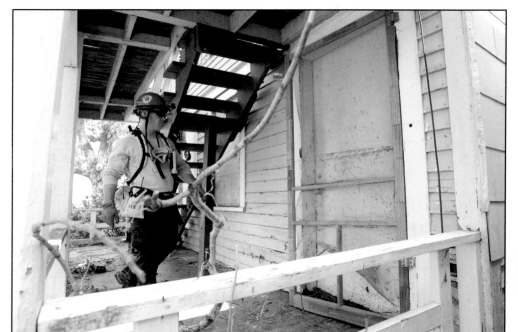

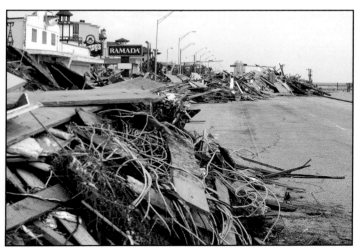
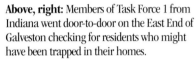

Above, right: Members of Task Force 1 from Indiana went door-to-door on the East End of Galveston checking for residents who might have been trapped in their homes.

JENNIFER REYNOLDS

Right: Plates were scattered — unbroken — between houses on the West End that were destroyed by Hurricane Ike.

JENNIFER REYNOLDS

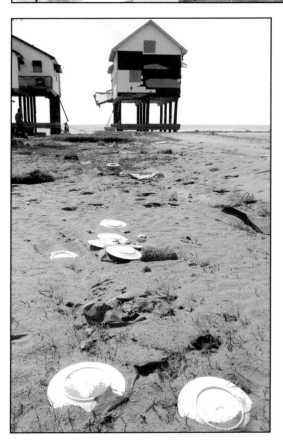

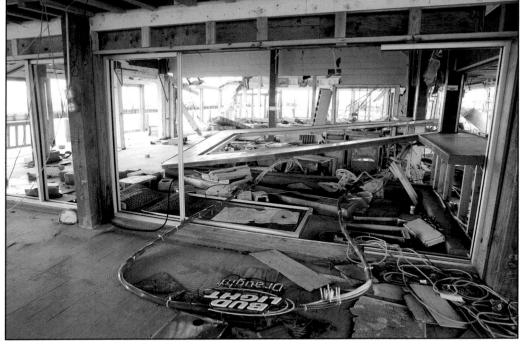

Above: Top Water Grill in San Leon was destroyed by Hurricane Ike. Owners planned to rebuild the popular bayside restaurant.

KEVIN M. COX

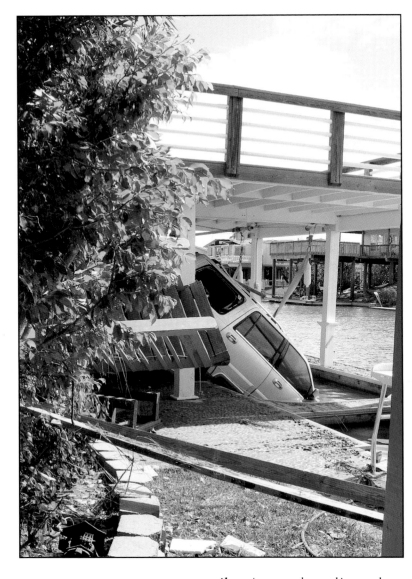

Above: A car was submerged in a canal behind a house in Jamaica Beach in the aftermath of Hurricane Ike on Tuesday afternoon, Sept. 16, 2008.

LEIGH JONES

Right: Jerry Harrington's house, which was 20 feet above sea level in High Island, was in shambles in the aftermath of Hurricane Ike on Thursday afternoon, Sept. 18, 2008. Harrington's neighbors said he was fine despite the damage to his house.

KEVIN M. COX

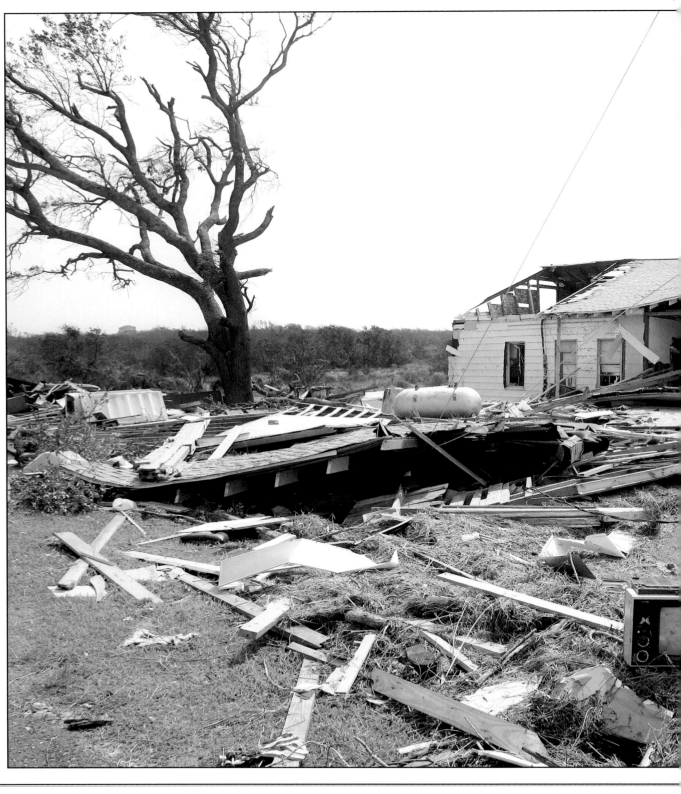

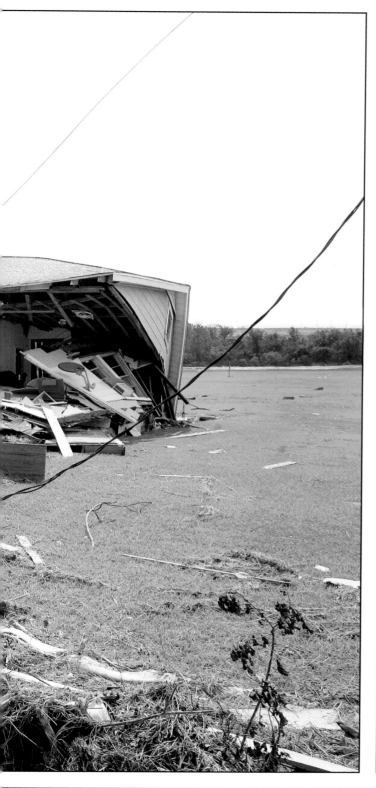

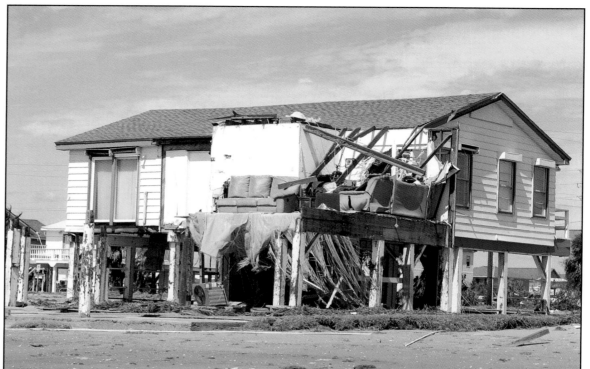

Left: Many houses in Jamaica Beach were damaged by wind and storm surge.

LEIGH JONES

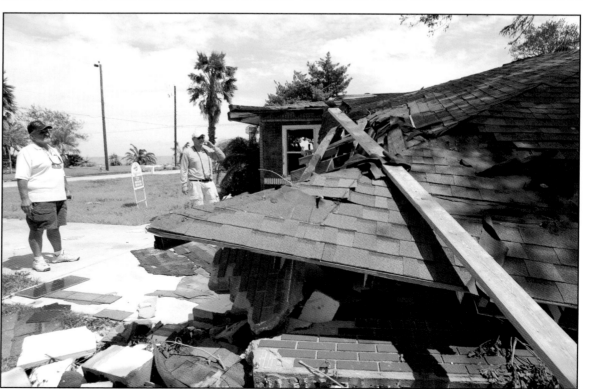

Left: Lyndon Young and his son, Stacy Young, looked at what's left of their house on Channelview in Galveston. The house was one of many in the neighborhood between the Galveston Bay and Harborside Drive that were destroyed by Hurricane Ike.

JENNIFER REYNOLDS

Following page: Jeff Harclerode took a break from cleaning up the mess at his Bayou Vista home and business to hit a few golf balls across the highway in the aftermath of Hurricane Ike on Wednesday morning, Sept. 17, 2008.

KEVIN M. COX

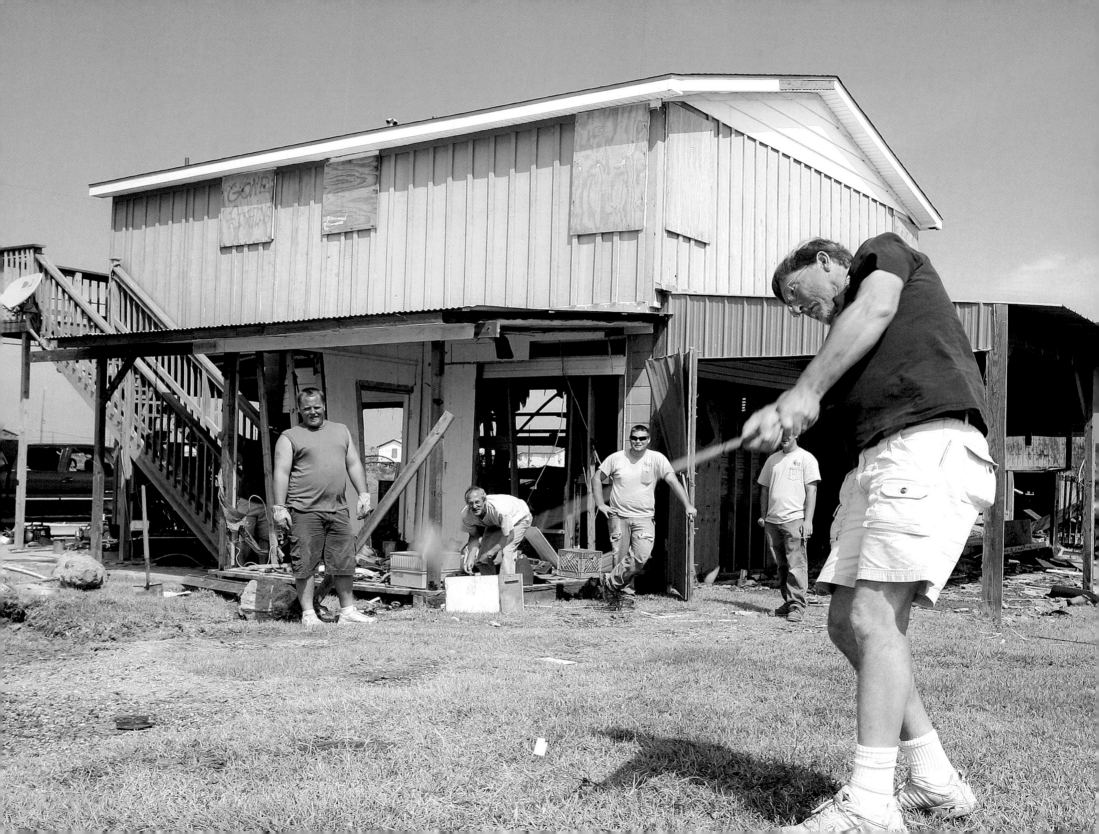

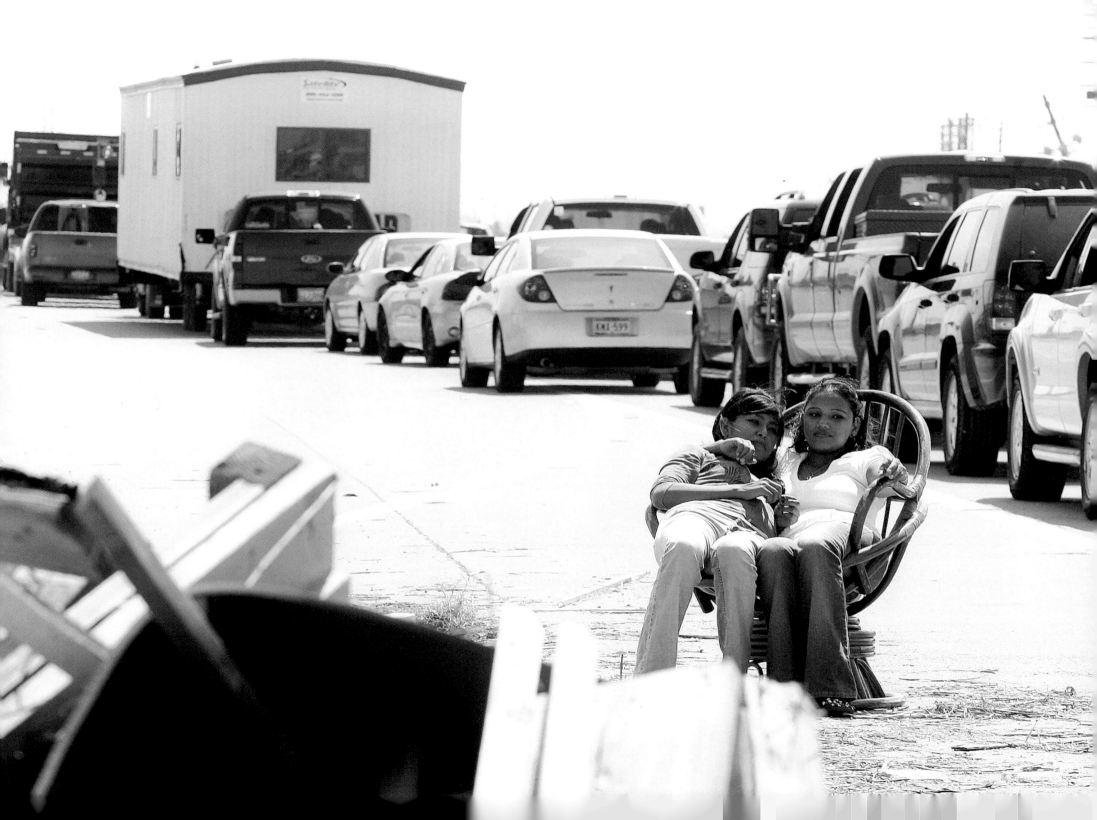

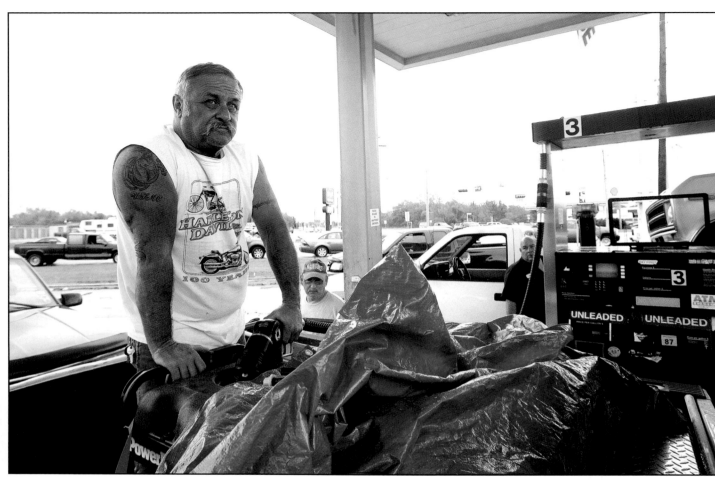

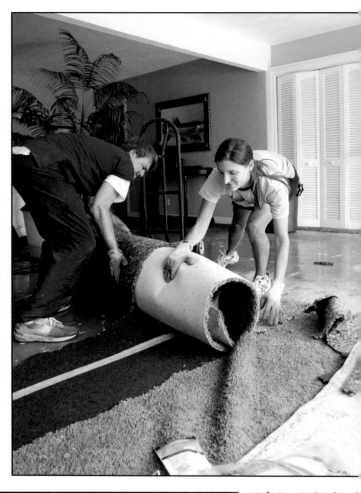

Above: Larry Schupe bought gas at Brownies at FM 646 and state Highway 3 in League City on Sunday morning. Sept. 14, 2008. Residents waited more than an hour for the station to open.

KEVIN M. COX

Above, right: Ryan and Kelly Sheppard rolled wet carpet and padding in their living room Wednesday, Sept. 17, 2008, as they tried to clean their house in Fish Village in Galveston.

JENNIFER REYNOLDS

Right: Galveston Mayor Lyda Ann Thomas addressed the media during a news conference Monday afternoon, Sept. 15, 2008.

KEVIN M. COX

Previous page: Maleni Garcia and Yesenia Vahena of Texas City relaxed in a rattan chair that washed up on the road while waiting for traffic to begin moving again on Interstate 45 as people tried to re-enter Galveston Island on Wednesday morning, Sept. 17, 2008.

KEVIN M. COX

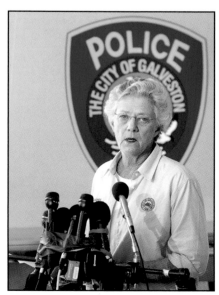

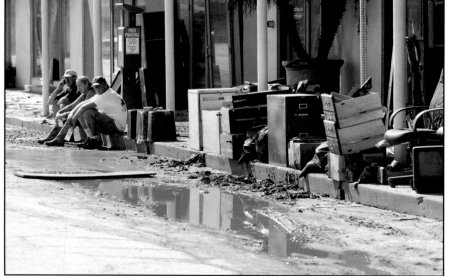

Left: Dave Corbin, from l(his wife, Suzanne Jackson Corbin, and Tom Anderso(took a break on the mud(curb in front of Sandcast(Realty on Market Street i(Galveston. The three sper(the day clearing mud and ruined office furniture out of the business, whic(had several feet of water in it during Hurricane Ik(Suzanne Jackson Corbin, who owns the real estate office, said she was trying stay ahead of the mold.

JENNIFER REYNOLDS

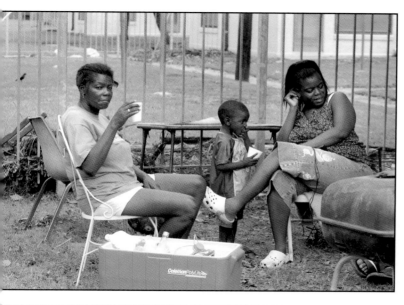

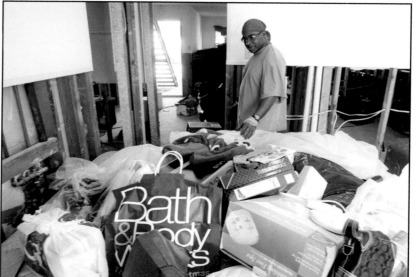

Far left: Linda Marie Rudd, from left, her grandson, Raymond Mays, 3, and her daughter, Shelly Rudd, sat in the shade of a palm tree at Oleander Homes in Galveston. They came back to find their apartment in the housing authority complex flooded.

JENNIFER REYNOLDS

Left: Issac Moore of Hitchcock helped clean out his mother's ground-floor unit at The Park Apartments in Galveston in the aftermath of Hurricane Ike on Saturday afternoon, Sept. 27, 2008. Peaches Williby said the apartment's management told her she had until the following Monday to remove all her belongings.

KEVIN M. COX

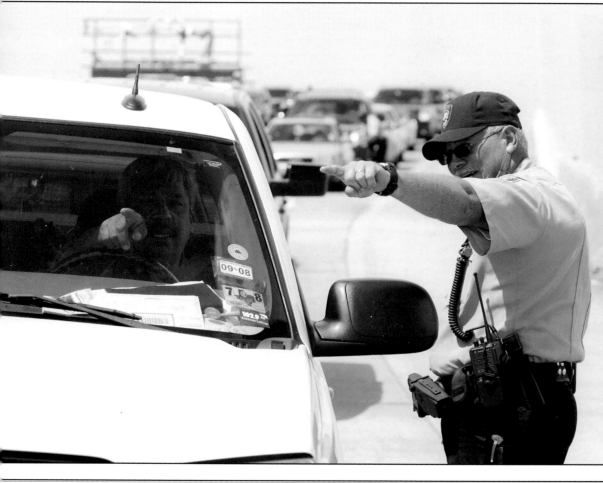

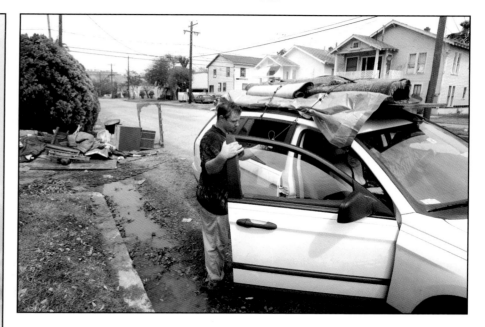

Left: Galveston Police Officer B. Stroud checked identification of people trying to enter Galveston at a checkpoint on Interstate 45 South in the aftermath of Hurricane Ike on Tuesday morning, Sept. 16, 2008.

KEVIN M. COX

Above: Chris Vanworth secured items he and Elizabeth Sarver and Sheila Lee salvaged from their East End house in Galveston on Friday, Sept. 19, 2008.

JENNIFER REYNOLDS

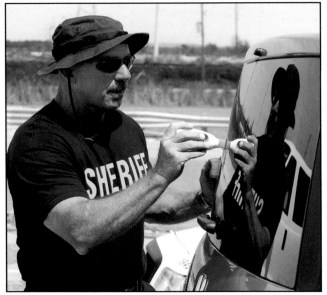

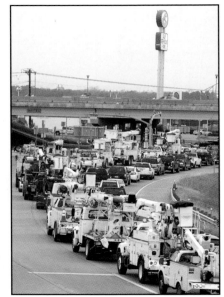

Above: Galveston County Sheriff's Sgt. Mike Barry marked "LL" for "look and leave" on the back of vehicles being allowed to enter Galveston Island at a checkpoint on Interstate 45 South in the aftermath of Hurricane Ike on Tuesday morning, Sept. 16, 2008.

KEVIN M. COX

Above, right: A caravan of utility trucks was stuck in traffic while trying to reach a staging area at Gulf Greyhound Park in La Marque on Wednesday, Sept. 17, 2008.

KEVIN M. COX

Right: Maureen Boyer wore a makeshift mask while trying to clear a path through her gallery on Postoffice Street in Galveston on Wednesday, Sept. 17, 2008. She said she wanted to clear a path to the back door to help air out the space, which was starting to mildew and mold.

JENNIFER REYNOLDS

Next page: Elisa Valdez Castillo waited for Aaron Silva and Alton Jones to fix Silva's car that broke down on the East End of Galveston on Wednesday, Sept. 17, 2008. They came back to the island to see how their homes had fared in the hurricane.

JENNIFER REYNOLDS

Family boats to find safety

Friday morning, my friend woke me up telling me there was 2 feet of water in front of my house on 62nd and Avenue L. I decided to go to my cousin's house on Youpon. We debated whether to leave or stay. The water started to rise, and the last fire truck came by for a final rescue call, which we denied, as water had never come that far into the neighborhood before.

We were on our own, and "officially" decided to ride the storm out in the house, seven of us.

We sat in the driveway and watched the water slowly creep up. We decided to move into the garage where there was a TV running off a generator.

After about an hour, the water had risen near the house so we moved everybody inside. Within hours, when water swirled around our waists, we decided we had made a bad choice.

In the eye, we launched the boat and made a break for the San Luis.

Driving down Stewart Road in a boat, with 8 feet of water underneath, seemed very awkward. We feared for our lives that the back of the storm would catch us. We took a right on Avenue T, a left on Avenue U, and the water became shallow around Moody Methodist Church. We tied the boat to a tree, and waded the rest of the way to the hotel where 911 was waiting with flashlights to guide us in.

Reaching the hotel, we knew we were finally safe. By God's grace, I'm still here to tell the story.

— *Jason Reuter, Galveston*

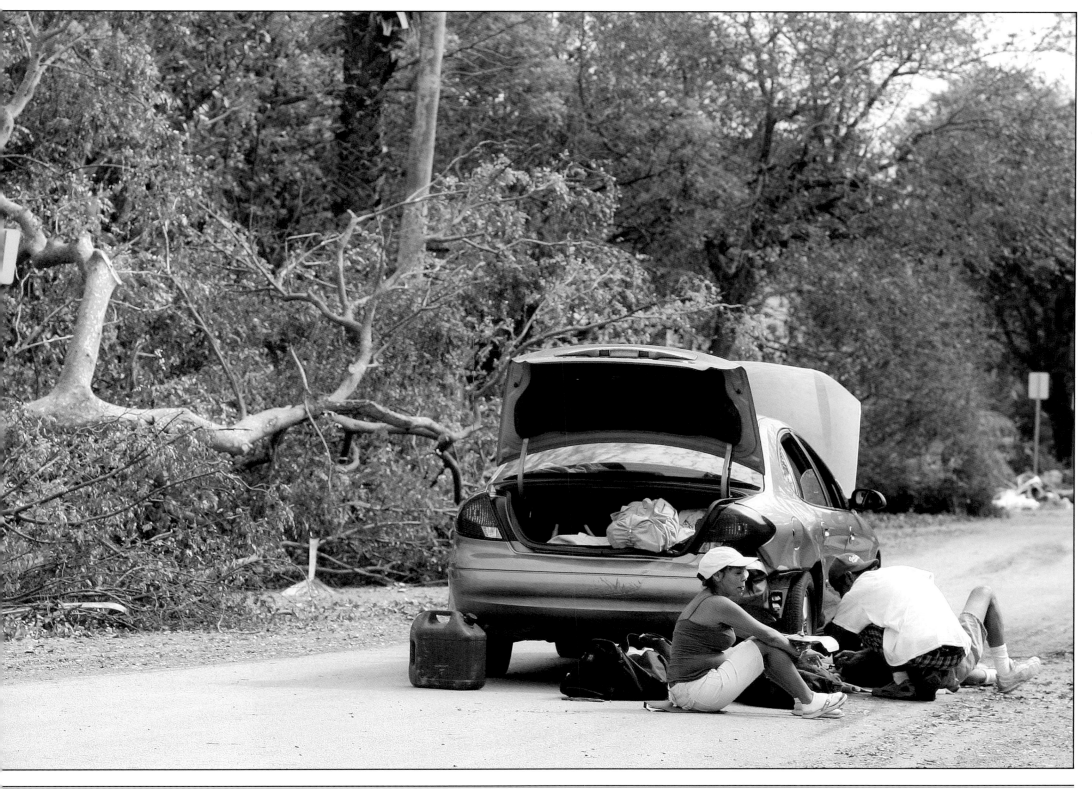

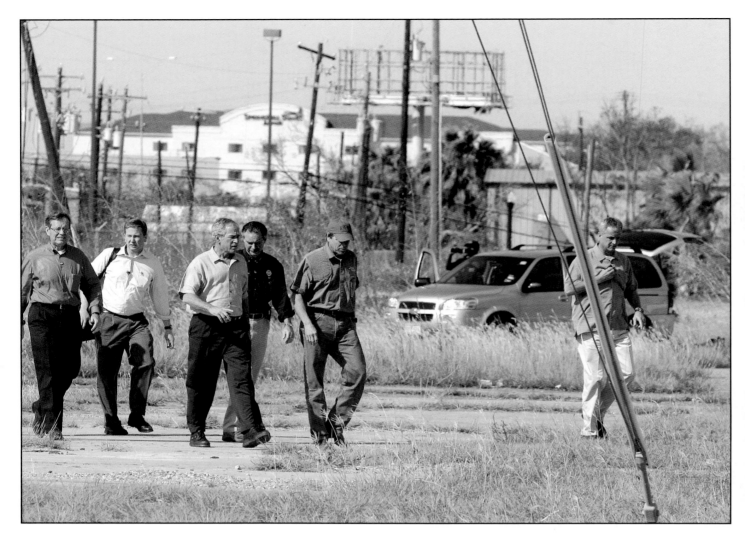

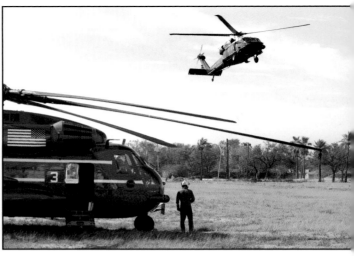

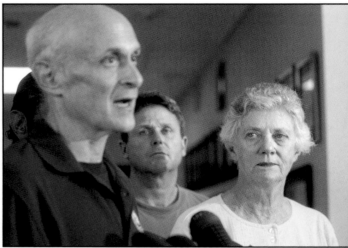

Monday, Sept. 15 — The Galveston Historical Foundation said the island's historical properties — including the tall ship Elissa — were not badly damaged during the hurricane.

Monday, Sept. 15 — Technicians began a search for sunken vessels in the Galveston and Houston ship channels.

Monday, Sept. 15, afternoon — Both major Houston airports reopened with limited service.

Tuesday, Sept. 16, morning — President Bush, touring the island and other areas hit by Hurricane Ike, applauded local leaders' efforts in preparing for the storm. Mayor Lyda Ann Thomas asked the federal government to make restoring com-

munications a priority.

Tuesday, Sept. 16 — Galveston officials restricted beach access because of water contaminated by oil, diesel fuel and other chemicals.

Tuesday, Sept. 16 — Officials announced that what had been Bolivar Peninsula was now three separate islands.

Tuesday, Sept. 16 — Texas City refineries shuttered for the hurricane began to reconnect water and power.

Tuesday, Sept. 16 — Texas Department of Transportation officials announced the Galves Causeway escaped dam age. They also confirm damage to the Bolivar ferry landing.

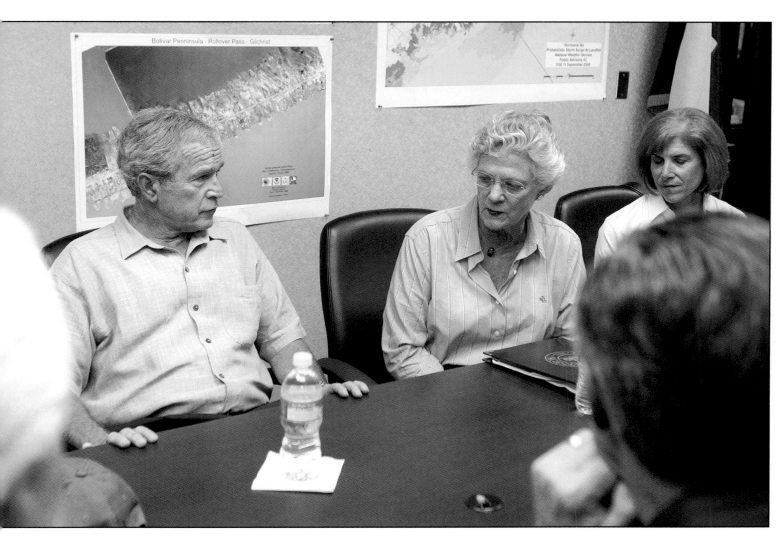

Far left: President Bush and Gov. Rick Perry talked as they walked to the Galveston County Justice Center in Galveston on Tuesday, Sept. 16, 2008, after an aerial tour of the damage from Hurricane Ike. The president and Perry met with Galveston Mayor Lyda Ann Thomas and other elected officials about the storm damage and recovery efforts.
JENNIFER REYNOLDS

Center, top: Marine One, with President Bush and Gov. Rick Perry aboard, landed at the Galveston County Justice Center in Galveston on Tuesday, Sept. 16, 2008, after an aerial tour of the damage from Hurricane Ike.
JENNIFER REYNOLDS

Center, bottom: Galveston Mayor Lyda Ann Thomas and City Manager Steve LeBlanc listened as U.S. Secretary of Homeland Security Michael Chertoff addressed reporters on Sunday, Sept. 14, 2008.
JENNIFER REYNOLDS

Left: President Bush talked with Galveston Mayor Lyda Ann Thomas on Tuesday, Sept. 16, 2008, at the Galveston County Justice Center in Galveston after he and Gov. Rick Perry took an aerial tour of the damage from Hurricane Ike.
JENNIFER REYNOLDS

sday, Sept. 16 — More half of mainland munities had electy, and 90 percent of n had running water.

Tuesday, Sept. 16, noon — Thomas announced a "look and leave" policy, allowing island residents and business owners to go to their properties to assess damage. They were asked to leave by 6 p.m.

Tuesday, Sept. 16, afternoon — Island business showed the first signs of recovery as Home Depot, 702 65th St., reopened and grocery store employees worked to remove spoiled food.

Tuesday, Sept. 16, 5 p.m. — City Manager Steve LeBlanc suspended the "look and leave" policy indefinitely after it spawned an 8-mile traffic jam leading to the island.

Tuesday, Sept. 16, evening — As city crews worked to re-establish water service, some East End residents reported having water.

Wednesday, Sept. 17, morning — Thomas extended her emergency powers — giving her complete control of city government — for seven more days after a fight between two council members broke the four-person quorum necessary for the group to take action.

Wednesday, Sept. 17 — The medical examiner put the county's death toll from Ike at 19. Later, it was amended to 16.

Wednesday, Sept. 17 — Jamaica Beach residents got their first look at the damage from the hurricane.

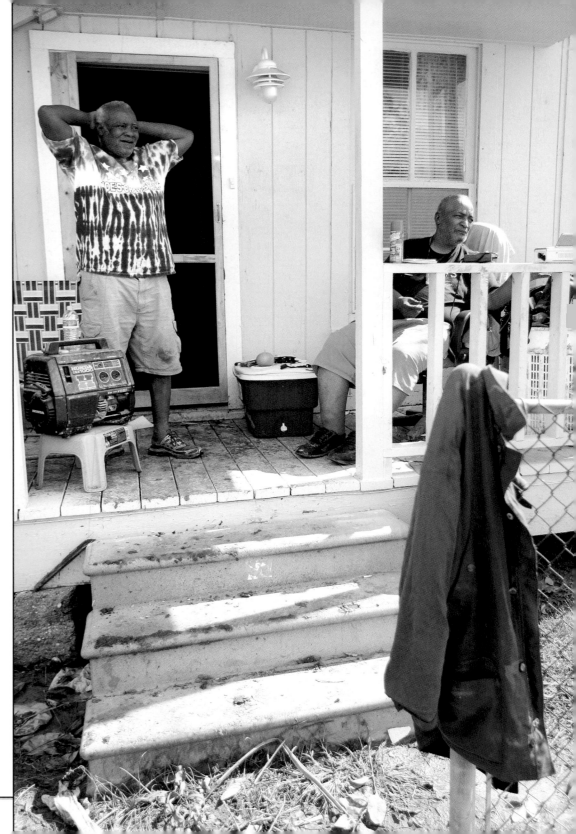

Above: Christopher Silliman dragged trash through his family's campground on Avenue R in Galveston in the aftermath of Hurricane Ike on Tuesday afternoon, Sept. 23, 2008.

KEVIN M. COX

Above, right: Ronald Moore, left, and his uncle, Lovie Oliver, took a break on the porch of their house on Ball Street in Galveston on Monday, Sept. 15, 2008. The two rode out Hurricane Ike in the house. Moore said the water was waist deep during the storm.

JENNIFER REYNOLDS

Left: Caitlin Hamilton, 9, carried a bucket of free cleaning supplies to a car at Moody Memorial First United Methodist Church in Galveston on Wednesday morning, Sept. 24, 2008. Most Galveston residents were allowed back onto the island to see their damaged homes for the first time 12 days after Hurricane Ike made landfall.

KEVIN M. COX

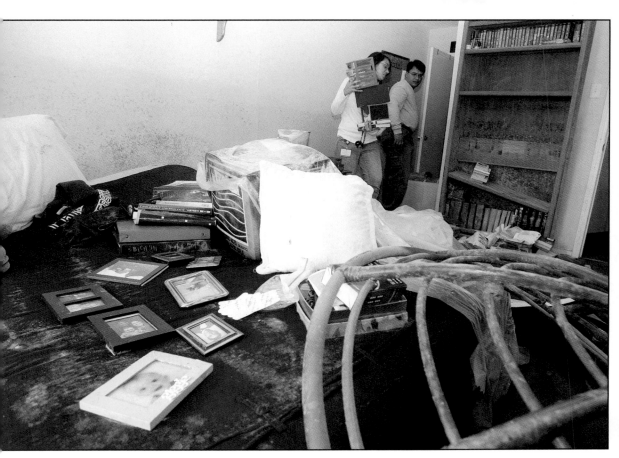

Left: Maya Srimushnam, a student at the University of Texas Medical Branch at Galveston, and her brother, Rama, cleaned out her ground-floor apartment at Villa Marina on Ferry Road in Galveston on Saturday afternoon, Sept. 27, 2008.

KEVIN M. COX

Below: Steve Fabian unloaded dozens of bags of cleaning supplies, food and water at his home on Avenue N in Galveston. Fabian, who owns Fabian Seafood, came in during the look-and-leave policy.

JENNIFER REYNOLDS

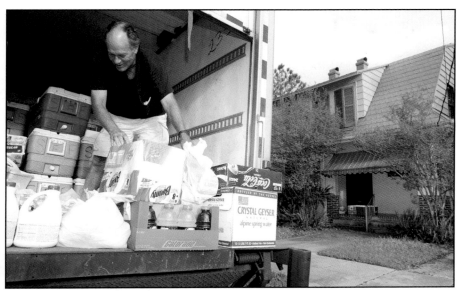

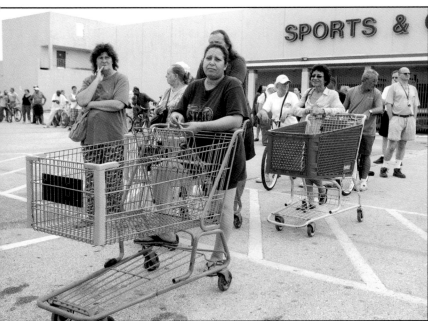

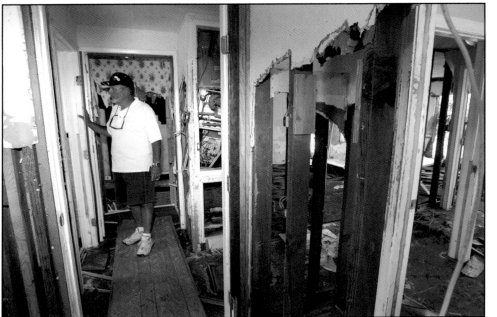

Far left: Janet Mimoune waited in line to get her family water, ice and Meals Ready to Eat in the parking lot of the Academy on Seawall Boulevard in Galveston. A National Guard unit from San Angelo set up the aid station.

JENNIFER REYNOLDS

Left: Lyndon Young walked through what was left of his house in the Channelview subdivision in Galveston. Young and his son, Stacy, came back to find the house destroyed. Young had just sold the house and was going to close on it when evacuations for Hurricane Ike were announced.

JENNIFER REYNOLDS

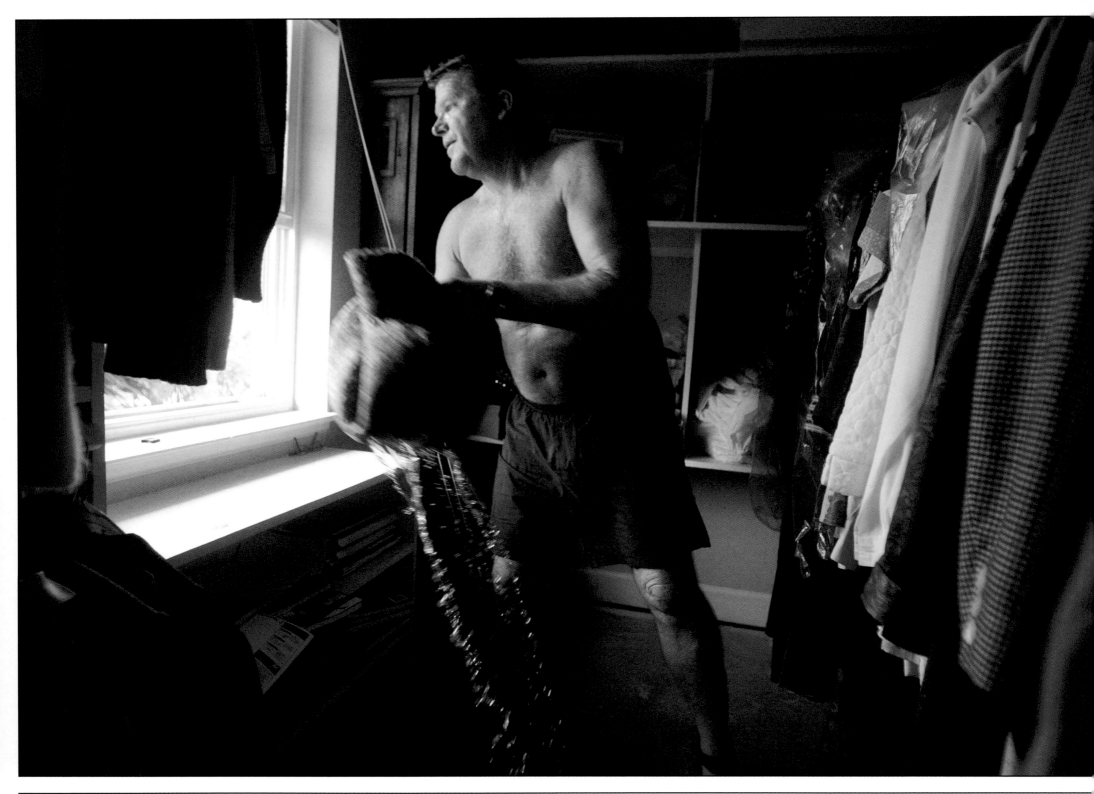

The root of the horror

In a blistering hot kitchen, with contaminated water trickling from the faucet, four middle-aged women took matters into their own hands.

Day Six of post-Ike living had dawned, and not one of the quartet had adequately prepared for this prolonged predicament of no electricity or water, long ice lines, government-packaged meals and, the ghastliest of all their woes... gray roots.

Among them were a judge, a social worker, a purchasing agent and a marketing professional. Their decisions, reached independently, to weather Hurricane Ike on the island, were as varied as their personalities. Friendly, but not all close friends previously, their paths had converged in a breathless backyard the day after Ike slammed ashore.

One rode out the storm with a savory bottle of Russian vodka and her aging parents in her childhood home. Two of the four had huddled together with other friends in a stately older home on Sherman Drive. And the fourth endured Ike in an East End cottage with 15 relatives and five feet of Gulf water lapping near the front door.

In the days of daze after Ike, these four women met every night to dine on whatever had been torched from the freezer for the evening's fare. They talked about the food, the fear and the future. Each shared her adventures that day of washing clothes in a tub, scavenging Diet Coke from the neighbor's garage, or carting belongings to the curb for a front-end loader to squash.

Some nights, they were quite pitiful, when every morsel of news delivered that day had been bad, and it seemed the world just might end. But other evenings revealed hope and pride and tenacity that, damn it, they were strong, proud Southern — no, better yet, Texas, no best of all, Galveston — women who could face down any disaster.

It was one of these latter nights, filled with bravado, that the dreadful topic of emerging gray roots was broached.

"Y'all, what are we gonna do?" one fretted in mounting desperation. "There's no electricity, the water's tainted, the beauty shops are all closed and I can't walk out my front door looking like this!" And it absolutely was not true that she'd been cavorting earlier that day with a couple of young hunks in a Georgia Power truck hunting downed electrical lines in the neighborhood.

Sadly, salon appointments for "touch up" had come and gone in the days just before and since Ike, and the unlikely foursome sat in plastic lawn chairs lamenting who needed a dye job the most. To a casual observer, their collective gray roots were mostly imagined, but try telling that to a woman feeling like a hurricane hag and dead-set on getting her hair done.

Joy comes in the oddest packages when you're truly down and out, and word that the local Walgreen's was opening the next day was cause for celebration. Now, not one among them had a license or any sort of training in the fine art of doing hair.

But the marketing gal had spent a fair amount of time in the 1960s marveling at her Mama's kitchen-based beauty shop, where bleach jobs, dye jobs and permanent waves were turned out regularly on every little girl in the neighborhood who stood still long enough. It was quickly determined, by the group, that all that hairdo watching four decades ago qualified her the most to color their hair.

Next afternoon, they climbed into the only gassed up vehicle among them and rolled on over to Walgreen's where each perused the shelves of "Medium Golden Brown," "Sparkling Sherry," "Hint of Henna" and a rainbow of other hair hues.

Clutching their purchases, the quad quickly headed back to the stifling kitchen, dimly lit and cooled by a box fan, thanks to the generator roaring out back. Over the next two hours, first one and then another, took her turn in the beauty chair.

While not one of them achieved coiffed perfection that afternoon, each of them was mighty pleased to kiss those pesky gray roots goodbye for another four to six weeks. And the day made for some fine friendship, quirky conversation and a pledge that what got told in that kitchen, stays in that kitchen.

I'm not sure any of the four, given the chance, would stay again if the likes of Ike were rapping at the door. But I know this for sure. If any one of these ladies did decide to ride out a hurricane on the island again, among the candles, flashlights and bottled water would be a couple of boxes of Miss Clairol tucked away on a high shelf.

— *Sheila Lidstone, Galveston*

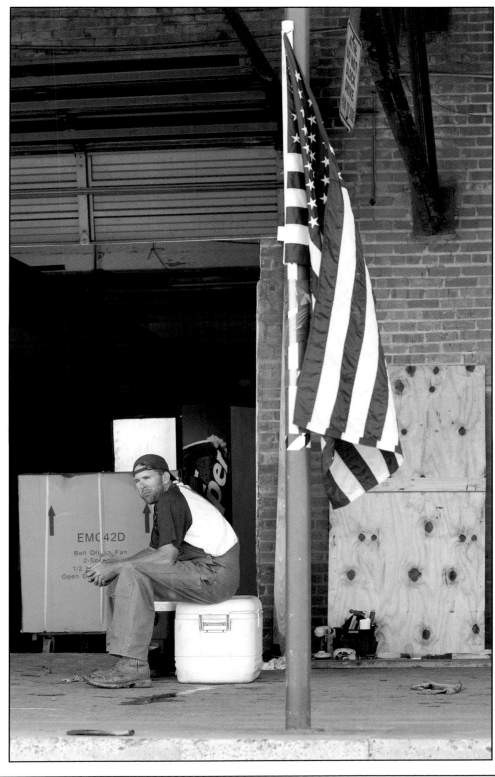

Previous page: Ed Rismiller tossed drenched carpet padding through a window of his house in Galveston on Sunday, Sept. 14, 2008. Rismiller started pulling up waterlogged carpeting and salvaging belongings soaked by Hurricane Ike.
JENNIFER REYNOLDS

Left: Ted Farmer, one of the owners of Farmer's Copper on Harborside Drive, took a break from cleaning his storm-damaged business Tuesday, Sept. 16, 2008, in Galveston. Farmer said he lost his home and business in the storm. He said the damage was a devastating blow.
JENNIFER REYNOLDS

Right: Tour guide George Osborn tried to salvage a small boat alongside the 1877 tall ship Elissa, which made it through the storm relatively unscathed, on Monday, Sept. 15, 2008.

KEVIN M. COX

Below: Thomas Grazier cut pieces of pilings that were scattered in the debris from Payco Marina. The pieces were then used to set salvaged boats on as workers cleared the shoulders of Interstate 45 leading into Galveston.

JENNIFER REYNOLDS

Below, right: Duke, a neighborhood dog, drowned while stuck in the fence at Palm Terrace on 41st Street in Galveston. Many people left pets behind when they evacuated for Hurricane Ike. Volunteers rounded up many cats and dogs and took them to makeshift animal shelters.

JENNIFER REYNOLDS

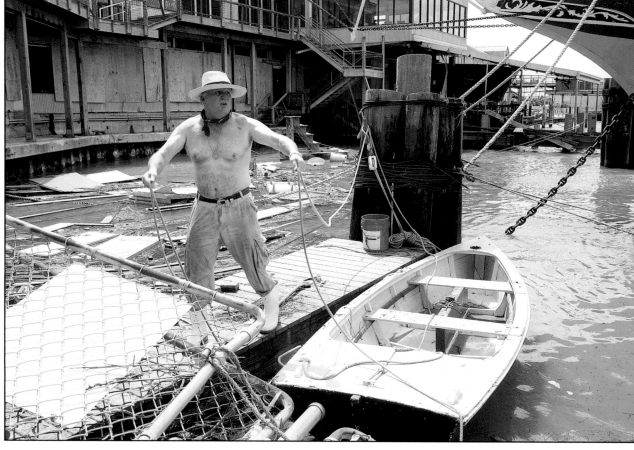

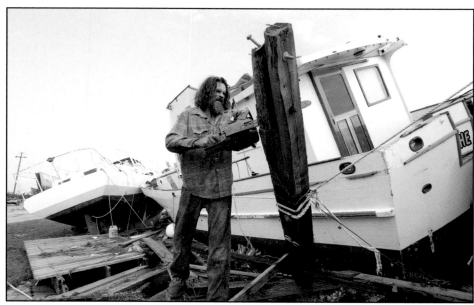

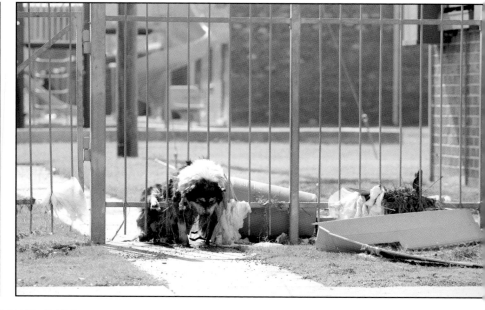

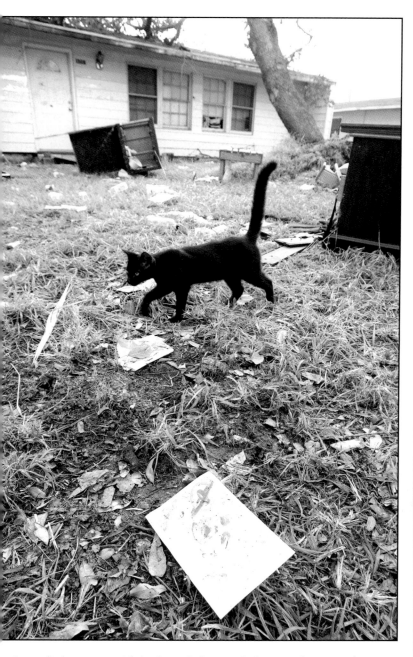

e: A cat walked past someone's baby photo, which was washed into a yard on Bayou Shores in Galveston by Hurricane Ike.

FER REYNOLDS

Above: Charles Coleman, left, and Javier Bryant pushed a grocery cart full of food, including flowers, down Broadway on their way home from the Kroger store in Galveston, which opened Wednesday, Sept. 17, 2008.

JENNIFER REYNOLDS

Left: An American flag flew behind Bacliff resident Terry Singeltary's bay-front home on Bayshore Drive on Tuesday morning, Sept. 16, 2008.

KEVIN M. COX

Far right: Bryce Long, a volunteer with the Denver Dumb Friends League, played with a kitten being checked in to the temporary Galveston Island Humane Society after the animal shelter was damaged by Hurricane Ike.

JENNIFER REYNOLDS

Right: A puppy sat in one of the kennels at the temporary shelter for the Galveston Island Humane Society.

JENNIFER REYNOLDS

Below: A rescued dog rested at the Seventh Street and Broadway animal clinic in Galveston on Monday afternoon, Sept. 15, 2008.

KEVIN M. COX

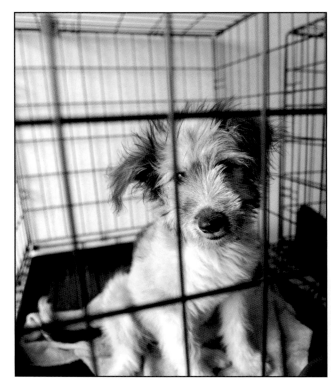

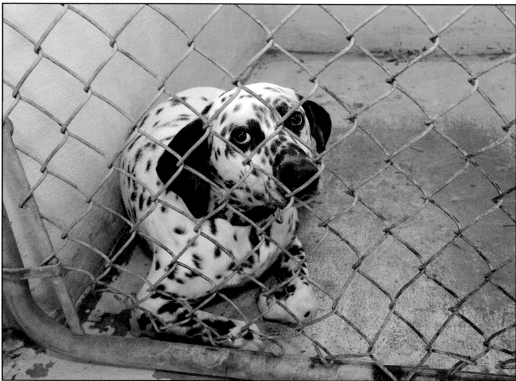

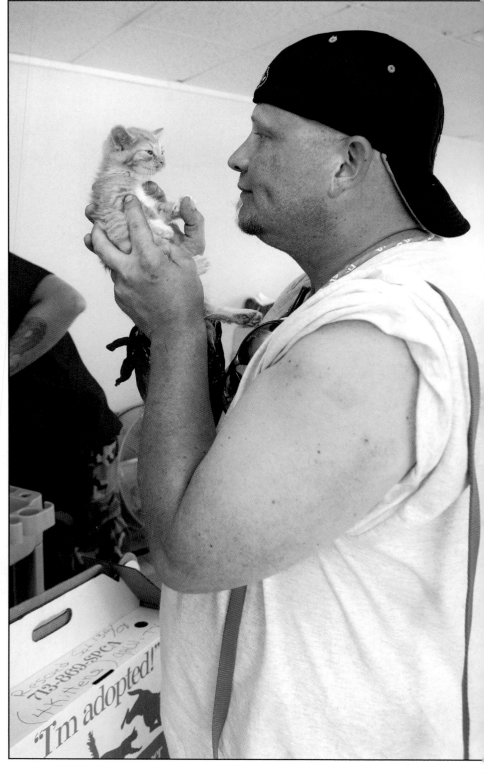

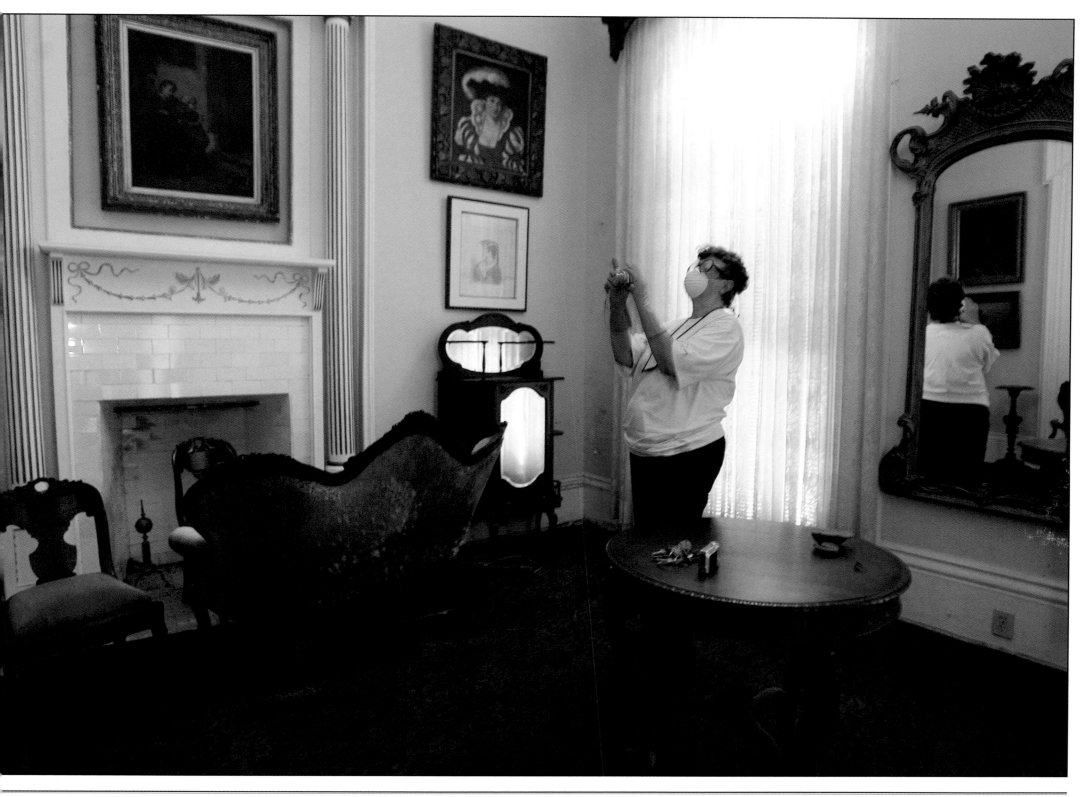

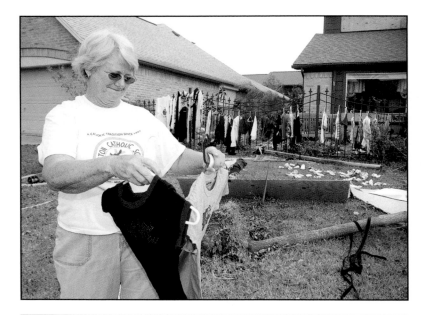

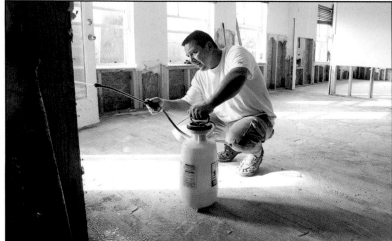

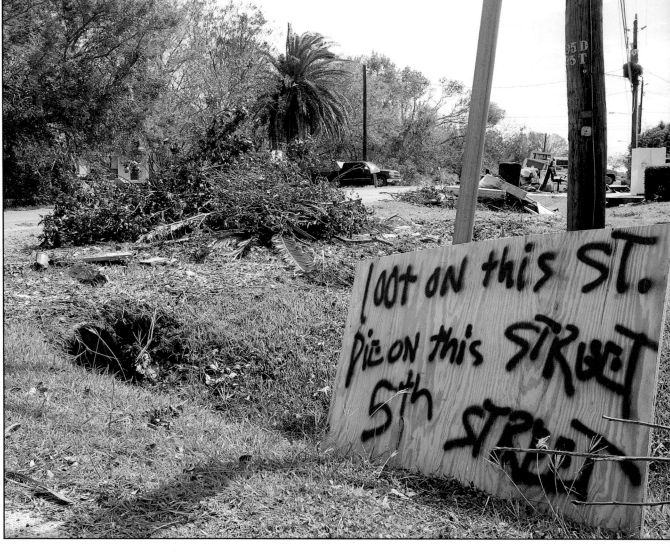

Top: Cindy Clement hung her daughter's clothes to dry in front of her house on Beluche Street in Galveston in the aftermath of Hurricane Ike on Tuesday, Sept. 23, 2008.

KEVIN M. COX

Above: John Anderson sprayed a bleach solution to kill mold inside the walls at his mother's house on Clara Barton Lane in Galveston on Wednesday, Sept. 24, 2008.

KEVIN M. COX

Right: Kenneda Jobe carried her belongings from Magnolia Homes in Galveston on Wednesday, Sept. 24, 2008.

KEVIN M. COX

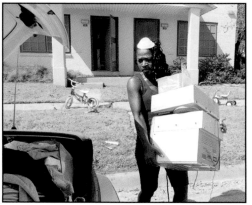

Above: A sign at the corner of Fifth Street and Avenue B read "Loo[t] this St. Die on this Street" in San Leon in the aftermath of Hurrica[ne] Ike on Tuesday morning, Sept. 16, 2008.

KEVIN M. COX

Left: Genaro Barrientos and his daughter, Valeria Barrientos, 18, threw away flood-damaged items from their house on Ninth Stree[t] Galveston on Wednesday afternoon, September 24.

KEVIN M. COX

Previous page: Merri Edwards, with the Galveston Historical Fou[n]dation, photographed water damage to Ashton Villa. The house, b[uilt] in 1859, had almost 2½ feet of water throughout the first floor.

JENNIFER REYNOLDS

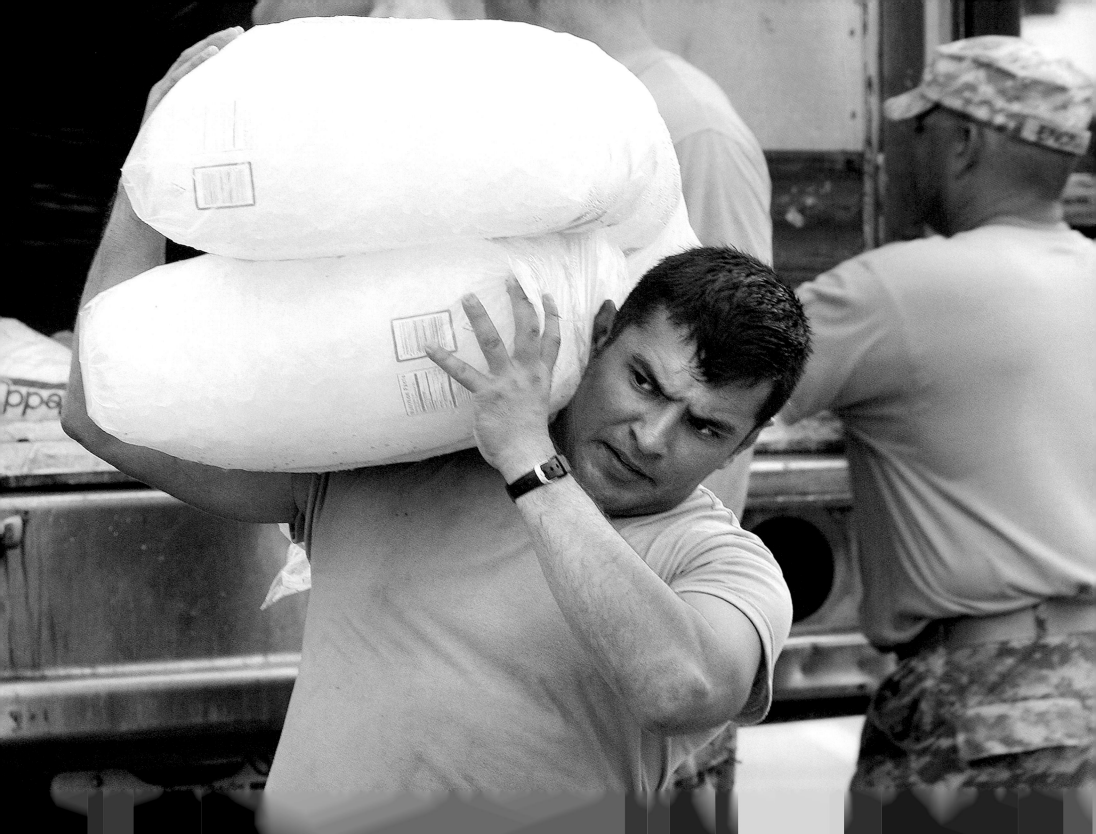

Previous page: Texas Army National Guard Staff Sgt. Javier Espinoza unloaded ice from a truck at a point of distribution for ice and water at the U.S. Post Office in Texas City on Sunday, Sept. 14, 2008.

KEVIN M. COX

Right: Galveston County sheriff's deputy B. Cooley distributed Meals Ready to Eat to Mike Savoie in San Leon on Tuesday morning, Sept. 16, 2008.

KEVIN M. COX

Far right: Trey Wolley, 9, helped his mother load groceries into their car at the Kroger in League City on Monday morning, Sept. 15, 2008. Power was slowly returning to portions of the mainland.

KEVIN M. COX

Below: Sgt. Ringo Hunt filled a shopping cart with water, ice and packaged meals for Janet Mimoune and her family at an aid station in the parking lot of the Academy store in Galveston on Sunday, Sept. 14, 2008.

JENNIFER REYNOLDS

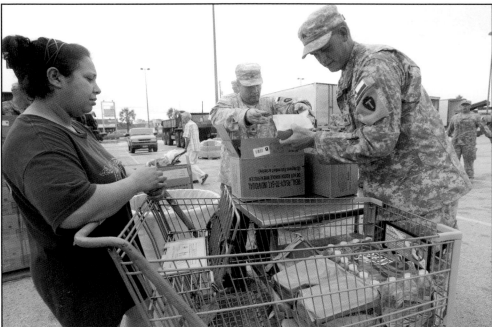

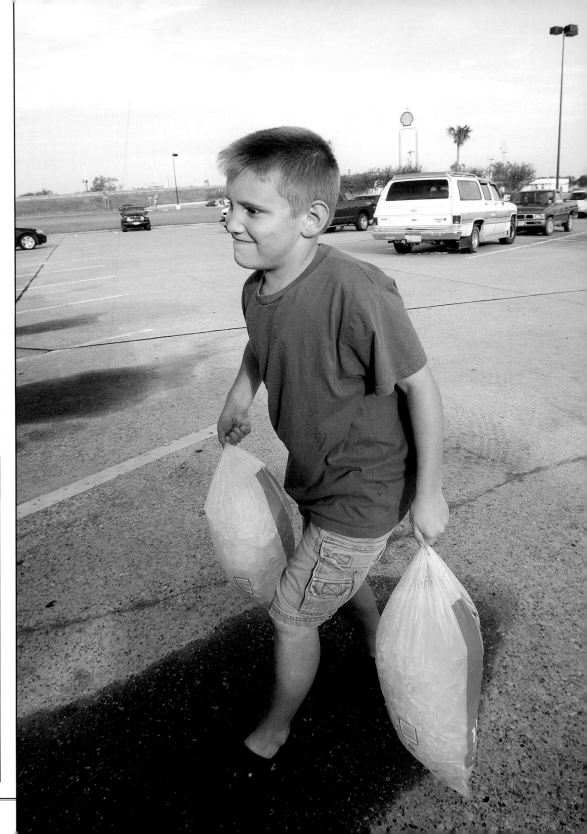

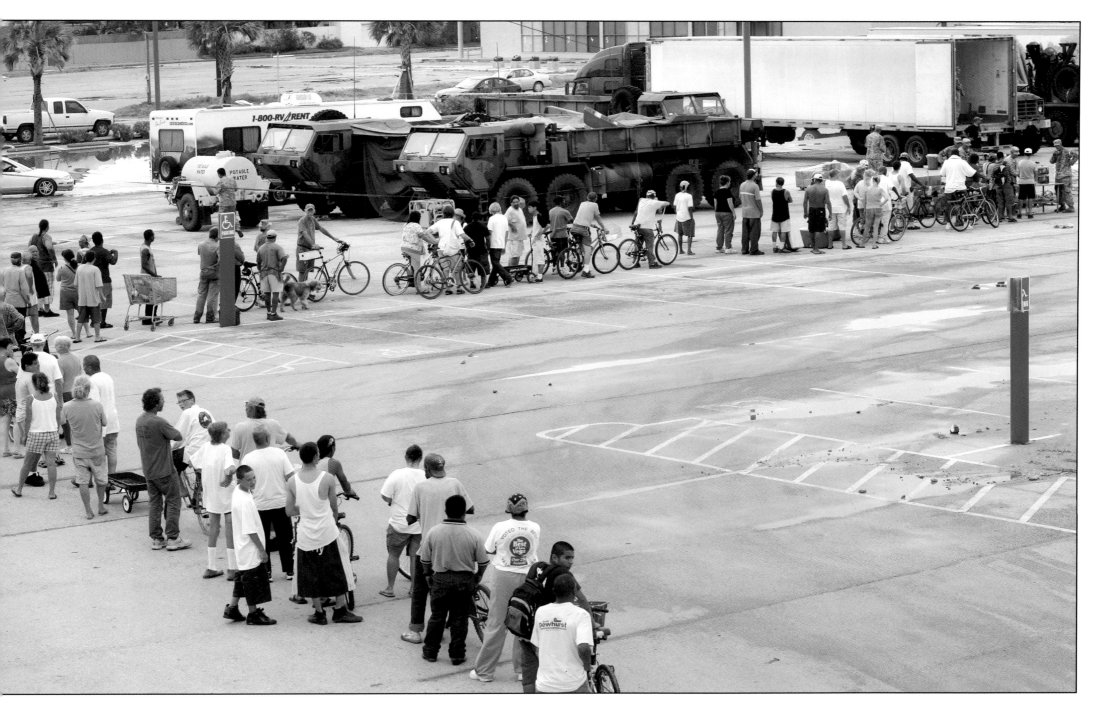

ove: Galveston residents waited in
 for food and supplies at the National
ard point of distribution at the Academy
 on Seawall Boulevard.

NIFER REYNOLDS

The kindness of strangers

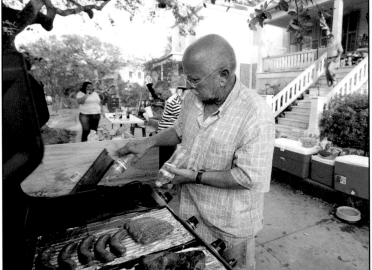

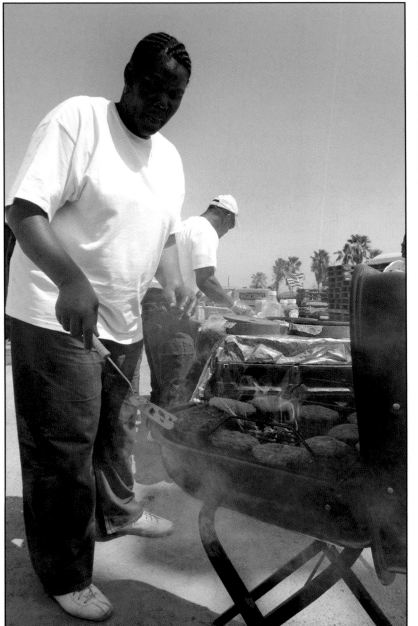

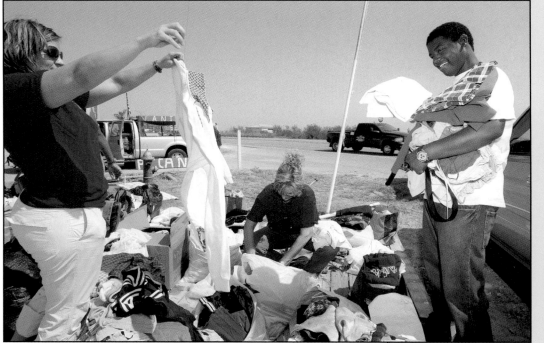

My husband uses a cane and I use a walker, and we were going to stay home during Hurricane Ike. Our oldest daughter, Jackie, had a "feeling" about this storm, so she was leaving. She and our youngest son, Jim, came over that Friday morning and urged us to leave. We packed a bag and loaded the car. Everyone left the house.

We headed out on state Highway 6. We had got to Sugar Land and Rosenberg, when the car stopped. A lady stopped behind us, and said she knew a good mechanic down the road.

In a few minutes, a pickup was in front of us, and he put a towline on us and pulled us into his shop. He stopped what he was working on and replaced our water pump.

His mother invited us into the air-conditioned office to wait, and we were offered food and drink. Then she called her friend who has a bed-and-breakfast-type business in two big old two-story houses. She invited us to stay in one of the houses and told us, "Make yourself at home."

The next two nights she moved us into her home, where she lived upstairs. She fed us three meals every day. We were treated like royalty!

These people did all of this for strangers, and then wouldn't take any form of payment from us. Of course, we paid for our car repairs.

— *Wilford and June Malm, La Marque*

Above: Ivy Williams, with the Tehilla Tabernacle Mission from Portland, Maine, grilled hamburgers and hot dogs for Galveston residents Thursday, Sept. 25, 2008, at the Island Community Center.

JENNIFER REYNOLDS

Top, right: Bill Beverage heated bottled water for coffee while cooking sausage and hamburgers and warming leftover brisket for dinner. Several neighbors living near 12th and Sealy streets in Galveston ate meals together after Hurricane Ike hit.

JENNIFER REYNOLDS

Above: Christy Bacon, left, and Janice Fancher, with Keller Williams Realty in Houston, helped Johnathan Cormier find clothes to replace those he lost during Hurricane Ike. Keller Williams International, in Austin, collected clothing for island residents who lost their houses and belongings in the storm.

JENNIFER REYNOLDS

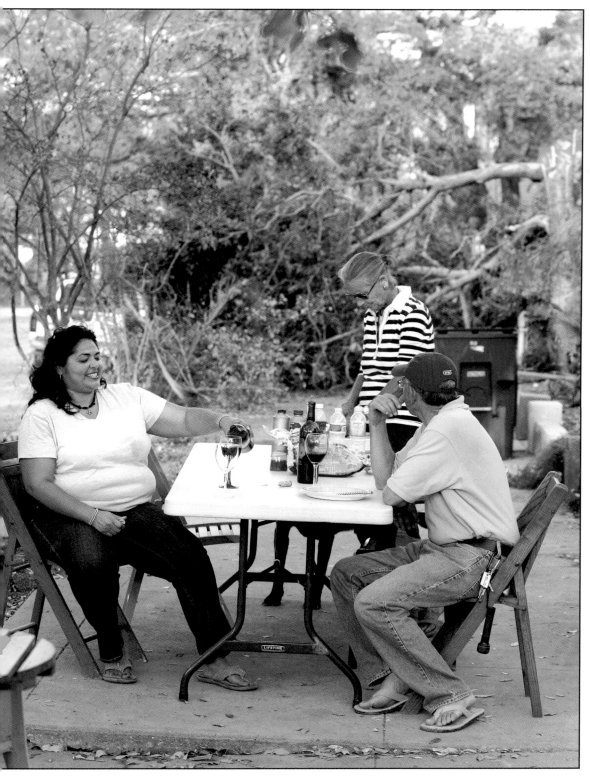

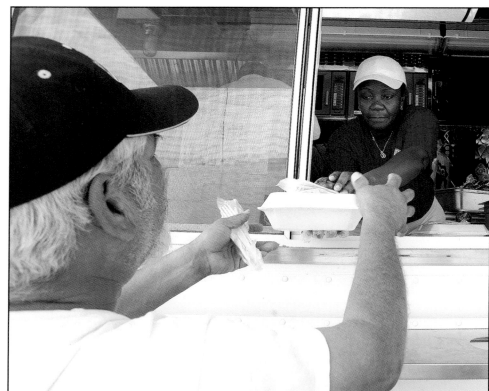

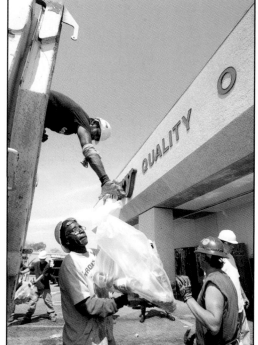

Above: Julia Wearrien of Beaufort, S.C., served hot meals from a Salvation Army mobile kitchen in Galveston on Monday afternoon, Sept. 15, 2008.

KEVIN M. COX

Left: Workers loaded bag after bag of damaged goods into Dumpsters at the H-E-B Pantry store in Galveston on Wednesday, Sept. 17, 2008. The store sustained water damage during Hurricane Ike, and officials announced it would not reopen.

JENNIFER REYNOLDS

Far left: Diana DeHoyos, left, poured a glass of wine as she, Pam Houston and Chris Robbian waited for Bill Beverage to grill dinner Friday, Sept. 19, 2008, on the sidewalk in font of their homes on Sealy Avenue in Galveston. The small group of neighbors rode out the storm in their East End homes. After the storm, they turned the sidewalks at 12th and Sealy into an outdoor dining room and kitchen.

JENNIFER REYNOLDS

Right: Natalie Binder, a Red Cross volunteer from Tallahassee, Fla., waited to hand out meals and water to Galveston residents Wednesday, Sept. 24, 2008, in the parking lot of Arlan's Market on Sixth Street.

JENNIFER REYNOLDS

Below: A national guardsman loaded ice onto the trailer Jason Jorgensen made for his bicycle Sunday, Sept. 14, 2008, at the Academy parking lot on Seawall Boulevard.

JENNIFER REYNOLDS

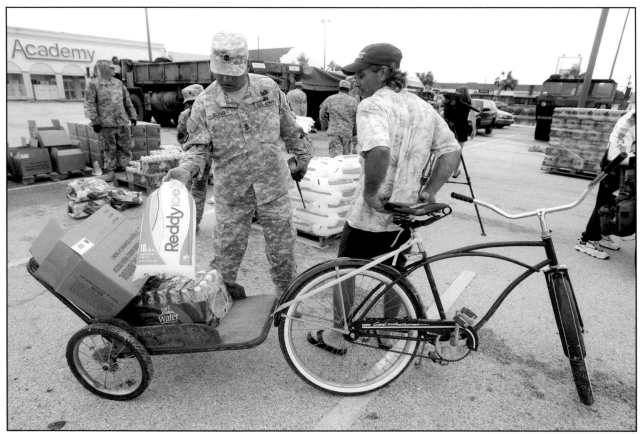

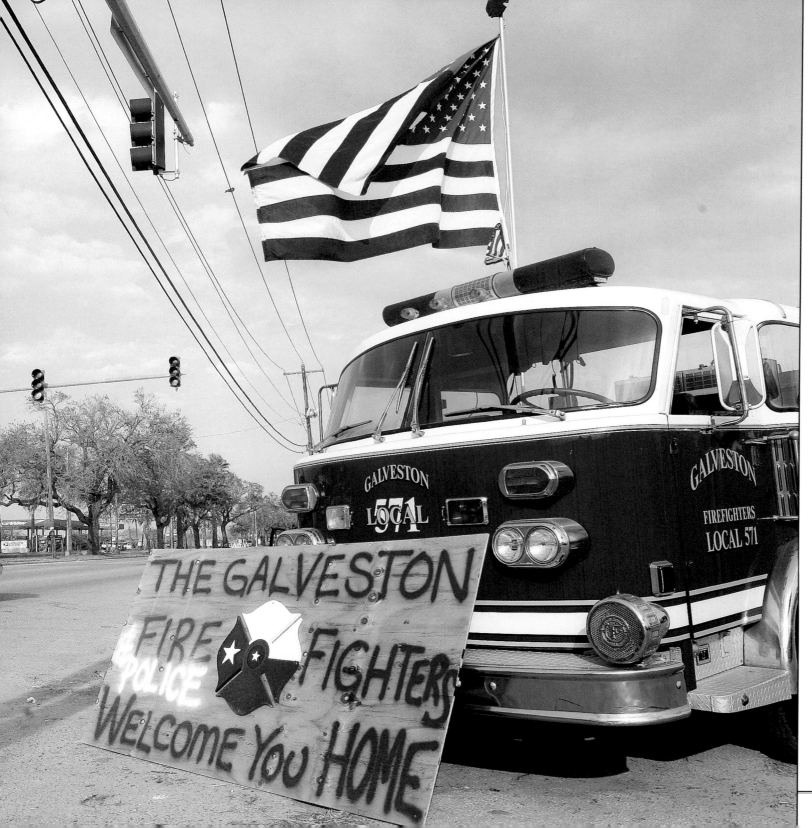

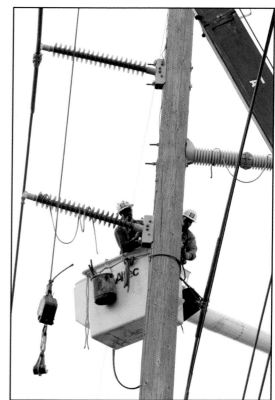

Left: A sign read "The Galveston Fire Fighters & Police Welcome you Home" at 59th and Broadway on Wednesday afternoon, Sept. 24, 2008. Most Galveston residents were allowed back onto the island to see their damaged homes for the first time 12 days after Hurricane Ike made landfall.

KEVIN M. COX

Above: Brian Hanson and Brian McKinnen, with PAR Electric Contractors, repaired utility poles and lines along 53rd Street in Galveston on Thursday, Sept. 18, 2008.

JENNIFER REYNOLDS

Right: Spc. Jonathan Hartman was all smiles as he got two plates of boiled shrimp Thursday, Sept. 18, 2008, during the First Responders shrimp boil at Gaido's at 39th Street and Seawall Boulevard in Galveston.

JENNIFER REYNOLDS

Below: Galveston Mayor Lyda Ann Thomas talked with Kimberly Gaido Thursday, Sept. 18, 2008, at the shrimp boil at Gaido's.

JENNIFER REYNOLDS

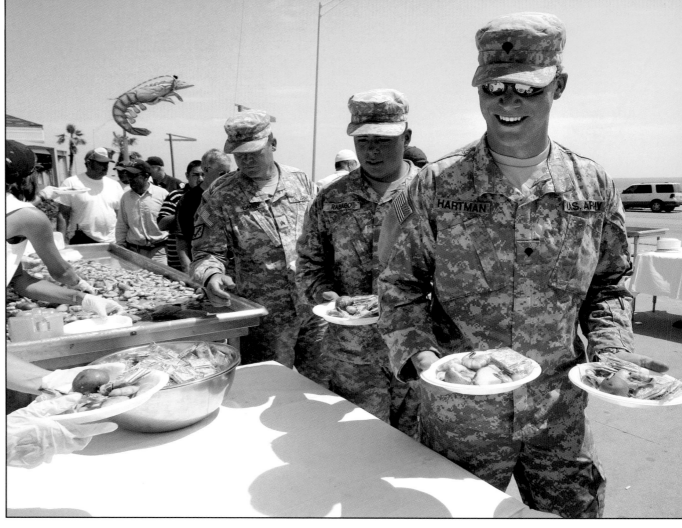

Wednesday, Sept. 17 — Interstate 45 was clogged as residents tried to make their way back to Galveston, only to find out the island was closed.

Wednesday, Sept. 17 — Carnival Cruise Lines announced it would operate ships Conquest and Ecstasy from the Port of Houston's new Bayport facility for at least four weeks. Company officials said they were committed to returning to Galveston.

Wednesday, Sept. 17 — Galveston Independent School District said it would reopen three days after electricity was restored to the island, but Superintendent Lynne Cleveland encouraged parents to enroll their children in schools where they had evacuated.

Wednesday, Sept. 17 — Leaders at the University of Texas Medical Branch at Galveston met to plan a return to normalcy. Patients there were being sent to other hospitals after they were stabilized.

Wednesday, Sept. 17 — Mainland Medical Center announced it would open the following day.

Wednesday, Sept. 17 — Texas City Mayor Matt Doyle urged refineries to race against each other to get back online in hopes of avoiding $5-per-gallon gas prices.

Wednesday, Sept. 17 — Texas A&M University officials announced that students whose classes were disrupted by Hurricane Ike would be moved to the College Station campus.

Wednesday, Sept. 17, afternoon — Kroger on Seawall Boulevard opened to lines of customers waiting to stock up on batteries, cigarettes, charcoal and other items to make life on the island more bearable.

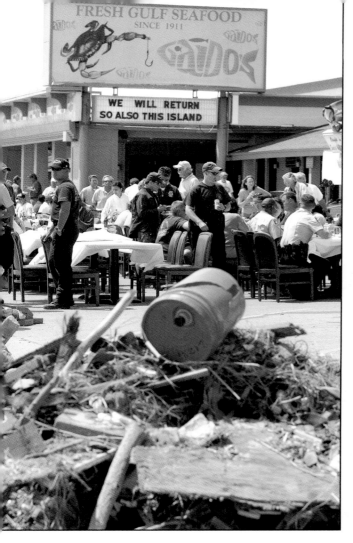

Left: With debris from Hurricane Ike piled curbside, local and national emergency personnel and disaster relief workers dined on boiled shrimp, corn and potatoes in the parking lot at Gaido's on Thursday, Sept. 18, 2008. The restaurant boiled 1,000 pounds of shrimp for the luncheon.

JENNIFER REYNOLDS

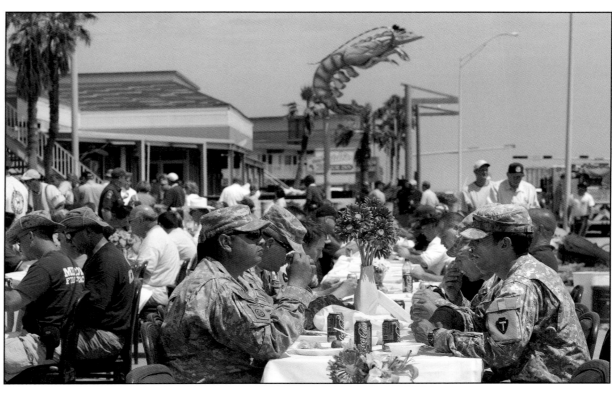

Left: Cpl. Neal Castillo, left, and Spc. Peter Strauch, with the National Guard, ate boiled shrimp in front of Gaido's restaurant Thursday, Sept. 18, 2008, during the First Responders shrimp boil.

JENNIFER REYNOLDS

...sday, Sept. 18 — City's library and ...ourse reopened.

Thursday, Sept. 18 — Galveston Mayor Lyda Ann Thomas said recovery efforts on Galveston Island were ahead of schedule, but she also urged residents to wait at least a week before trying to return.

Thursday, Sept. 18 — Port of Galveston officials said cruise passengers' cars that were parked at the port were flooded and not drivable.

Thursday, Sept. 18 — The county medical examiner said six residents died as a direct result of the storm and another 13 died from medical conditions worsened by the hurricane. Three of the deaths were by drowning. The death toll later was amended to 16.

Thursday, Sept. 18 — Federal officials completed sonar sweeps of the Galveston Ship Channel and found no obstructions.

Thursday, Sept. 18 — Island seafood restaurant Gaido's had a shrimp boil for emergency responders.

Thursday, Sept. 18 — Pets rescued in Galveston after the hurricane were moved to Houston.

Thursday, Sept. 18 — Authorities began allowing High Island residents to return home to retrieve belongings and survey damage.

Right: Texas Department of Transportation worker Mike Joines worked to clear downed power lines from state Highway 87 on the Bolivar Peninsula on Saturday morning, Sept. 20, 2008.

KEVIN M. COX

Below: Wally Meeks with Mertz Sausage and Catering from San Antonio served dinner for Texas New Mexico Power Company utility workers trying to restore power to Galveston County on Friday evening, Sept. 19, 2008. Meeks said company workers served an average of 600 meals three times each day.

KEVIN M. COX

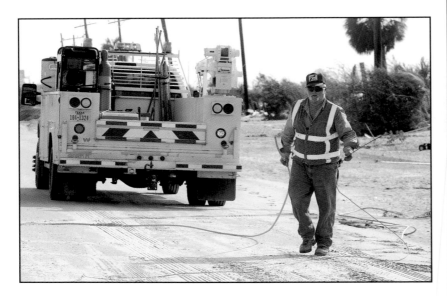

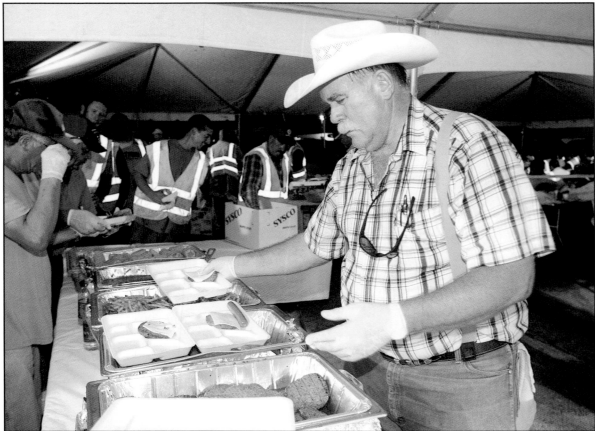

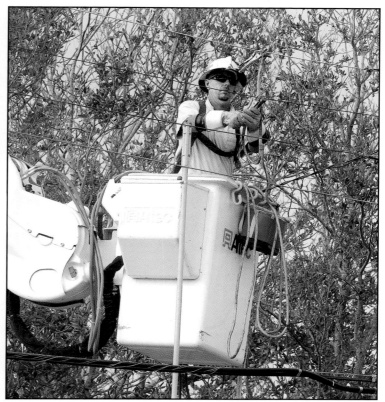

Above: Jeff Smith with Georgia Power worked to restore power at 50th Street and Fannin in Galveston on Wednesday afternoon, Sept. 24, 2008.

KEVIN M. COX

Left: Jerry Salas with P&M from Alamogordo, N.M., raised a bucket truck 60 feet above a staging area for Texas New Mexico Power Company and CenterPoint Energy trucks at Gulf Greyhound Park in La Marque on Friday evening, Sept. 19, 2008.

KEVIN M. COX

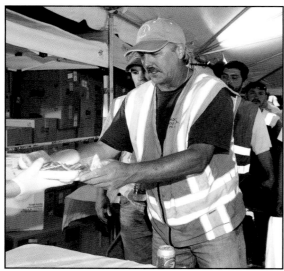

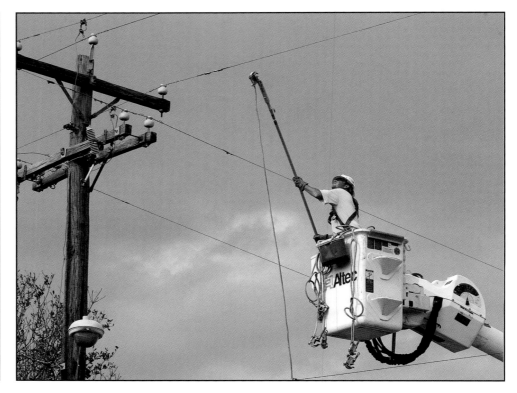

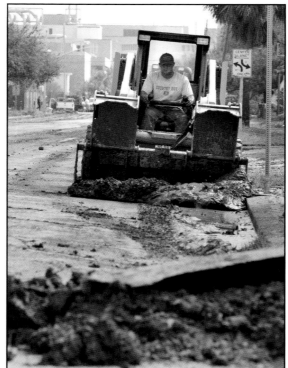

Ike brings out best in folks

I may be prejudiced, being a native Texan and all, but these are some tough folks around here. As soon as the roads were cleared and the locals were allowed back on the island, it became a beehive of activity, and it still is today. Businesses have construction crews in, tearing out the flood damage and rebuilding; homeowners still not back to work are just as busy.

Yes, we Texans are tough.

Disaster seems to bring out the very best in people, and I've had the privilege of seeing the best of humanity in action! Neighbors helping neighbors, sharing what they have and doing what they can for each other.

Even Houston drivers, notorious for their sometimes-rude driving habits, waved my truck through intersections when it wasn't my turn to go. I'm pretty sure that it had everything to do with the placard on my trailer, which read, Apache Oil Company Emergency Services Division. They knew what my truck was about; it was about fueling the generators that were keeping the few convenience stores, truck stops, hotels and people's homes open and functioning.

I was preparing to fuel the generator at a convenience store at the very end of Post Oak Boulevard when a woman seemed to come out of nowhere and appeared next to my trailer. "You're working the disaster relief?" she asked me. "I guess I am," was my answer. When she didn't respond, I turned to look at her to see if she was still there. When I met her gaze, she paused for a moment, and then simply said, "Thank you."

The woman's simple acknowledgment stuck in my head and got me to thinking about the hundreds of linemen who came from all over the lower states to help restore power to the region.

They've slept in their trucks and worked 12 to 16 hours a day. Every opportunity that I get, I roll down my window and thank them, too. Those of us who were spared total disaster are helping those that were not so fortunate.

I don't believe God had a hand in this storm. Storms are completely random acts that provide us with an opportunity to be more like the people that God would have us be. What a blessing to share; what a gift to receive.

— *Cindy Milina, La Marque*

Above, left: Red Cross volunteers David Lomax, from left, Rick Elster and Donna Borner checked a map of Galveston neighborhoods during a damage assessment survey.
JENNIFER REYNOLDS

Left: A recovery worker bulldozed mud and silt from the gutters on Mechanic Street on Wednesday, Sept. 17, 2008.
JENNIFER REYNOLDS

Above: James Holland with Georgia Power worked to restore power at 50th Street and Fannin in Galveston on Wednesday afternoon, Sept. 24, 2008.
KEVIN M. COX

Next page: City crews began clearing Seawall Boulevard of debris left by Hurricane Ike on Saturday, Sept. 13, 2008, after the storm passed.
JENNIFER REYNOLDS

Above: Ray Page of Trees Inc. of Salt Lake City, Utah, got dinner at a staging area at Gulf Greyhound Park in La Marque on Friday, Sept. 19, 2008, after working all day for Texas New Mexico Power Company.
KEVIN M. COX

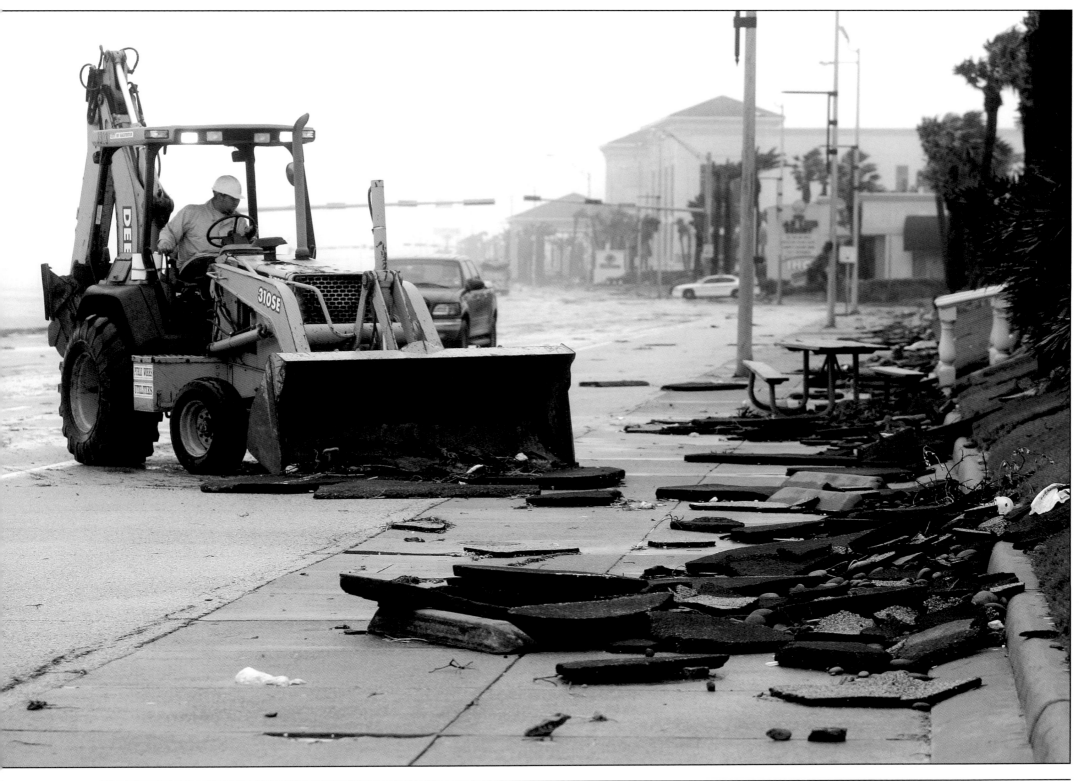

Right: Lizbeth Sanchez, a student at K.E. Little Elementary School, and her nephew, Kevin Sanchez, 2, of San Leon, sorted through piles of clothes donated by the Dickinson school district at Bayshore Park in San Leon on Wednesday afternoon, Oct. 8, 2008. More than 500 people from parts of the Galveston County hardest hit by Hurricane Ike showed up to search through the loads of clothes.

KEVIN M. COX

Below: Kenneth Humphrey, left, from Alabama, ate dinner at a Red Cross truck in the parking lot of Target in Galveston on Wednesday, Sept. 24, 2008. Humphrey and several other debris-removal workers got a hot meal from the Red Cross.

JENNIFER REYNOLDS

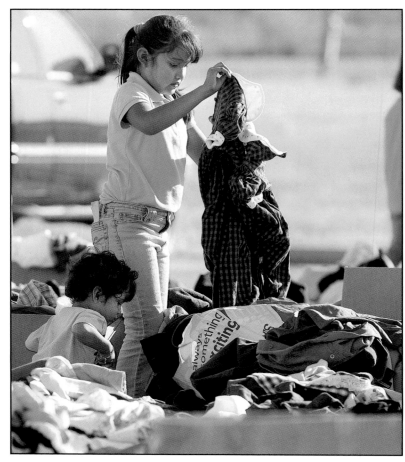

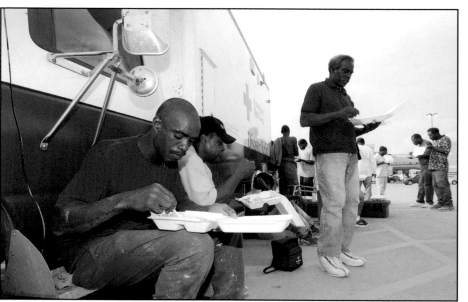

Above: American Medical Response paramedic John Prichard of Spokane, Wa signed a shirt at the Kemah Fire Station before heading to Galveston on Saturday morning, Sept. 20, 2008. Prichard and other ambulance crew members were flo in from all across the country to assist in recovery efforts.

KEVIN M. COX

Left: Marybelle Mata, left, and Pedro Del Bosque bagged up children's books Thur day, Sept. 18, 2008, at Rosenberg Library. John Augelli, the library director, estimat the library had close to 75 inches of wate the first floor. All of the children's collecti on the first floor were ruined.

JENNIFER REYNOLDS

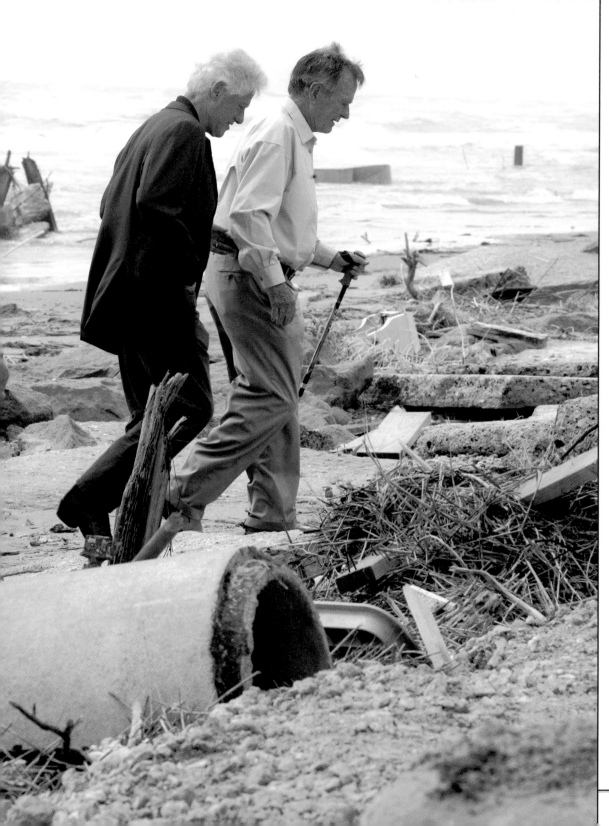

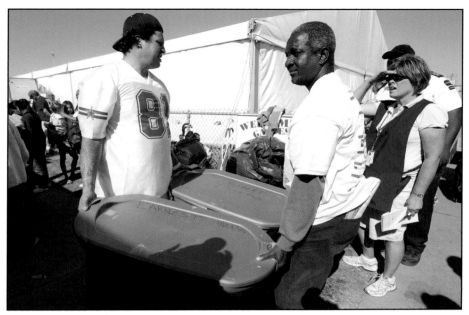

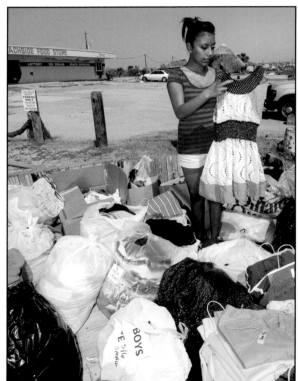

Above: Gilbert Cisneros, left, and Earnest Wells carried plastic tubs with their belongings into the Red Cross Shelter in Galveston on Wednesday, Oct. 1, 2008. They returned to Galveston after evacuating to a shelter in San Antonio after Hurricane Ike hit the island.
JENNIFER REYNOLDS

Far left: Former Presidents George H.W. Bush and Bill Clinton toured the damage from Hurricane Ike at Bermuda Beach in Galveston on Tuesday, Oct. 14, 2008. The pair established a fundraising effort for Ike relief.
JENNIFER REYNOLDS

Left: Rosa Guillen picked out clothing for her family Tuesday, Sept. 30, 2008, from the dozens of bags donated by Keller Williams Realty.
JENNIFER REYNOLDS

Above: Texas Land Commissioner Jerry Patterson, center, participated in the benediction Sunday, Sept. 21, 2008, at Moody Memorial First United Methodist Church in Galveston. The service was one of a handful around the island nine days after Hurricane Ike made landfall.

JENNIFER REYNOLDS

Next page: Jimmy Anderson squeegeed mud and water from Cruz Co Clothier in downtown Galveston on Friday, Sept. 25, 2008. Anderson, w works for Paramount, a restoration company, was washing the mud a debris from the business two weeks after Hurricane Ike flooded the are

JENNIFER REYNOLDS

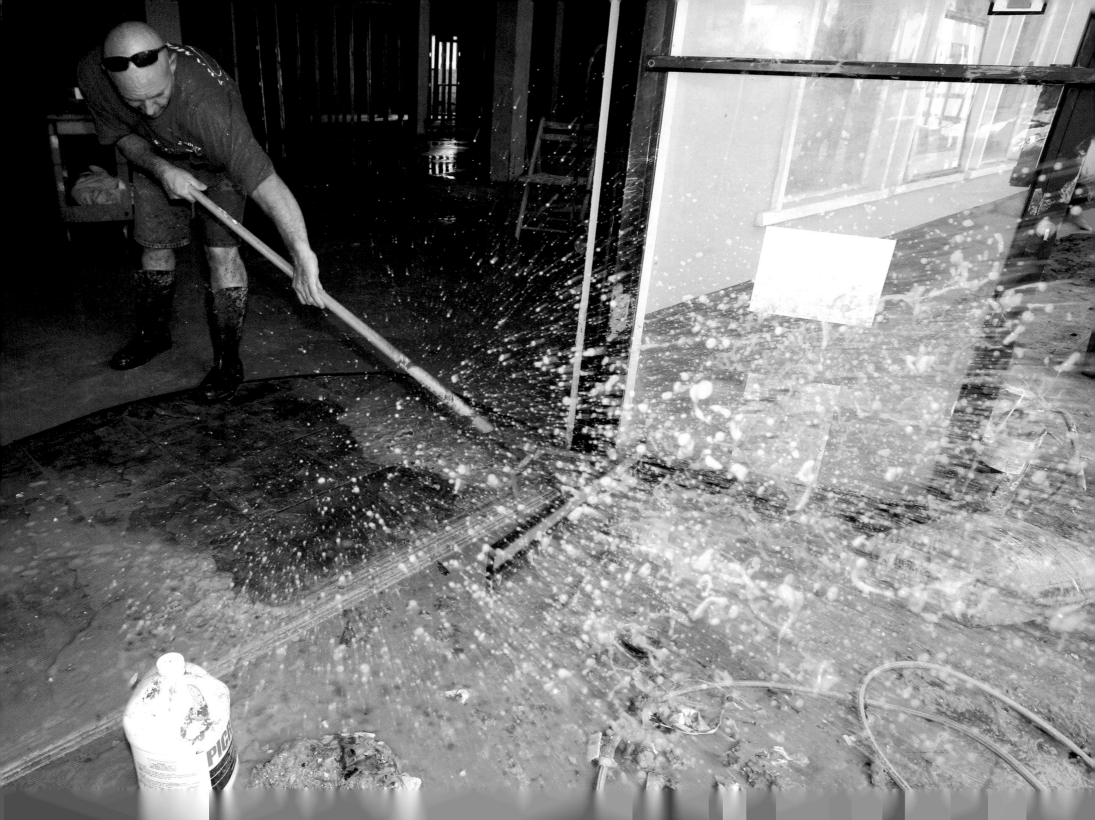

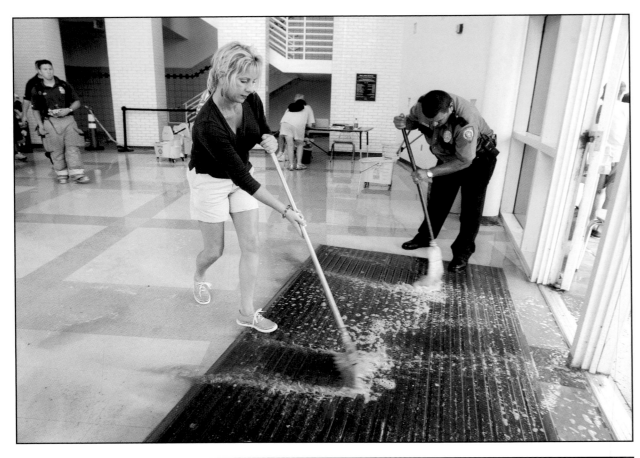

Above: Lynne Cleveland, Galveston school district superintendent, swept waters from the entrance of Ball High School Saturday, Sept. 13, 2008, after Hurricane Ike hit.

JENNIFER REYNOLDS

Far right: Jennifer Garza hung her head as she waited for a cleaning crew at etc Theater on Postoffice Street in Galveston on Sunday, Sept 21, 2008. Garza said the community theater had 6 feet of water in it.

JENNIFER REYNOLDS

Right: Ellen Graham, left, and Doc Kilroy took a break from cleaning Graham's house, which flooded during Hurricane Ike.

JENNIFER REYNOLDS

Far left: Rae Rupp, a junior at Ball High School, sorted through her family's waterlogged belongings on Tuesday afternoon, Sept. 23, 2008.
KEVIN M. COX

Left: Susan Parker tried to save her grandmother's silver that had been sitting in a drawer full of flood water for almost two weeks. Parker and her husband were among the thousands of Galveston residents returning after evacuating for Hurricane Ike. Parker found her house had been flooded with nearly 4 feet of water.
JENNIFER REYNOLDS

Far left: Yvonne Hill fought back tears as she talked about her house of 45 years. It flooded during Hurricane Ike.
JENNIFER REYNOLDS

Left: Lena Strickland sorted through her belongings in what was left of her Bayou Vista home with help from Carol Jones on Tuesday afternoon, Sept. 30, 2008. Strickland, who had lived in Bayou Vista for 22 years, planned to rebuild. She said she couldn't imagine living anywhere else.
KEVIN M. COX

Took a lickin', kept on tickin'

T wo days after the storm surge, my girlfriend, Maelina, and I were checking out the damage to my house. Everything was gone — no furniture, no clothes — there was nothing left. Both sides of my house, mostly glass, were gone.

Then Maelina's voice from the bedroom shouted, "Frank! I found the Texas Longhorn 2005 National Champions watch that you loved!" I said, "Yes! I'll take it to the jewelers, have it cleaned and ask if it's restorable."

Maelina then replied, "Frank, you know that would be a waste of time… this watch has been under the salt water of English Bayou for two days!"

Then I heard her cry out, "Frank! The watch is running!" I could hardly believe it. I bought the watch as a remembrance of the 2005 national championship.

I have never been a watch-wearing person, but now — I'll never take it off!

— *Frank Defferari, Galveston*

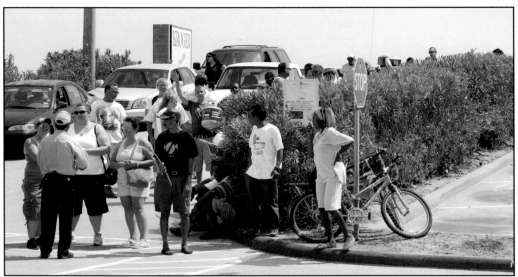

Above, right: Lucky welcomed home residents during the daylong "look and leave" policy at 61st Street and Heards Lane on Tuesday, Sept. 16, 2008.

JENNIFER REYNOLDS

Right: Galveston residents waited in line hours at the Kroger grocery store at 57th Street and Seawall Boulevard on Wednesday, Sept. 17, 2008, to go shopping. They walked, drove and rode bicycles to buy food and supplies.

JENNIFER REYNOLDS

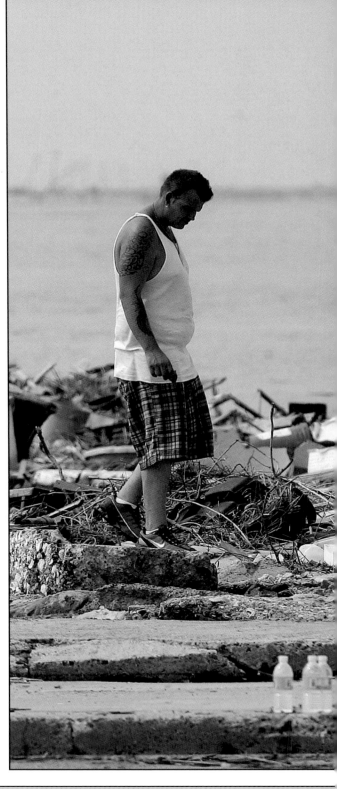

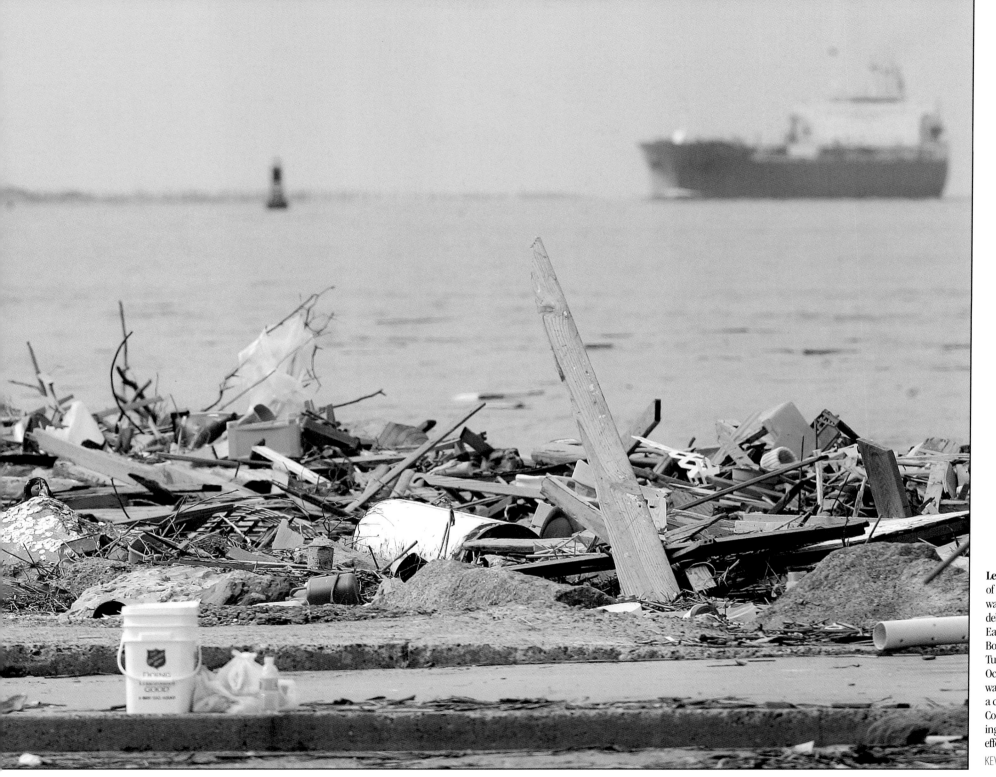

Left: Eric Bullard of Crossville, Tenn., walked amid storm debris on Galveston's East End near Boddeker Drive on Tuesday afternoon, Oct. 7, 2008. Bullard was in town with a crew from Do All Construction helping with recovery efforts.

KEVIN M. COX

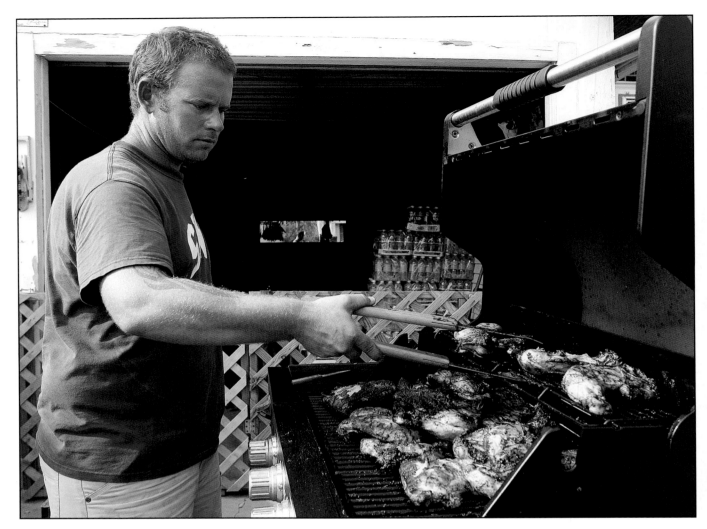

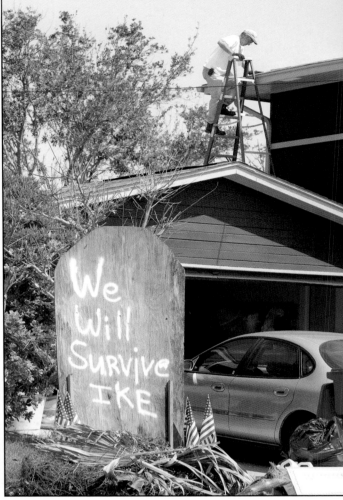

Thursday, Sept. 18 — County Judge Jim Yarbrough said authorities had completed rescue efforts on Bolivar Peninsula and were turning their focus to recovery.

Thursday, Sept. 18 — Kemah residents were allowed to return home after electricity was restored to 60 percent of the city.

Thursday, Sept. 18 — La Marque school district Superintendent Ecomet Burley said the district's facilities sustained more than $5 million in damage. He also said schools would reopen by Oct. 6.

Thursday, Sept. 18 — Texas City school district announced it would reopen Tuesday, Sept. 23 and expected an influx of students left homeless by the hurricane.

Friday, Sept. 19 — H-E-B announced it would serve meals from a mobile kitchen in its parking lot in Galveston.

Friday, Sept. 19 — AT&T announced it had restored wireless service on the island.

Friday, Sept. 19 — Water service had been restored to all areas on the island behind the seawall.

Friday, Sept. 19 — The Texas Windstorm Insurance Associated said it likely would pay out more than $4.2 billion in Hurricane Ike claims. It later cut that estimate to $2 billion.

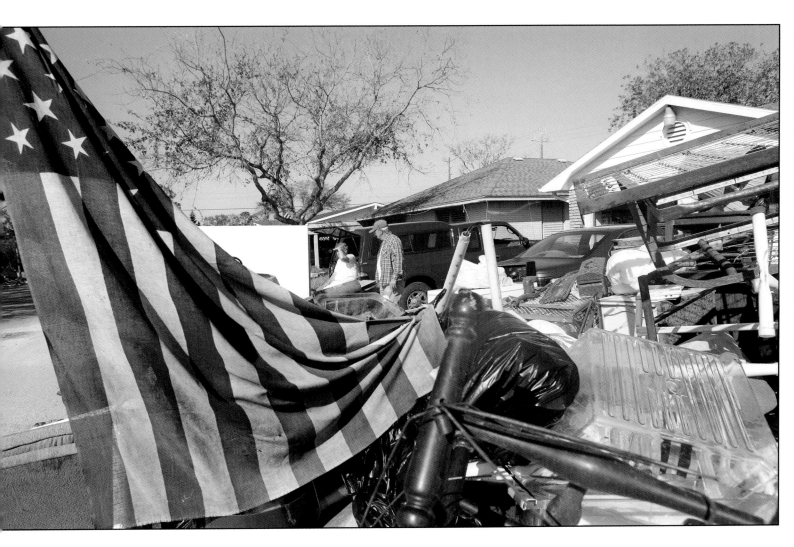

Left: A flag that was found in Doyce Richardson's flood-damaged house was displayed in the pile of debris and furniture from the house he and his wife, Beverly, had lived in for more than 50 years.

JENNIFER REYNOLDS

Center: A sign painted on the back of an old Halloween decoration welcomed Robert Mihovil's neighbors who returned to Galveston.

JENNIFER REYNOLDS

Far left: Bernie Youngblood barbecued chicken for between 10 and 15 people at his parents' house on Fannin Drive in Galveston on Wednesday afternoon, Sept. 24, 2008. The Youngbloods rode out the storm at home.

KEVIN M. COX

...ay, Sept. 19 — ...veston College ...ounced its campus ...tained minimal dam- ...during the hurricane ...would be ready to ...pen when utilities were ...ored on the island.

Friday, Sept. 19 — O'Connell High School announced it would reopen in two weeks after its cleanup was complete. The school library, cafeteria and gym were damaged.

Friday, Sept. 19 — Dickinson school district officials said schools could reopen by Wednesday, Sept. 24.

Friday, Sept. 19 — Clear Creek school district delayed its reopening until Sept. 29 after 39 of its 40 campuses were damaged.

Friday, Sept. 19 — Santa Fe school district said it planned to reopen 48 hours after electricity was restored to all campuses.

Friday, Sept. 19 — State health and human services commission staff was inundated with long lines of people applying for food stamps.

Friday, Sept. 19 — Dillard's announced it would not reopen its store at Mall of the Mainland in Texas City after it sustained more than $4 million in damage.

Friday, Sept. 19 — Officials announced that 18 people in Galveston County had been arrested for looting.

Below: Eugene Overbeck, right, and his son-in-law, Orlando Cortinas, cleaned out Overbeck's house on Poplar Drive in Galveston on Wednesday morning, Sept. 24, 2008. Overbeck and most other Galveston residents weren't allowed back onto the island to see their damaged houses for 12 days after Hurricane Ike made landfall.

KEVIN M. COX

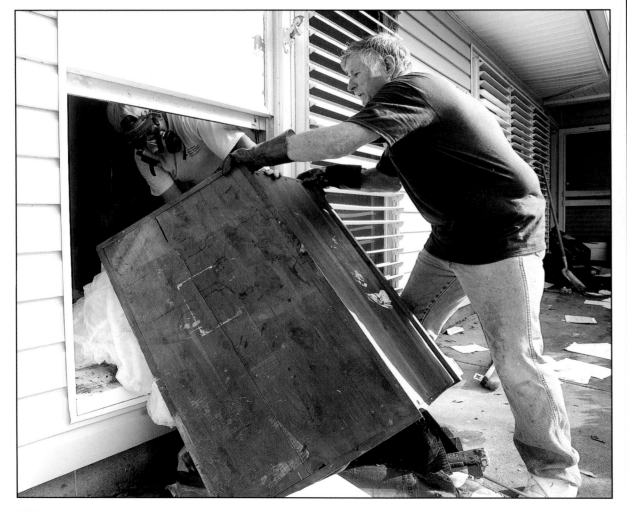

Above: Martha Engel tried to save the dress she wore to her wedding reception by airing it out on the front porch of her house on Bayou Shores Drive in Galveston on Saturday, Sept. 20, 2008. Engel said her wedding dress was in worse shape, but she was assured it could be restored. She and family members were cleaning the house and salvaging what they could. "I came in on Wednesday for the 'look and leave' and cried and cried and cried," she said.

JENNIFER REYNOLDS

Left: Angela Lemons walked past molding furniture and belongings at her house in Galveston on Thursday, Sept. 25, 2008. Lemons was trying to salvage what she could from the house.

JENNIFER REYNOLDS

Right: Michael Geml salvaged several photos and keepsakes from the flooded first floor of his house on Channelview Drive in Galveston.

JENNIFER REYNOLDS

Below: A bicycle was partially buried in the sand under a house in the Pirates' Beach subdivision on the West End of Galveston on Monday, Sept. 15, 2008.

JENNIFER REYNOLDS

Below, center: A great egret looked for lunch amid storm debris on Galveston's East End on Tuesday afternoon, Oct. 7, 2008.

KEVIN M. COX

Below, right: Mark Gosnell, left, and workers from Kustom cleared a display case from a souvenir shop on The Strand on Wednesday, Oct. 1, 2008.

JENNIFER REYNOLDS

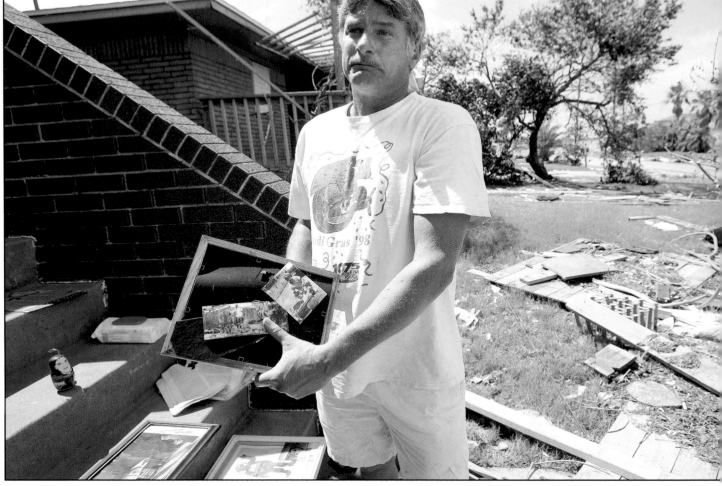

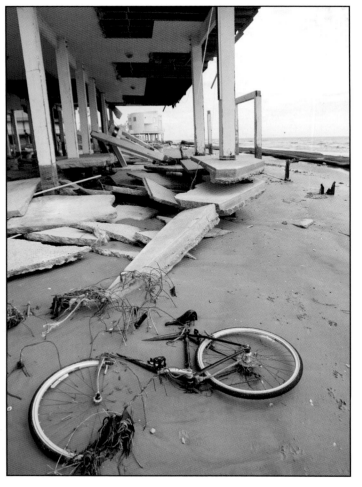

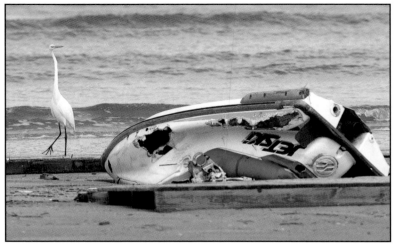

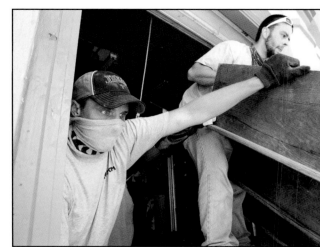

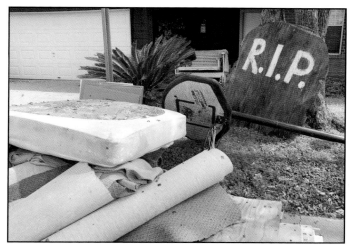

Left: Homeowners on Marine Street in Galveston gave their hurricane-soaked belongings a curbside tombstone.

JENNIFER REYNOLDS

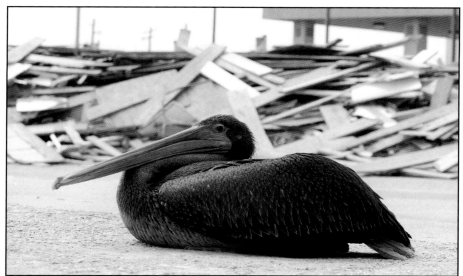

Above: A brown pelican rested near the debris pile on Seawall Boulevard at 23rd Street in Galveston on Thursday, Sept. 18, 2008. Volunteers with the Houston SPCA were called to catch the bird, which was thought to be more tired than injured.

JENNIFER REYNOLDS

Left: Mary G. Bazan and her son, Pete Bazan, sat on the porch of their home on Postoffice Street in Galveston on Saturday, Sept. 20, 2008. Bazan said they spend most of the day on the porch. "It's cooler than in the house" she said.

JENNIFER REYNOLDS

Above: Christian Martinez, 3, waited for Heidi Alcocer and Wendy Shu to finish registering with the Federal Emergency Management Agency on Thursday, Sept. 18, 2008, at city hall in Galveston.

JENNIFER REYNOLDS

Above, left: Kristopher Johnson, 3, was ready to help clean up the water-damaged belongings from his grand-parents' house on Avenue L in Galveston on Monday, Sept. 22, 2008.

JENNIFER REYNOLDS

Left: Brenda Schuck, left, drew a pair of lips on Angel Martinez's mask Friday, Sept. 25, 2008, during a break from cleaning a co-worker's flooded house in Galveston.

JENNIFER REYNOLDS

ht: Paul Ozymy, whose father lives in veston, prayed during church services at dy Memorial First United Methodist Church alveston on Sunday, Sept. 21, 2008. The ice was one of a handful nine days after ricane Ike made landfall.

IFER REYNOLDS

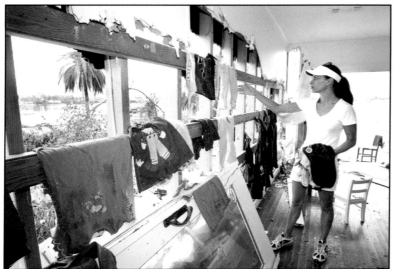

Left: Stephanie Vasut took down children's clothing drying on the studs of her house on Bayou Shores Drive on Friday, Sept. 19, 2008, in Galveston.

JENNIFER REYNOLDS

Below: Chloe guarded furniture drying in the sun in front of Big House Antique's on Mechanic Street in Galveston on Wednesday, Sept. 17, 2008.

JENNIFER REYNOLDS

Bottom: Homeowners Saron Praker, left, and Debbie Delgado helped insurance adjuster David Medearis photograph the high water mark on their house in Galveston.

JENNIFER REYNOLDS

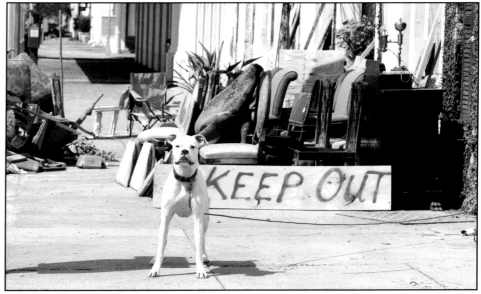

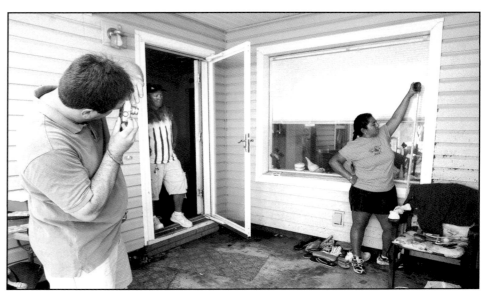

Far right: Genell Simmons, wiped away tears outside of the Red Cross shelter in Galveston on Tuesday, Oct. 22, 2008. Simmons and her husband were turned away from the shelter, which had stopped taking in residents. She said they had nowhere else to go after staying several weeks with a friend. Their apartment at Oleander Homes was flooded by the hurricane, and the housing authority had condemned the property.

JENNIFER REYNOLDS

Right, above: William Armstead waited outside Alamo Elementary School in Galveston on Thursday, Sept. 25, 2008, for a Red Cross shelter to open for island residents displaced by Hurricane Ike. Armstead had evacuated by bus before the storm and had yet to see his home upon returning.

JENNIFER REYNOLDS

Right, center: Shibohn Young carried her belongings to a bus headed to the Red Cross shelter in Galveston on Tuesday, Sept. 30, 2008. She and her husband, Johnny, had evacuated the island after Hurricane Ike hit. They were on one of the first buses returning residents from the shelter in San Antonio.

JENNIFER REYNOLDS

Right: Starr Cisneros, 9, stayed with Elsie, the family dog, outside the Red Cross shelter in Galveston after returning to the island from the evacuation shelter in San Antonio.

JENNIFER REYNOLDS

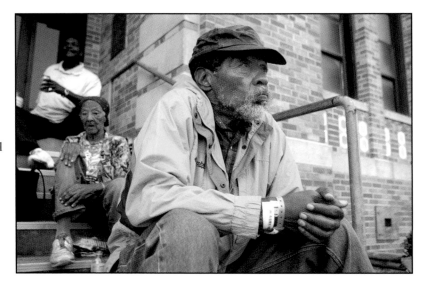

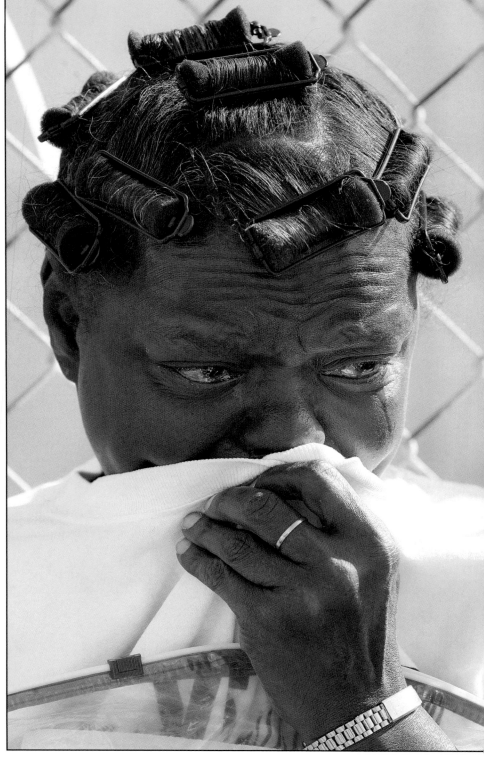

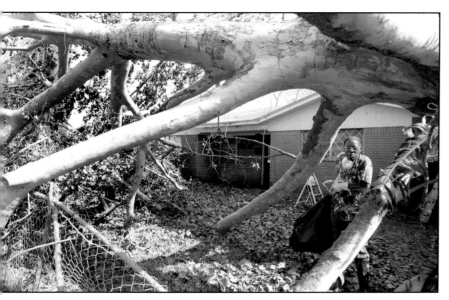

Left: Angela Lemons lugged a garbage bag full of water- and mold-damaged movies under a sycamore tree that fell across her front yard during Hurricane Ike. Lemons' one-story home on Winnie Street in Galveston was flooded with almost 5 feet of water. Her mother's home across the street also was flooded during the storm. Lemons, whose family has lived in the neighborhood for more than 40 years, said she wanted to rebuild her home higher.

JENNIFER REYNOLDS

Below: Rosa Lewkowitz walked through her candlelit home in Galveston on Saturday, Sept. 25, 2008. The 82-year-old Holocaust survivor lost nearly everything when her first-floor home flooded during Hurricane Ike.

JENNIFER REYNOLDS

Peace, calm in dark morning

When we came home after the storm, no one else was staying in our town house community.

We carried on with a generator and a couple of portable air-conditioning units. The cell phone was our only portal to the world beyond our neighborhood.

I didn't like the flies that were breeding in the debris piles. Black, fat, slow-flying flies. There was something I did like, however. I usually get up early, before sunrise. During those first days after Sept. 25, I would take a cup of good, strong coffee (made using electricity from the generator) and, in my pajamas, I would go down to the neighbor's at the end, and sit on her stairs, to get away from the noise of the generator.

What struck me was the out-and-out blackness all around me. It had its own kind of unexpected beauty. There were no house lights, no street lights. No lights at all. I had no choice but to just be there. There was peace and calm. I found the stars one morning and liked it even more. What a show. Having lived in or near a well-lit city for decades, I can't remember seeing such a marvelous show.

I took out my cell phone almost every morning and called my brother in Stowe, Vt.

I liked to tell him about Galveston, that beery middle-aged woman with too much makeup on her broken face. Her ruby red lipstick curved into a little grin, and I heard her husky whisper, "Don'tcha wanna dance?"

— *Jim Plagakis, Galveston*

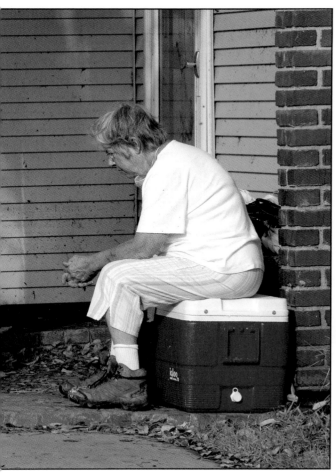

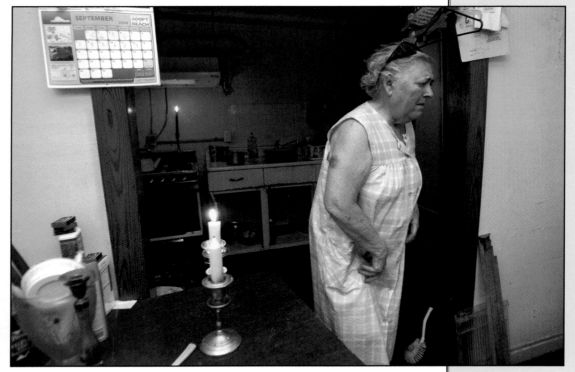

Left: Dolores Johnson sat outside her house Wednesday, Sept. 24, 2008, after returning to Galveston to find it flooded. She and her husband, Andrew, had lived in the house for 44 years. "We're not going to stay," she said.

JENNIFER REYNOLDS

Next page: A crane lifted the 32-ton, 55-foot yacht Narcosis from between the houses of Paul and Linda Merryman and Frank Sager and Valerie Kalupa on North Shore Drive in Clear Lake Shores on Friday afternoon, Oct. 10, 2008.

KEVIN M. COX

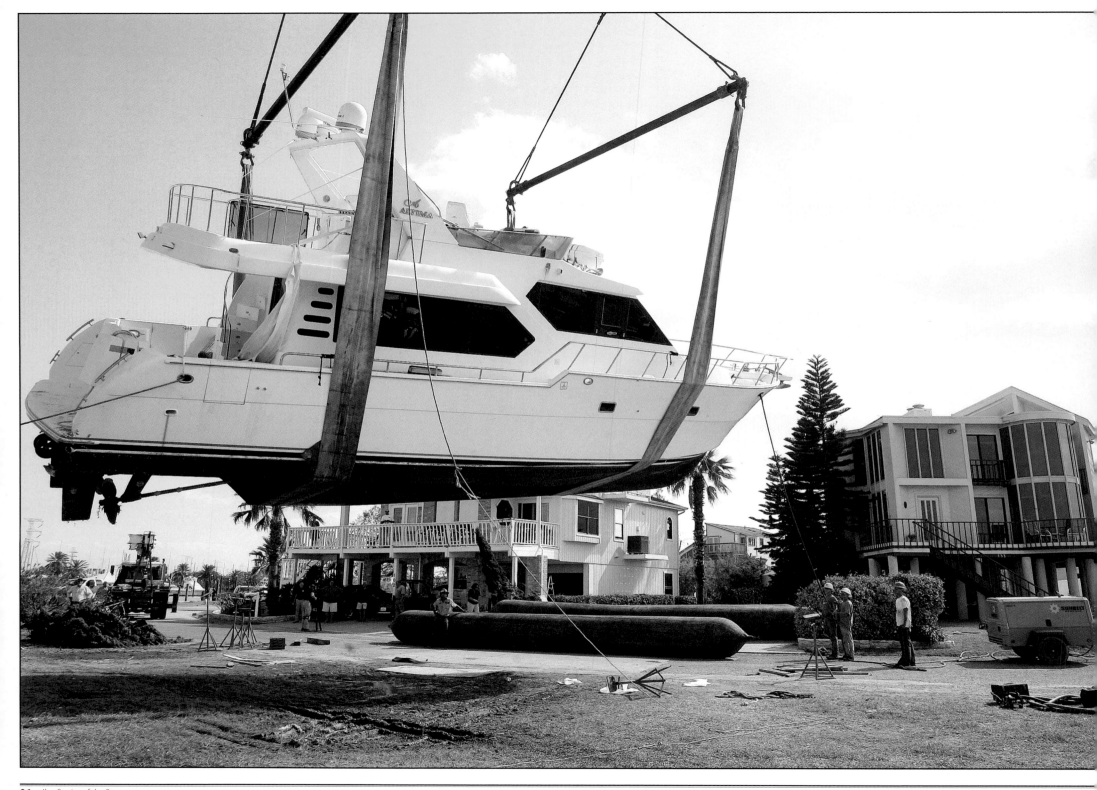

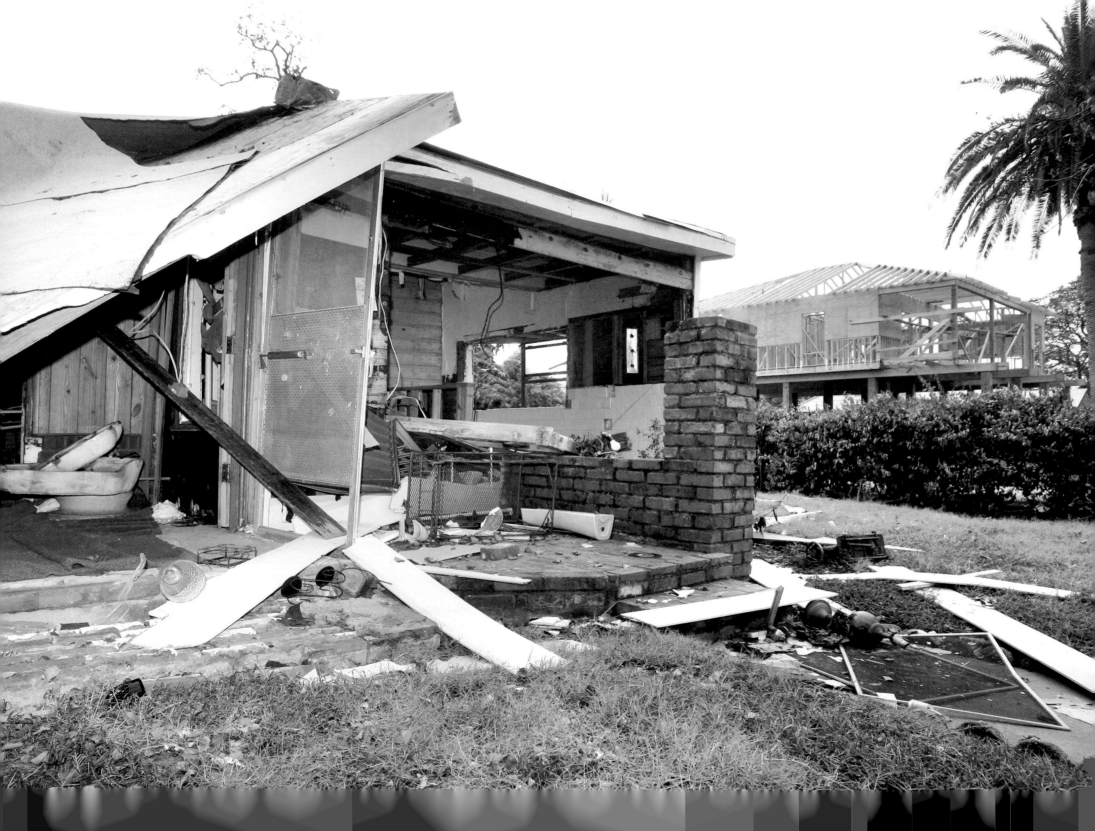

Previous page: A one-story house on Bayou Shores Drive in Galveston was destroyed by Hurricane Ike's storm surge, but a newer house, still under construction, that was elevated showed no signs of storm damage.

JENNIFER REYNOLDS

Right: Gloria McAfee sorted mail at the temporary post office in La Marque on Friday afternoon, Sept. 26, 2008. McAfee and other employees from the Galveston main post office were working to help displaced Galveston residents continue to receive their mail.

KEVIN M. COX

Center: A U.S. postal inspector allowed Galveston residents in two at a time to retrieve mail from the temporary post office at Gulfway Plaza in La Marque on Thursday afternoon, Oct. 2, 2008.

KEVIN M. COX

Far right: A stuffed bear sat on a flood damaged dryer in front of John Machol's home in Colony Park in Galveston.

JENNIFER REYNOLDS

Friday, Sept. 19 — Bolivar Peninsula residents living east of Rollover Pass were allowed to return to survey property damage.

Friday, Sept. 19 — Texas-New Mexico Power said service had been restored to about 75 percent of its customers.

Friday, Sept. 19 — FEMA closed points of distribution in Dickinson, Kemah and Friendswood.

Saturday, Sept. 20 — Texas City Mayor Matt Doyle announced the Texas City Dike would be closed indefinitely because it was not drivable or safe to walk on.

Sunday, Sept. 21 — A handful of Galveston churches met for the first time since Hurricane Ike struck.

Sunday, Sept. 21 — The first oil ships docked in the Port of Texas City, delivering crude oil to the Valero refinery.

Tuesday, Sept. 23 — Galveston Mayor Lyda Ann Thomas went to Washington, D.C., to testify before a U.S. Senate subcommittee on disaster recovery. She requested $2.4 billion in assistance, including $600 million for UTMB.

Tuesday, Sept. 23 — T U.S. Postal Service announced that it would set up a temporary po office in La Marque fo Galveston residents.

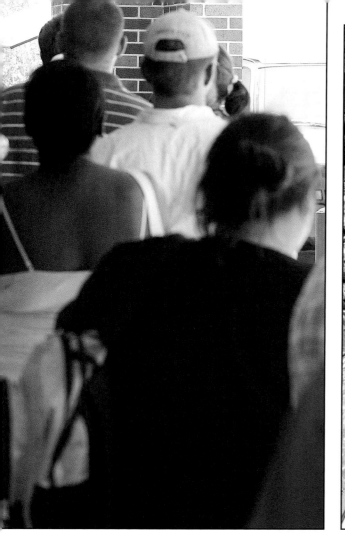

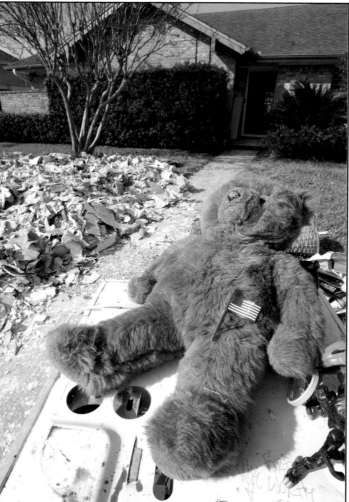

Hurricane Ike victims

In late October, authorities had compiled this list of Galveston County residents who died in the county from effects of the storm:

• Martha Ferguson, 69, of Galveston died Sept. 13, no electricity for breathing machine
• Charles Lively, 79, of League City died Sept. 15, pre-existing health condition
• George Helmond, 72, of Galveston drowned Sept. 14, found in his submerged truck
• Yong Seng Teo, 49, of Galveston died Sept. 14, pre-existing health condition, couldn't reach hospital in time
• Carolyn Williams, 64, of League City died Sept. 15, pre-existing health condition, lack of dialysis
• John Manley, 66, of League City died Sept. 15, pre-existing health condition lack of dialysis
• Jim Devine, 76, of San Leon drowned, listed date of death Sept. 16
• Robert Dort, 76, of Galveston died Sept. 20, pre-existing health condition

• Eddie Bailey, 64, of League City found dead Sept. 23, pre-existing health condition
• Ruben Ramos, 60, of Galveston found dead Sept. 23, pre-existing health condition
• Herman Moseley, 48, of Galveston, drowned, found on Goat Island
• Gail Ettenger, 58, of Gilchrist found Sept. 23 near Chambers County debris field
• Shane Williams, 33, of Port Bolivar, found drowned Oct. 6 on Goat Island
• Unidentified woman, found drowned on Pelican Island
• Unidentified woman found Oct. 6 on Goat Island north of Port Bolivar, cause of death not determined
• Unidentified man found Oct. 6 on Goat Island north of Port Bolivar, cause of death not determined

— Sources: Galveston County Medical Examiner's Office and Chambers County Judge Jim Sylvia

...day, Sept. 23 — With ...sland campus ...rely damaged, UTMB ...ounced plans to ... off-island clinics. ...medical branch also ...John Sealy Hospital's ...ening was at least ...months away.

Wednesday, Sept. 24 — The island reopened to residents, although they were urged to leave after surveying damage. Police reported few problems with traffic on the island, although most traffic lights were still out.

Wednesday, Sept. 24 — The Galveston Housing Authority announced all five of its housing projects were condemned. Residents were given two weeks to salvage their belongings.

Wednesday, Sept. 24 — The Galveston City Council extended a disaster declaration for one year, giving Mayor Thomas limited executive powers.

Wednesday, Sept. 24 — Galveston County Judge Jim Yarbrough said the recovery for Bolivar Peninsula was "longer than we ever imagined." He estimated it could take up to to six months before power would be restored there.

Thursday, Sept. 25 — Evacuees who went to Austin on buses returned to the island two weeks after the storm hit.

Thursday, Sept. 25 — Rescue workers found the body of a woman believed to be from Bolivar Peninsula in a debris field in Chambers County.

Thursday, Sept. 25 — The city of Galveston and the Red Cross set up a "tent city" shelter at Alamo Elementary School. The tent was big enough to hold 500 people, but the city expected to need room for 1,000.

Saving the middle class vital to rebuilding island

H ere is a stark truth: After Galveston's most serious calamity since the 1900 Storm, the way forward is partly obstructed by the fact that the community has no clear vision for its future. The community must create such a vision quickly. Without it, the way forward is murky, and it will be much harder to address major community issues. The central, looming issue is this: Shall Galveston Island focus its efforts to retain a healthy middle class?

Do not smile. Some actually believe the way forward for Galveston is only as a haven for wealthy people who do not live here. Of course, the poor, who make up a growing slice of the population and do not have the resources to flee, will be with us always.

But will Galveston in 2020 still offer middle-income families housing, health care and decent public education? That is the key question.

Community vision is hard to come by, especially in the aftermath of disaster. The mayor and city council cannot create a vision by decree; neither can any individual. To be meaningful, a community vision must be the product of consensus.

In the first weeks after Ike, this issue has been on our minds constantly. What is the way forward? What is the underlying philosophy that should be at the basis of major community decisions?

We have asked the question again and again, and three things stand out:

• The people of Galveston yearn for a unifying vision in rebuilding.

• There is consensus that consensus does not exist. There is no clear, unifying vision of the future.

• Everyone agrees the island city will survive in some manner, but the overriding question is the one we raised at the outset: In the future, can Galveston support middle-class families, and does it even want to try?

"Galveston is a poor community that on Sept. 13 became measurably more destitute," said conservationist and businessman Ted Lee Eubanks. "The first people to leave the island will be those with the resources to do so. Given the challenges we face, how do we attract the middle class back to the island? This is the island's most pressing concern."

We offer here at least one vision for Galveston's future, based on the ideas of dozens of ordinary citizens and community leaders.

Our vision is simply stated but not simple, and it is based on six essential ideas. We believe most people can agree with most of these six ideas:

1) Preserving Galveston's middle class is not just important; it is vital. Without a healthy middle class, no community can be healthy. So, decisions about building permits, zoning, schools, health care — every key decision — must be made with nurturing the middle class firmly in mind. Ironically, some of the Galveston neighborhoods hit hardest by Ike are home to much of the island's middle class. Rebuilding those neighborhoods, and doing it quickly, should be a top priority.

Much rides on not punishing the middle class with unrealistic taxes and fees for city services, and much depends upon creating policies that encourage rather than discourage re-investment by the middle class. Local leaders must control the cost of government.

2) Make sure the island continues to be insurable. Insurance companies and even FEMA must look at a national and international set of financial demands, and thus their focus will be more on that bigger picture than on Galveston's survival.

Once again, local leadership must look to legislative and business models used elsewhere, and once again the drive in that direction must come from the self-interest of local people.

3) Devise a plan for the University of Texas Medical Branch that no longer depends solely upon the University of Texas Board of Regents to ensure the facility's future.

As the community's only public hospital, we must ensure the hospital remains strong and serviceable, and we must fight for continued employment

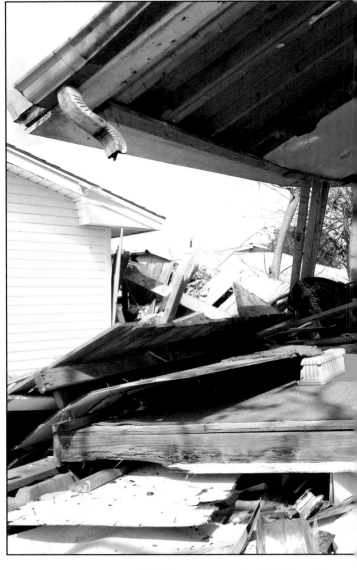

Dolph Tillotson is president and publisher of The Galveston County Daily News. This piece originally ran as an editorial in the Sunday, Oct. 19, 2008, editions of the newspaper.

Read other civic leaders' thoughts on how the Galveston Island should approach its philosophy to rebuilding on Pages 102-103.

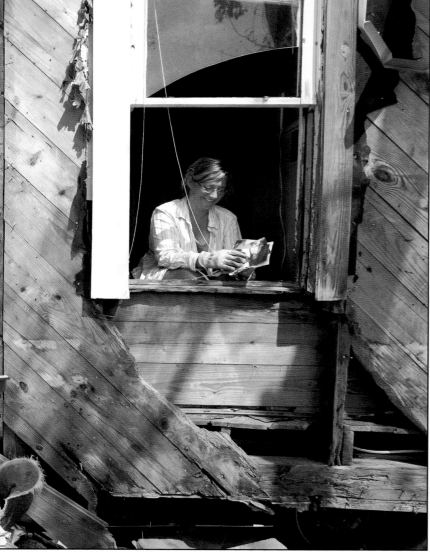

Above: Alisha Goldberg looked through photos she found in her partially collapsed house on 62nd Street in Galveston on Monday. Sept. 22, 2008. Storm surge destroyed several houses in her neighborhood.

JENNIFER REYNOLDS

Above, right: Margaret Epps carried bags of flood-damaged items from her house in Galveston on Friday, Sept. 26, 2008.

JENNIFER REYNOLDS

Right: Nancy M. Jones began cleaning out her flood-damaged house in Galveston. Jones returned early Wednesday, Sept. 24, 2008, to find her house had close to 3 feet of water in it during the storm.

JENNIFER REYNOLDS

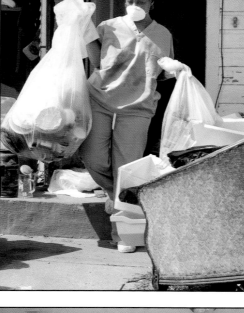

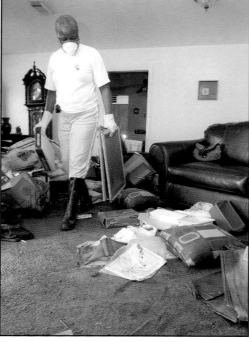

of as many people as possible.

That likely will require creation of a regional hospital district, and it certainly will be funded less and less by state appropriations.

That trend was clear before Ike, and it won't change.

The UT system necessarily will focus on its main mission elsewhere, not on the needs of our region's poor and middle class.

4) Change the course of the Galveston Independent School District.

The trend toward a smaller school system is not a bad thing, but the trend toward low achievement is one of the most critical factors that will drive middle-class families to leave Galveston forever.

5) Develop a plan now to capitalize on the good things we know will happen in coming months.

The Galveston National Lab is a good example of a pipeline of money that may or may not be tapped to aid the local economy. The proposed container terminal port of Pelican Island is another example.

The incoming flood of money from insurance payments and FEMA reimbursements is another.

The Bush Clinton Coastal Fund is another. There are many sources of financial help available for the island, but Galveston must be aggressive and well organized in seeking them.

6) Think regionally.

For too many decades, island leadership has taken a parochial, purely local approach to problem solving.

In the competition for federal dollars for transportation, for the environment, for redevelopment of our infrastructure, such parochialism guarantees failure.

Does anyone really think Galveston will challenge and defeat Houston in the competition, for example, for federal port funding? It's not likely. Galveston cannot afford further isolationism.

There you have it. This vision, based on the simple notion of preserving Galveston Island's middle class, is offered not to attempt to dictate to anyone, but to begin a discussion that is vital.

We hope others carry the discussion further and to greater depth, and we hope that happens soon.

We are optimistic about the future of Galveston.

We take comfort in the example of our journalistic ancestors, who wrote to the New York Herald Tribune after the 1900 Storm, "We (Daily News personnel) were dazed for a day or two after the storm, but there is no gloom here now as to the future. Business has already resumed."

However, in 1900 the community's vision was simple: Rebuild and preserve the city of Galveston as a place for all people, especially for the middle class. That was a good starting point for a vision of recovery in 1900.

It still is.

— *Dolph Tillotson*

James D. Yarbrough
Galveston County judge

"The city's charm and historic flavor will re-emerge to help the island recover and rebuild.

"It will be a different Galveston Island, to be sure. Some neighborhoods will return stronger than ever, a testament to the character of our citizens and institutions. Others will be forever changed, perhaps converted to parks or open space where new memories of a pleasant island breeze can be born.

"From every disaster there are challenges, as well as opportunities.

"If our collective vision of Galveston Island is a place where affordable housing is plentiful, where quality education, health care and employment are attainable and sustainable, we must embrace every opportunity to turn 'acceptable' into 'better' or 'best.'

"We can restore the island we have known and cherished. Or we can create a new island, and a new county, that exceed our expectations and dreams. We can do it together!"

Maureen M. Patton
executive director, The Grand 1894 Opera House

"Over and over again, I've heard friends say that we'll rebuild better and smarter and I believe that.

"What I've discovered personally in the aftermath and recovery from Ike is that sharing time with family is a treasure; sunrise is a glorious time of day as is sunset; the stars are brighter with fewer street lights; a hug and meaningful conversation with friends at a local restaurant, in the grocery store or on the street is not something to be taken lightly; excellent civic leadership is a weighty responsibility in the easiest of times and priceless in a crisis; and saying thank you to those who serve, whether first responders or front-liners, should be done sincerely and frequently.

"My hope is that we will all remember these days as an opportunity to change, not just the city's infrastructure, but ourselves, remembering that time is a gift and we've probably been spending far too much of it rushing from place to place."

Jimmy Kessler
rabbi

"One of the unique aspects of Texas and clearly Galveston is the entrepreneurial heritage that gave birth to our city.

"That's what has to be our tomorrow. We have to identify our needs and create new responses aimed at the future. Granted, knowledge of the past is important, but it cannot be a bridle by which we are constrained.

"Moses knew nothing of the needs of the Promised Land, but he knew it was God's promise ... the same is true for us. We should know we need to continue, we need to develop and we need to advance. It may be that the path will be new and unknown, but the goal is readily discernible — growth, development and survival."

Kenneth Shelton Jr.
Realtor

"If Galveston survives and thrives, it will be because of the will and perseverance of its citizens. The city government can help enable a renaissance by fostering rebuilding, or it can impede the process by applying endless red tape to the wound until the patient enters a coma."

Barbara Crews
former mayor and civic leader

"We have a rare moment now to rebuild Galveston as a sustainable community, where people can live and work. We must use this opportunity to design a plan to diversify and expand our job base, using imaginative strategies that require us to think more regionally than we're used to.

"We must find a way to develop a full range of housing types and a downtown retail mix that is supported by residents as well as tourists.

"This will be tough and complicated. It will require imagination, vision and a local and regional approach that will be new for Galveston. I am hopeful that we will take full advantage of this rare moment in time, because I am confident we can succeed."

Ted Lee Eubanks
conservationist and businessman

"In the most fundamental ways, Galveston will remain the same — a fragile sliver of sand subject to natural forces unimaginable to the interior of our country. We will remain a community of incomparable historical significance, one that will retain much of the charm and spirit that so uniquely characterized it before the storm."

David L. Callender
M.D. and president, University of Texas Medical Branch

"Galveston may become even more of a resort community with a strong service sector. But what distinguishes Galveston from other resorts is the strong presence of our higher education institutions — Galveston College, Texas A&M-Galveston and UTMB.

"Despite Ike, Galveston will continue to benefit from these robust academic institutions that contribute to the fabric of life here.

"Like UTMB, Galveston must always honor its history, but must also focus on its future."

Craig Brown
developer and business owner

"This recovery will ... be affected by an intangible that has been lacking for quite a while in Galveston and that is the inability of our city leadership to set a clear direction and develop a sense of cooperation to attain a common goal. If our city council continues, as it did prior to Ike, to revel in contentiousness and spend an inordinate amount of time in trying to correct perceived past wrongs instead of coming together to develop a spirit of cooperation, then our rebuilding efforts will continue to be disappointing.

"This need for cooperation, which was fundamental in the island's past rebuilding efforts, is far more important than any amount of money or materials.

I've heard from many citizens that with the destruction comes the ability

of looking at our community as a blank canvas where we can establish a new picture for the future of Galveston. This same restructuring needs to permeate the focus of our city government. Many businesses are hanging on by a thread and unless our leadership sets a clear cooperative vision for the island's future, many businesses will elect to move elsewhere."

Lyda Ann Thomas
mayor of Galveston

"Ike struck at a point in our history similar to 1900; it smacked us squarely in our face when we were looking the most beautiful and boasting of the most promising future.

"Like our forebears, we will rebuild with perseverance, ingenuity and intelligence.

"The seawall and grade raising proved their worth and the willingness of Galvestonians to sacrifice for the future.

"All our shorelines must be protected from erosion and surge, whatever the cost.

"Our houses and buildings that were built to recent code withstood Ike's torrent; we will build even smarter and better.

"This I believe: As much as the face of Galveston may change, its future is anchored in the faith and resiliency of our citizens. It is called the 'Galveston Spirit.'"

Betty Massey
executive director of the Mary Moody Northen Foundation and chair of Galveston's Comprehensive Plan Committee

"As busy as city officials are clearing the destruction of Ike, we need to start a community dialogue about the future of Galveston, what we are going to look like and what we want to be. In some sense, we are getting a 'do-over,' another chance to get things right. We have a monumental housing crisis, huge challenges in our schools, a very fragile national economy compounded by the fragility of our local economic and business situation, but we have to start talking and planning to do our rebuild right."

Could a levee save the island?

In the late 1970s, Army engineers foresaw a storm that so closely resembled Hurricane Ike their description of it reads like a premonition.

They also described in detail how to prevent that damage.

In the middle of all the destruction, Texas City came through with little damage or flooding. That's because it was ringed by a levee system — the same kind of system that engineers recommended for Galveston almost 30 years ago.

Left: Seawall Manager Paulo Flores with the Galveston County Road and Bridge Department pointed out the erosion on the county hurricane levee caused by Hurricane Ike on Skyline Drive north of Texas City on Wednesday afternoon, Oct,1, 2008. County Engineer Mike Fitzgerald said a levee system like the one that protects Texas City could have prevented much of the flooding Ike caused in Galveston.
KEVIN M. COX

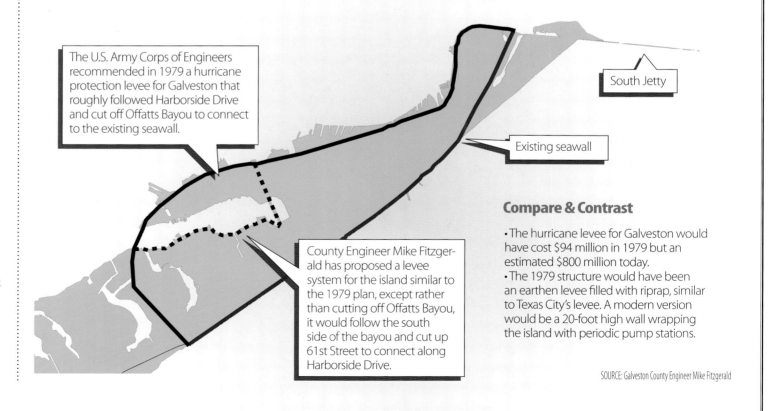

The U.S. Army Corps of Engineers recommended in 1979 a hurricane protection levee for Galveston that roughly followed Harborside Drive and cut off Offatts Bayou to connect to the existing seawall.

South Jetty

Existing seawall

County Engineer Mike Fitzgerald has proposed a levee system for the island similar to the 1979 plan, except rather than cutting off Offatts Bayou, it would follow the south side of the bayou and cut up 61st Street to connect along Harborside Drive.

Compare & Contrast

• The hurricane levee for Galveston would have cost $94 million in 1979 but an estimated $800 million today.
• The 1979 structure would have been an earthen levee filled with riprap, similar to Texas City's levee. A modern version would be a 20-foot high wall wrapping the island with periodic pump stations.

SOURCE: Galveston County Engineer Mike Fitzgerald

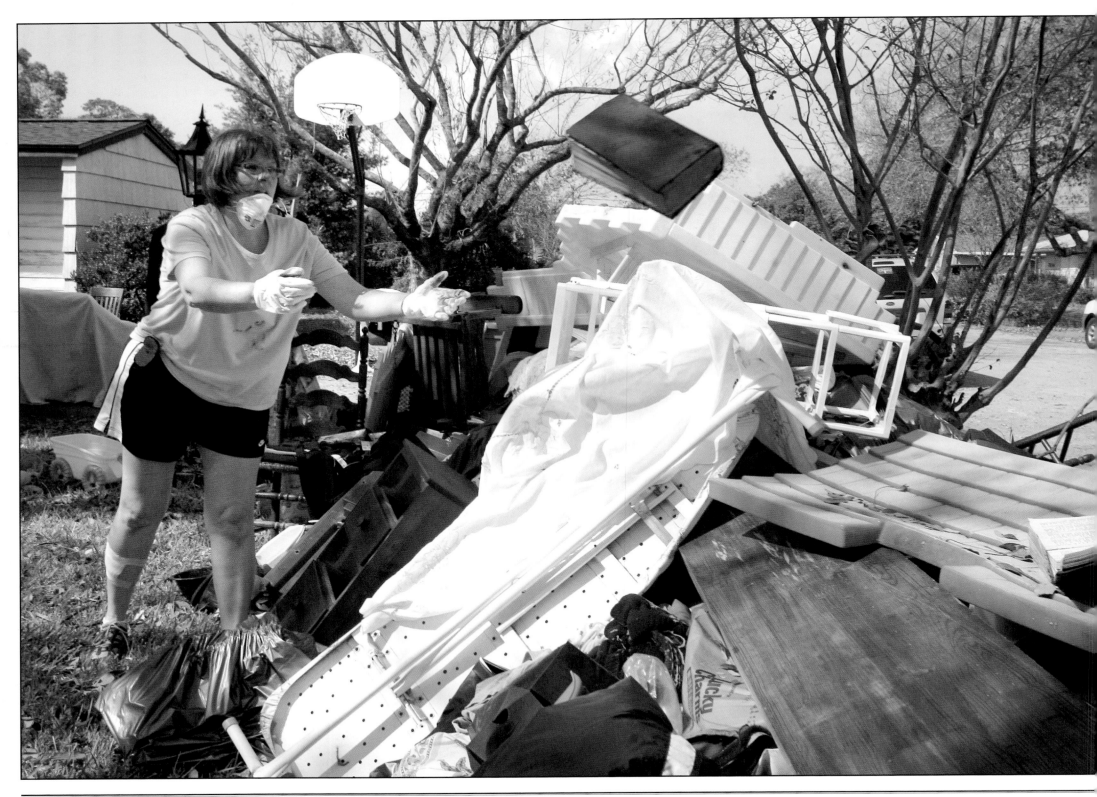

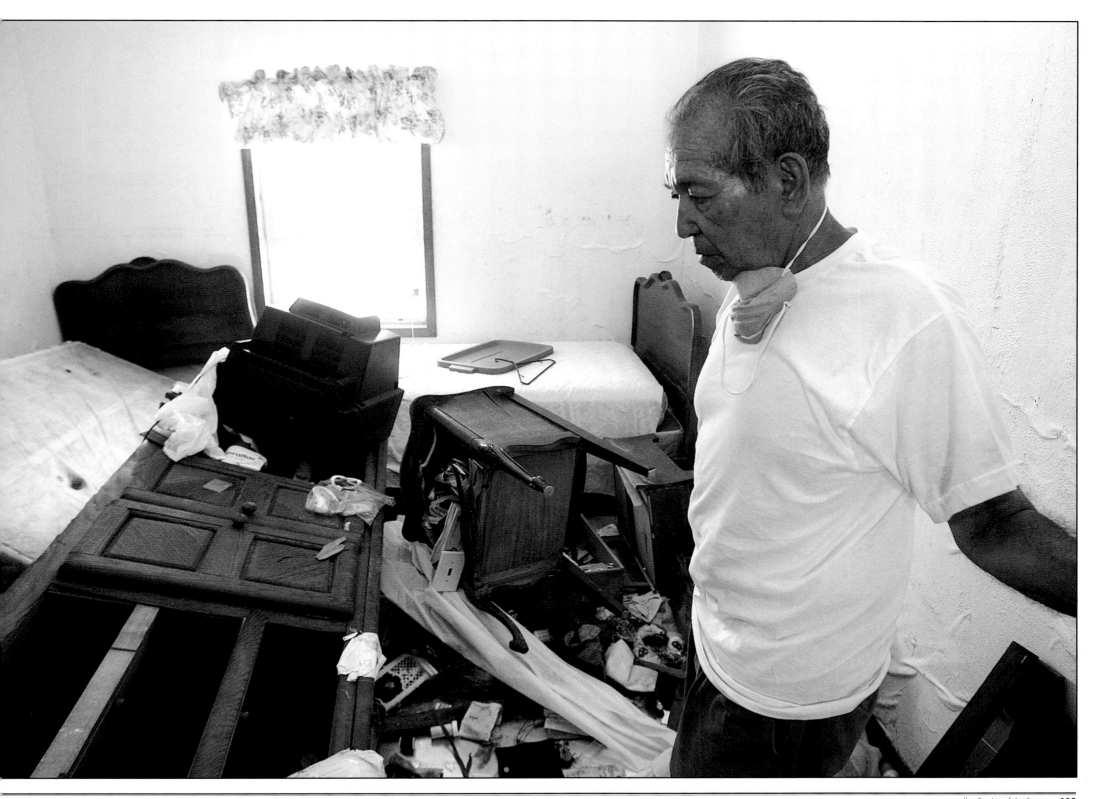

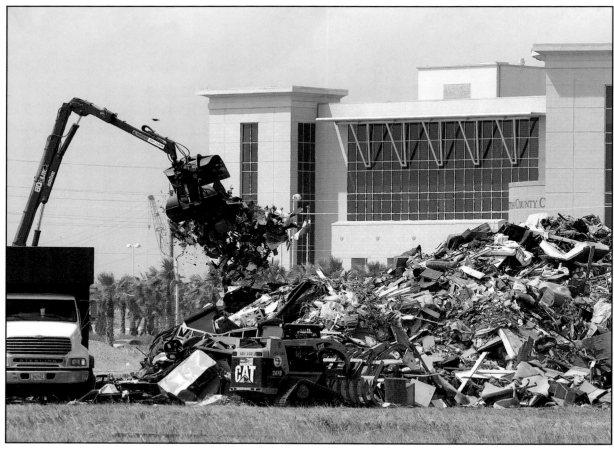

Previous pages: Betty Boone tossed her father's waterlogged medical books onto the growing pile of debris from her house on Poplar in Galveston on Sunday, Sept. 21, 2008. Boone had several feet of water from Hurricane Ike in her house.

JENNIFER REYNOLDS

Gregorio Rodriguez cleaned out his house in Freddiesville on Friday afternoon, Sept. 26, 2008. Rodriguez had lived in the home with his wife since 1957, and they had never seen the water rise as high as it did during Ike.

KEVIN M. COX

Above: Trucks unloaded piles of debris in the field between the Justice Center and Broadway in Galveston on Tuesday afternoon, Sept. 23, 2008.

KEVIN M. COX

Far right: A worker unloaded his truck at the debris pile in front of the Galveston County Justice Center on Monday, Oct. 6, 2008. The field was rapidly filling as crews continued to remove debris from houses and businesses damaged by Hurricane Ike.

JENNIFER REYNOLDS

Right: An excavator moved debris from Hurricane Ike at the debris collection site on Seawall Boulevard in Galveston on Friday, Sept. 25, 2008. The massive pile was five stories high.

JENNIFER REYNOLDS

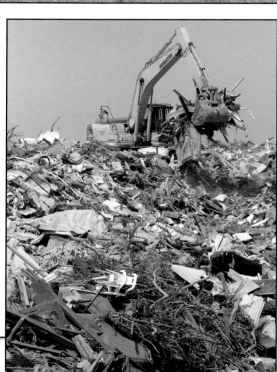

Above: Patrick De Santo, 4, played on the monkey bars at Centennial Park in Friendswood, one of the few parks open, on Thursday morning, Sept. 25, 2008, as life in the North County began returning to normal.

KEVIN M. COX

Right: U.S. Postal Services letter carrier Linda Palomo delivered mail in Galveston on Monday, Sept. 29, 2008.

JENNIFER REYNOLDS

Far right: Samantha Melendez, a sixth-grader at Weis Middle School, drew all the things she lost during Ike.

JENNIFER REYNOLDS

Above, right: Al White (24) made a 19-yard first down reception for the Mustangs during the Friendswood vs. Texas City football game on Friday evening, Sept. 26, 2008. It was the first county football game played after Hurricane Ike.

KEVIN M. COX

Left: Hayden McNeil (34) and Rodrick Sparks (80) stopped the Mustangs' Andre Gautreaux (3) during the Friendswood vs. Texas City football game on Friday evening, Sept. 26, 2008, in Friendswood.

KEVIN M. COX

Far left: Wearing an "I survived Ike" T-shirt, Rebecca Romero, left, attended a Welcome Back pep rally for Ball High School with Anneliese Enriquez and her daughter, Giselle, on Friday, Oct. 3, 2008, at Spoor Field in Galveston.

JENNIFER REYNOLDS

Left: Efrain Alvarez, 12, slid on a tarp near his home in Freddiesville on Friday afternoon, Sept. 26, 2008. Alvarez, his brother, sister and cousin were cleaning the tarp before they turned it into a slip-n-slide to escape the heat.

KEVIN M. COX

Above: Wearing an "I survived Gustav" T-shirt he got while working in Louisiana, Jerry Malone picked out a Hurricane Ike T-shirt Wednesday, Oct. 1, 2008, in Galveston. Malone, a contractor, was helping restore cable service in the aftermath of the storm.

JENNIFER REYNOLDS

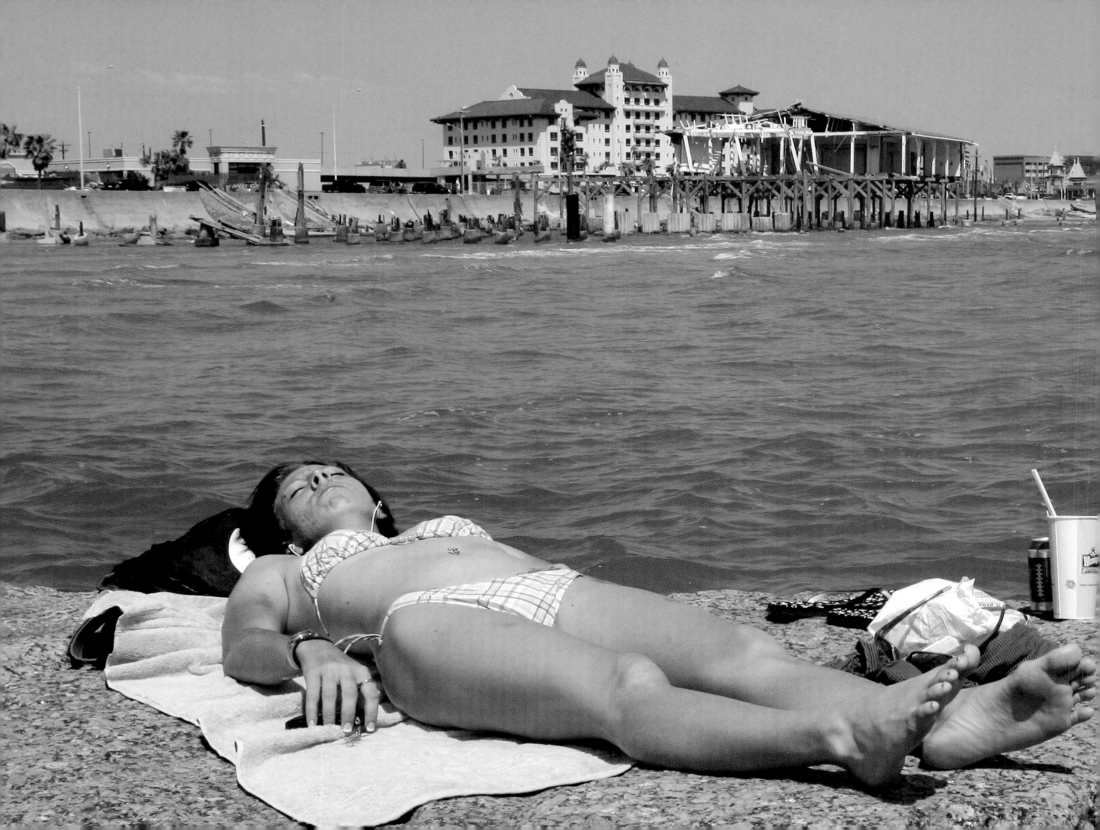

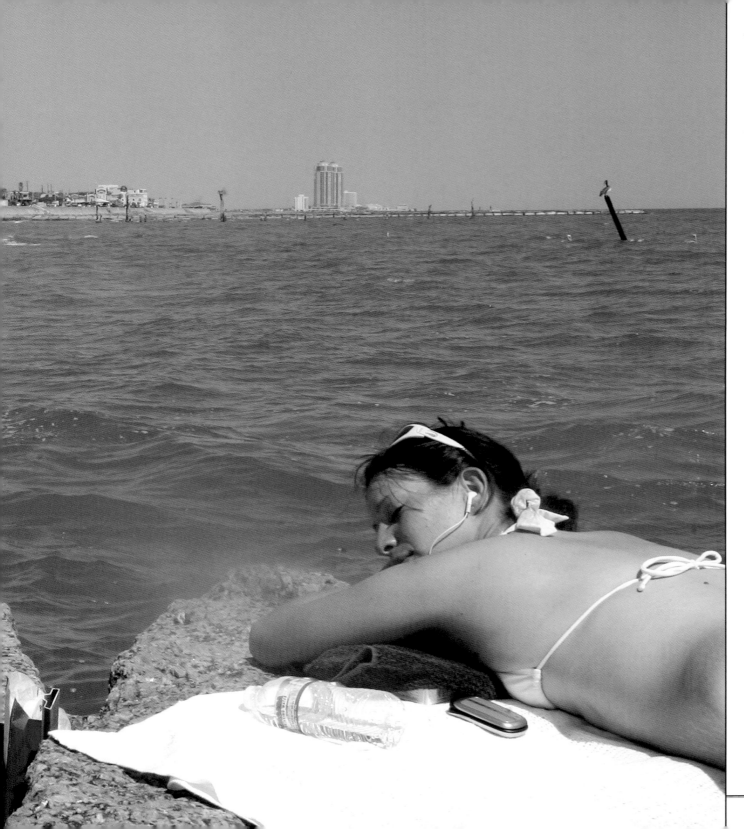

Jennifer Watz, left, and Emily Golden, both in the Texas Army National Guard, soaked up some sun on the jetty near 23rd Street in Galveston during their day off from working at the point of distribution in the parking lot of Academy on the seawall. Watz said she thought the jetty was safer to lie on than the sand.

JENNIFER REYNOLDS

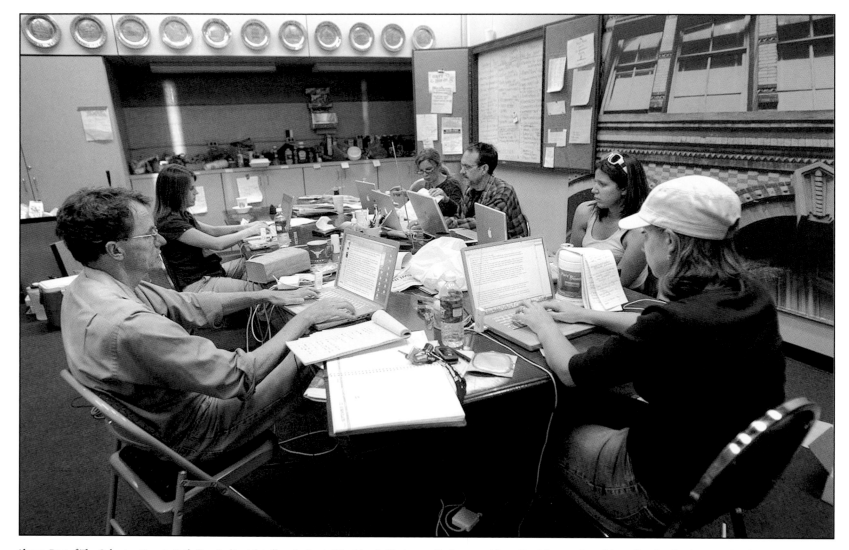

Above: Part of The Galveston County Daily News' editorial staff worked out of the island office's conference room after Hurricane Ike struck. They include, clockwise from left, Edtior Heber Taylor, Leigh Jones, Laura Elder, Assoicate Editor Michael A. Smith, Sara Foley and Rhiannon Meyers. A generator powered laptops and charged cell phones until power came back on in the building.

JENNIFER REYNOLDS

Back cover: Mason Daniel, a member of the Ball High School Tor Watch, added "Ike was here" on his painted jeans that usually show school spirit. The pep rally on Friday, Oct. 3, 2008, not only celebrated Ball High's first football game after Hurricane Ike, but also it served as a "Welcome Back" rally for the school district and community.

JENNIFER REYNOLDS

Photo reprints and additional features can be found online at storiesofthestorm.com